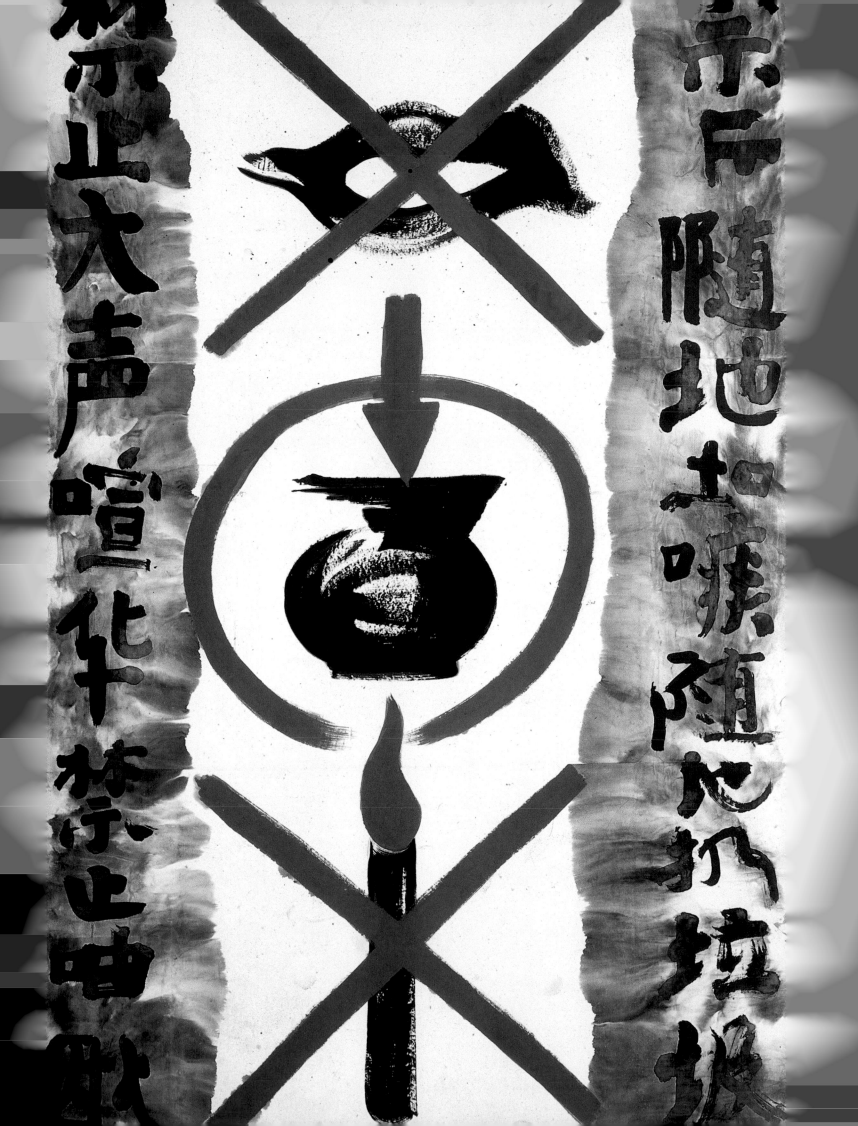

Wenda Gu

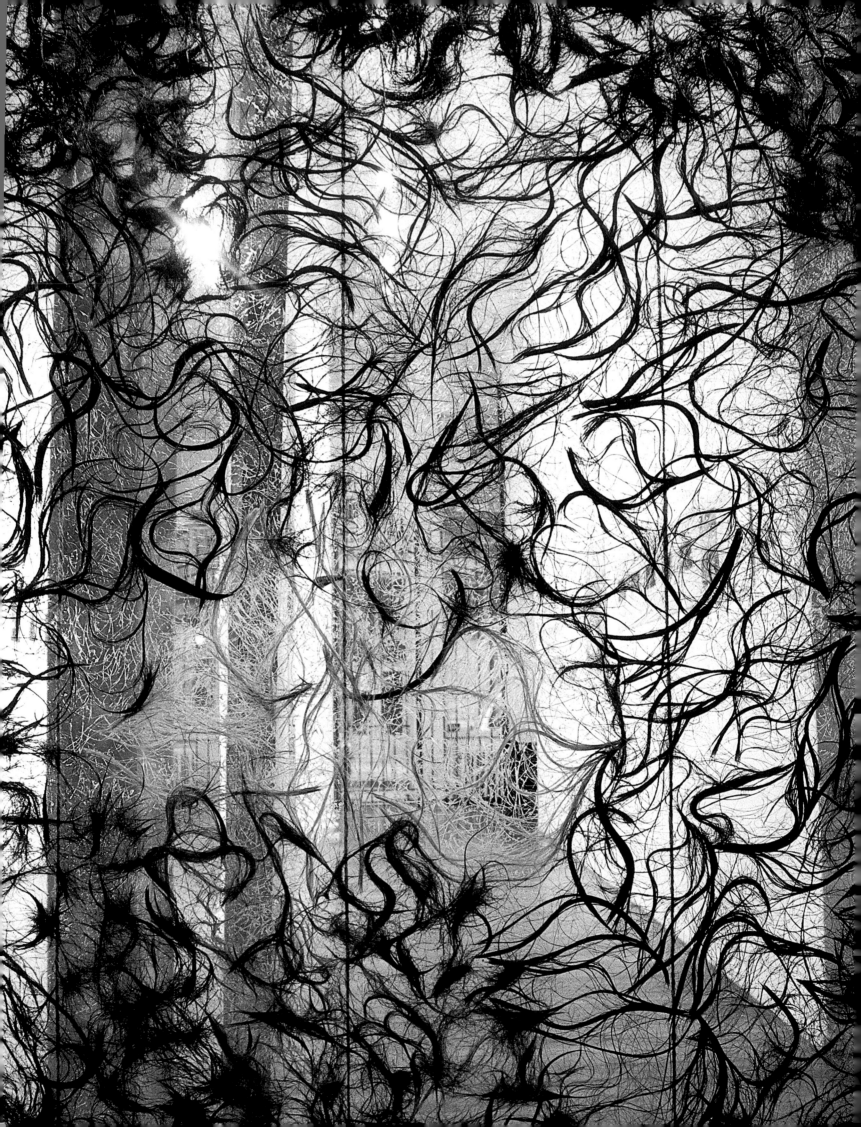

Wenda Gu

Art From Middle Kingdom to Biological Millennium

Edited by Mark H.C. Bessire

The MIT Press
Cambridge, Massachusetts
London, England

The exhibition **Wenda Gu: from middle kingdom to biological millennium** is organized by a consortium of art colleges: the University of North Texas Art Gallery, H&R Block Artspace at the Kansas City Art Institute, and the Institute of Contemporary Art at Maine College of Art.

The project was generously supported by **The Andy Warhol Foundation for the Visual Arts** and the **National Endowment for the Arts.**

EXHIBITION SCHEDULE
January 16 – February 25, 2003
University of North Texas Art Gallery, Denton, Texas

June 6 – September 6, 2003
H&R Block Artspace at the Kansas City Art Institute, Kansas City, Missouri

June – October, 2004
Institute of Contemporary Art at Maine College of Art, Portland, Maine

CURATORS
Mark H.C. Bessire, Diana R. Block, and Raechell Smith

The book was set in Scala and ScalaSans, designed by Martin Majoor in 1988–90 and 1993 respectively, Alphatier, designed by Mark Jamra in 2000–03, and was printed and bound in Hong Kong.

DESIGN
Margo Halverson and Charles B. Melcher, Alice Design Communication

Library of Congress Cataloging-in-Publication Data
Gu, Wenda, 1955–
 Wenda Gu: art from middle kingdom to biological millennium/edited by Mark H.C. Bessire.
 p. cm.
 Catalog of an exhibition held at University of North Texas Art Gallery, Denton, Tex., Jan. 16–Feb. 25, 2003. H&R Block Artspace at Kansas City Art Institute, Kansas City, Mo., June–Sept., 2003, and the Institute of Contemporary Art at Maine College of Art Portland, Me., June–Oct., 2004.
 Includes bibliographical references.
 ISBN 0-262-02552-3 (hc : alk. paper)
 I. Gu, Wenda, 1955—Exhibitions. 2. East and West in art—Exhibitions. 3. Gu, Wenda, 1955—Criticism and interpretation. I. Bessire, Mark. II. University of North Texas, Art Gallery. III. Kansas City Art Institute. IV. Maine College of Art. Institute of Contemporary Art. V. Title.

N7349.G8A4 2003
759.951—dc21 2003044524

Front cover: *united nations: the babel of the millennium,* 1999.
Hair, glue, and rope; 116 panels, 78 x 48 in. each.
Collection of Vicki and Kent Logan; Fractional and promised gift to the San Francisco Museum of Modern Art. Installation image from "Inside Out: New Chinese Art."

Back cover: *Forest of Stone Steles: Retranslation and Rewriting of Tang Poetry,* 1993–2003. Installation image from National Gallery of Australia, Canberra, 2001.

Page 2: *united nations – usa monument #1: post-cmoellotniinaglpiostm,* 1995. (detail) Site-specific installation, Space Untitled Gallery, New York, New York, U.S.A.

Page 6: *Ink Alchemy,* 2000–2001.

Page 13: *Fake Seal Script Seal,* 1983. (detail) Seal carving on stone.

Contents

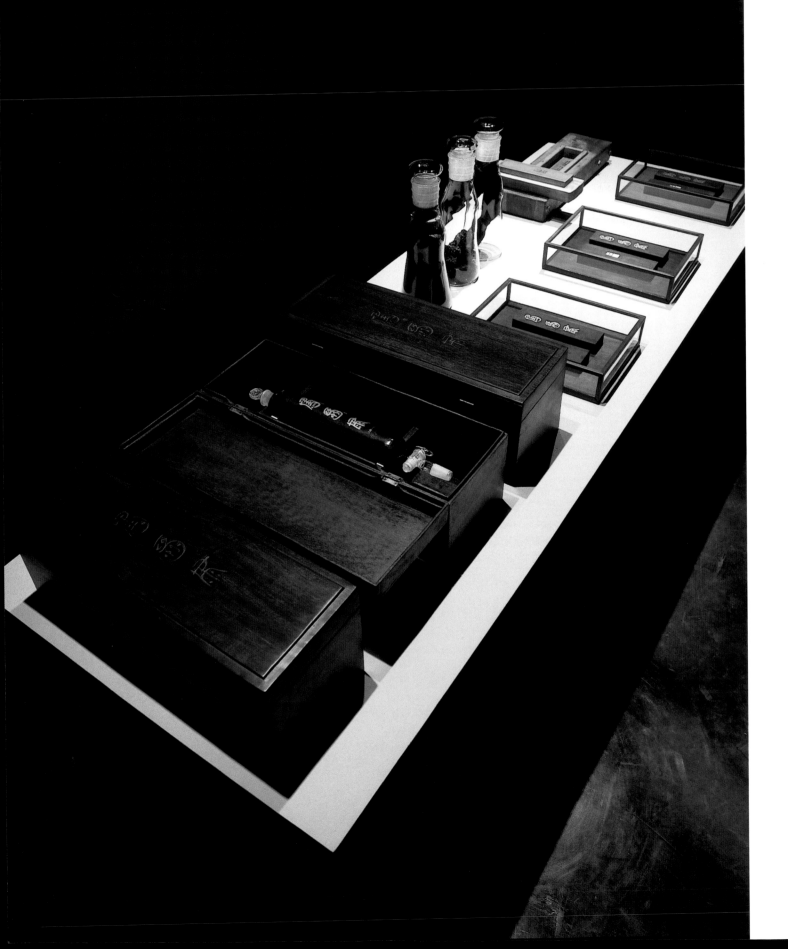

Foreword | **Mark H.C. Bessire, Diana R. Block, and Raechell Smith**

THE GROUND BREAKING 1993 exhibition "China's New Art, Post-1989" and 1998 exhibition "Inside Out: New Chinese Art"" greatly expanded international perceptions of Chinese art and its growing role in the global contemporary art world. While viewing "Inside Out: New Chinese Art" at the P.S. 1 Contemporary Art Center and Asia Society Galleries, I took voracious notes and recorded various artists' names in my notebook. I spent the most time viewing Wenda Gu's *united nations – china monument: temple of heaven*. The piece was elegiac yet subtle in its use of grand themes and materials. It created a cultural and aesthetic bridge from the Chinese traditions of ink painting, calligraphy, and Ming furniture to the new global, or what Wenda Gu calls, the "biological millennium," characterized by video monitors and banners of human hair. The banners or scrolls of pressed hair were the conveyance for an untranslatable, hybrid calligraphic language of characters also made from hair.

Months after "Inside Out: New Chinese Art" closed and soon after I had become the Director of the Institute of Contemporary Art at Maine College Art, Dr. Gan Xu, an art history professor at the College, proposed an exhibition for the ICA. He began by contextualizing the exhibition with a story of his introduction to the artist's work in China and how it radically influenced Chinese art, specifically ink painting. This artist's work, he said, had greatly impacted his own career as a young art historian unable to view contemporary art outside of China. Laying out images on a desk I realized that he was proposing an exhibition of the artist Wenda Gu. I agreed to his proposal immediately and we began to plot a path to bring the artist to Maine. We both felt strongly that after ten years of group exhibitions of contemporary Chinese art, it was time to examine Wenda Gu's work in depth beyond a strictly Chinese context. This would require a traveling exhibition and a major publication.

Five years later that proposal has manifest into everything we aspired to accomplish. The goals were achieved through an elaborate and efficient collaboration among contemporary academic art spaces at the University of North Texas, Kansas City Art Institute and the Maine College of Art; with the support of the National Endowment for the Arts and The Andy Warhol Foundation for the Visual Arts; and the scholarship of MIT Press. Collectively we have shared our resources and expertise to proudly present the art of Wenda Gu.

Mark H.C. Bessire
Director
Institute of Contemporary Art at Maine College of Art

WHEN I WAS INTRODUCED TO WENDA GU by his wife, native Texan Kathryn Scott, I knew little about his work except what I read in the mainstream American art press (March 1999 *Art in America* cover and September 2000 *ARTnews* feature). I soon invited him to speak at the University of North Texas, looking forward to learning more. He arrived in Denton on January 18, 2001 and delivered a powerful lecture, impressing us with the scope of his vision and invention. Gu's path from China to America and his experiments with form and materials, eventually focusing on the body, were extremely interesting. Moreover, the limitless nature of his work, truly global in design, was inspiring to a primarily young artist audience. I promptly ushered him into our gallery and proposed a project for the university. At that time, Gu was not thinking of developing small scale projects. He was receiving inquiries from other curators concerning new work and put me in touch with other museums. Thus began the collaboration between the Maine College of Art's Mark Bessire, Kansas City Art Institute's Raechell Smith and myself, to work with Wenda Gu to create an exhibition directed towards teaching institutions.

As directors of academic art spaces with limited resources, our initial task was clear – raise the funds necessary to commission new work from Wenda Gu. A successful grant application to the National Endowment for the Arts followed by significant funding from the Andy Warhol Foundation for the Visual Arts enabled us to ambitiously move ahead with our project. We then met in New York to discuss Gu's ideas on creating new work and to formalize exhibition plans. All three curators knew Wenda, but none had met each other in person. We needed to conceptualize the exhibition and Wenda had very definite ideas about a site-specific installation piece related to his *united nations* series for the three very different spaces. At the University of North Texas (the smallest space), I was to make not only the gallery available, but also the center atrium of the art building and foyer areas, so that the presentation could take over the School of Visual Arts and be experienced on all three levels of the building.

Soon after the meeting, Wenda prepared a new written description of the proposal and "from silkroad to pop highway" (original working title) became "from middle kingdom to biological millennium." The new project consisted of two primary, large-scale works, one a manifestation of his very recent stone tablet work *(Forest of Stone Steles – Retranslation and Rewriting of Tang Poetry)*, and the other a flexible, site-specific temple structure, to be made entirely of human hair braids *(united nations – united 7561 kilometers)*. He also added four smaller "altars" to present aspects of earlier conceptual pieces: *Tea Alchemy,* 2002; *Ink Alchemy,* 2000 – 2001; *Hair Bricks,* 1994; and *Enigma of Birth,* 1993. An opening performance was outlined entitled *united nations – we are united.* (Gu customarily opens each new project with a local performance event). Altogether it would make a coherent presentation of this remarkable work being introduced to various regions in the United States for the first time. Because the opening venue would be at the University of North Texas, my task was to assemble and present the exhibition requiring ongoing conversations and negotiations with the artist.

Gu declines standard gallery representation, preferring to remain independent, so all communications and negotiations are directly with him. Fortunately, Wenda Gu is a wonderful communicator. Email is his medium – wherever the peripatetic Gu may be in the world, messages come frequently, always written in lower case except for the subject line that forever reads the same, "No Subject." These missives may relate to the project or read like diary entries:

dear diana,

...leaving in few days for singapore for the grand opening of singapore national theaters. my huge installation "united nations - man & space" consists [of] 188 hair [panels] made [into] national flags of the world. it is up at the concourse of [the] esplanade for its grand opening on oct. 12th. it looks wonderful.

...however, my shanghai project for the opening of shanghai international arts festival is very difficult [and is] in progress. it is a performance on land art [that] will take place on the centennial ave. in pudong on nov. 2nd. the project [is performed] with 188 pianos, 188 pianists, 188 live sheeps and 188 children.
w

dear diana,
the hair braid is 4mm.
thank you – w

New works for the exhibition, *Forest of Stone Steles* and *united nations – united 7561 kilometers*, were created in China, assembled at Gu's Shanghai studio, and then crated and transported to America. *Tea Alchemy, Ink Alchemy, Hair Bricks,* and *Enigma of Birth* came from Gu's New York studio. Presentation tables for the four altars were designed by Gu and made at the University of North Texas, as was the superstructure for the *united nations – united 7561 kilometers* installation, a world "temple" created from a five-kilometer length of thin human hair braid. The braid is divided into one hundred ninety-one sections, one for each country currently existing in the world, each connected to the next by a rubber stamp inscribed with the country name printed in English backwards. According to the artist, the 7561 kilometers (4698 miles) represents the length that would be achieved by placing each strand of hair contained in the braids that compose the temple end to end. The very end of the braid has a "tail" of ten blank rubber stamps, available, should they be needed, to mark any newly constituted countries that might occur during the course of the exhibition. (The configuration of this temple may change radically at each venue, according to the demands of the physical space.)

Wenda Gu is constantly working on projects at many levels, traveling frequently and yet very much in control of each aspect of his work. At the University of North Texas, he attended to each detail of the exhibition design including the config-uration of new walls and color of the space. For his opening performance, Gu commissioned an original sound piece from Chicago-based, electro-acoustic composer Olivia Block, who worked with Gu and faculty from the University of North Texas Dance and College of Music for the presentation.

As my colleagues would surely agree, one of the great pleasures of curatorial work is the opportunity to work with an exceptional artist such as Gu to facilitate the production of original work. The exhibition "from middle kingdom to biological millennium" is just such an opportunity, and, therefore, a challenge well worth accepting in terms of preparation and installation. It is indeed an honor to work with Wenda Gu and to assist with the development and presentation of such a visionary.

Diana R. Block
Director
University of North Texas Art Gallery

NATURALLY, IDEAS ARE EXTENDED through the process of collaboration. Through their shared dialogue and collaboration, three institutions with individual interests in the work of the artist Wenda Gu (the University of North Texas Art Gallery, the Institute of Contemporary Art at Maine College of Art, and the H&R Block Artspace at the Kansas City Art Institute) organized an ambitious exhibition with nation-wide itinerary, a comprehensive catalogue, and a public symposium.

Across the United States, cities and towns that play host to university museums and college galleries possess a unique resource for the informed or inquisitive audience. Public programs at these institutions are inextricably linked with creative, questioning communities and dynamic environments of learning and share a common, two-fold mission: to expand educational opportunities through innovative, quality programs and to extend these resources to public audiences in a relevant and thought-provoking manner. Ideally and at their very best, these unique programs serve a multitude of constituencies – students, educators, professionals, and an increasingly diverse public – and they do so in a distinctive way.

In a recent article published in *The New York Times* under the heading "Arts in America," Stephen Kinser cites the new role that university museums have assumed in recent years.[1] As an alternative to the trend of blockbuster exhibitions hosted by large civic museums to draw very large audiences, or in regions that lack these public museums altogether, he points out that university museums are filling a unique niche and have gained wider regard locally, regionally, and nationally. They are doing so by organizing and presenting more innovative, multidisciplinary exhibitions that take full and creative advantage of their resources.

The University of North Texas Art Gallery, the Institute of Contemporary Art at Maine College of Art, and the H&R Block Artspace at the Kansas City Art Institute, working together to organize and present "Wenda Gu: from middle kingdom to biological millennium," have formed a model partnership. An altogether ambitious endeavor, the intended aim of this partnership is multifaceted. As both an example and prototype for innovative approaches to creating public programs, this exhibition suggests a standard that provides greater access to audiences, expands the project scope beyond the ambition of a single university museum, and combines the expertise and resources of regarded university museums across the nation.

Often, it is an ambition and situation born of necessity, including small staffs and prescribed budgets, that leads university museums to further develop a penchant for creative, expansive thinking. To the benefit of many, opportunities to expand the scope of programs and stretch the reach of collective resources may be realized through collaboration.

As our individual and collective sense of community broadens, a shift in perspective encourages a different kind of consideration, one that is less defined by immediate and imaginary boundaries, both geographic and conceptual. In a cultural era dominated by a focused discourse on issues of globalism and its impact on economics, politics, art, and fostering a better understanding of the world we live in, it seems entirely fitting for an exhibition such as "Wenda Gu: from middle kingdom to biological millennium," to be organized in precisely this way at just this time.

A Chinese-born artist now living and working in the United States and exhibiting internationally, Wenda Gu creates imaginative and compelling art. His work is an intelligent fusion of historical and contemporary influences from Eastern and Western spheres alike. In his work, we see blended ideas of cultural isolation and assimilation. Ultimately, Gu is inviting notions of a metaphoric narrative that dares to speak of a brave new identity where differences of race, religion, language, tradition, culture, and geographical divisions begin to collapse and suggest something new.

These ideas are indeed timely and well suited for thoughtful and contextual consideration within more than one community. As university museums, serving as destinations and purveyors, strive to be relevant and add value to their immediate communities, they also look to absorb lessons, and cooperate with their peers within

a larger, more national community. Timely meetings between issues and ideas, both local and global, begin and converge in the most likely and appropriate of settings.

Research centers, laboratories, studios, and other learning oriented environments like university campuses, classrooms, and museums enjoy and are by design positioned to capitalize in a positive way from the benefits and freedoms associated with innovation, experimentation, and the pursuit of new ideas. As quoted in Mr. Kinser's article, Ann Philbin, director of the UCLA Hammer Museum, a nationally admired program focusing on recent contemporary art, claims this as exactly the unique purview of university museums.[2] In their aim to produce public programs, university museums are afforded license to explore and stretch boundaries within an environment that fosters dialogue, collaboration among colleagues, and a dynamic exchange of ideas.

Raechell Smith
Director/Curator
H&R Block Artspace at the Kansas City Art Institute

1 Stephen Kinser, "More Ambitious Art Shows and Catalogs on Campus," *The New York Times*, Wednesday, 11 December 2002, Sec. E, 2.
2 Ibid.

Introduction|**Mark H.C. Bessire**

GLOBALISM HAS INTENSIFIED ETHNIC DIFFERENCE on a local level while increasing ethnic unity on a global level. This environment (which may or may not be reconcilable) is referred to as "transculturalism" by Wenda Gu whose work tends to parody the role of cultural colonialist from a suspended cultural position as a citizen of the diasporan world.[1]

Drawing from this notion of transculturalism, Wenda Gu claims that his *united nations* series has included hair donated by a million people across the globe. The series, an ongoing worldwide art project begun by Gu in 1993, consists of site-specific installations or "monuments" made of human hair. In these national monuments Gu blends hair collected from barbershops across the globe and presses or weaves it into bricks, carpets, and curtains as a metaphor for the mixture of races that he predicts will eventually unite humanity in "a brave new racial identity." This monumental and ambitious international project combines and expands Gu's early interest in subverting traditional Chinese ink painting, seals, and calligraphy by reinvigorating those traditions making them relevant to a twenty-first century global audience. The exhibition "from middle kingdom to biological millennium," presents the twentieth monument of the *united nations* series along with the installations *Tea Alchemy* (2002), *Forest of Stone Steles – Retranslating and Rewriting of Tang Poetry* (1993–2003), *Ink Alchemy* (2000–2001), and *Enigma of Birth* (1993). These four installations reveal the artist's ability to use the *united nations* project as a source for new ideas and an on-going site where he can integrate new work. Over the years Gu has reinvigorated each monument in the series through the local history referenced by the individual sites, an examination of the concepts of translation and taboo, and the use of new media such as ink manufactured from hair.

Wenda Gu is one of the most important artists to emerge from China following the government's "Open Door" policy of the 1980s. He left China in 1987 and since then has mined a utopian territory that views diasporan life and globalism as a site of unity and diversity with no national or cultural boundaries. Unlike many diasporan artists, Gu is an idealist at heart who reveals the possibilities of globalism even while creating local and international conflict. This dichotomy of idealism and conflict were most evident in such exhibitions as "Interpol" in Sweden and "4th Construction in Process" in Poland, where he addressed local history and universal themes of humanity with his unique take on cross-cultural exchange and a global utopia. When one considers the artist's early radical work in China which challenged traditional paradigms of painting, it is not surprising that Wenda Gu has continued in recent work to raise major questions concerning the expectations and possibilities of the era he refers to as the "biological millennium." His work with body fragments and

traditional Chinese art such as calligraphy and seals are an attempt to weave together the gap between the "middle kingdom" of China (a reference to the Chou empire of circa 1000 B.C.[2]) and the new global "biological millennium." The combination of "middle kingdom" and "biological millennium" is seen in his newest *united nations* project, *united nations – united 7561 kilometers*, where he braided together seven thousand five hundred and sixty-one kilometers of hair (biological material) and constructed a tower of pseudo-characters referencing and complicating notions of the "middle kingdom."

Like the weaving of hair, Wenda Gu weaves conceptualism throughout his work as he explores the potential of different media to communicate symbolic references. The use of hair, placenta, and blood emphasize his interest in societal taboos, biological research, and their ramifications. The work also recognizes and reveals that traditional cross-cultural exchange could lack relevance when considered in light of the biological millennium. In this new world, Gu's work suggests that cultural exchange will be defined by the reproduction and natural mixing of ethnic groups in a global society without defined borders with the added potential of science taking over the entire reproductive process. The intermingling of hair from different ethnic groups around the globe in the *united nations* series constructs a utopian space, a physical representation of a fragment of what the biological millennium could accomplish if unleashed. Just as he collects physical fragments (hair) from around the globe to create scrolls or hair walls for the monuments of the *united nations* series, so too is his pseudo-language an accumulation of language fragments from around the world including Arabic, Chinese, English, and Hindi. The untranslatable hybrid characters are based on the conceptual nature of Chinese seal script, which Gu referred to as "the oldest form of Chinese language which was codified by the first emperor of China, Qing Shi Huang."[3] He also suggested that "it is unidentifiable whether the script is real or fake to both Chinese and non-Chinese audiences."[4] The work resonates with Gu's interest in "a distrust of language" which expresses "fear, anxiety, and a mistrust of our own knowledge [and places] human language in the predicament of absurdity and irony."[5] For Gu, translation, like most cross-cultural exchange, is based on "misunderstanding" and the notion of misunderstanding reflects the limitations of knowledge based on language. This is evident in the artist's play with language, poetry, and translation/retranslation in his *Forest of Stone Steles – Retranslating and Rewriting of Tang Poetry* (1993–2003) and in the use of language in the seals in *Fake Seal Script* (1983). The understanding of our own limitations is key to understanding the work and utopian vision of Wenda Gu.

This book, which accompanies the traveling exhibition "from middle kingdom to biological millennium," provides an opportunity to present new scholarship on Wenda Gu. The book explores the exhibition themes including Gu's utopian vision, the consequences of globalism and cross-cultural exchange, the body as object and subject, and the limitation of knowledge or "misunderstanding" in the context of language, the diaspora, science, and globalism. Divided into three sections, the book includes the following: the first full study and thorough documentation of Wenda Gu's *united nations* series; a candid conversation with Wenda Gu concerning his work and the national traveling exhibition "from middle kingdom to biological millennium"; and an examination of the artist's consistent subversion of tradition and theoretical approach to global society.

The first section of the book examines Wenda Gu's most influential and ambitious body of work, the *united nations* project. To date, the series includes twenty monuments which have been installed in countries throughout the world: Australia; Canada; China, France; Great Britain; Holland; Hong Kong; Israel; Italy;

Japan; Poland; Republic of Korea; South Africa; Sweden; Taiwan; and the United States. The monuments have been displayed in many one-person and group exhibitions including: 3rd Kwangju Biennale, "Man and Space," Republic of Korea; First Chengdu Biennale, China; 5th Lyon Biennale of Contemporary Art, "Sharing Exoticism," France; "Inside Out: New Chinese Art," United States; and the Second Johannesburg Biennale, "Trade Routes: History and Geography," South Africa. Wenda Gu's work is unique in the global contemporary art world in terms of its scale and message. No other artist currently works on such a grand scale creating a critical forum to discuss the pressing issues of globalism and the biological millennium.

In "Seeking a Model of Universalism," Dr. Gao Minglu explores the origins and impact of the *united nations* project and its relationship to language, a utopian ideal, and globalism. He traces its origins to Gu's early work and philosophical studies in China, where as a graduate student Gu already viewed himself as a citizen of the world foretelling his future as a member of the Chinese diaspora. Minglu analyzes Gu's radical ink painting, his use of body materials in *Oedipus Refound #3: The Enigma Beyond Joy and Sin* (exhibited in "Fragmented Memory," Wexner Center for the Arts, 1993), and the artist's use of hair and language in the *united nations* series. He considers Gu's art in terms of the "phenomena of dislocation of identity and the misunderstanding between a specific cultural history in its own terms and Gu's interpretation of the history based on his utopian univeralism."[6]

This section of the book also includes Wenda Gu's essay on the *united nations* series, "face the new millennium: the divine comedy of our times." This edited version, originally written in 1995, provides a rare glimpse into the artist's process from the conception of the project when his aspirations and theories were ḟrst explored. Gu's text, in conjunction with Minglu's essay and the visual evidence of the plates from many *united nations* monuments reveal for the first time the immensity of Gu's international impact.

In the next section, entitled *from middle kingdom to biological millennium*, Dr. David Cateforis presents a candid and engaging conversation with Gu before and after the first installation of the exhibition "from middle kingdom to biological millennium." He expertly engages Gu in dialogue about his family life, education, and artistic nascence leading toward critical questions of specific works in the exhibition. We learn how the artist's name was switched to Wenda Gu (from Gu Wenda) when he applied for his social security card in a classic clash of identity and assimilation. When querried about Homi Bhabba's notion of a "third space," between East and West (and insider/outsider), Gu responds by suggesting that he feels more Chinese in America even though Chinese critics view him as more Western than Chinese.[7] Gu also explains that for writing purposes he uses only lower case in his adopted language as "artists are not traditionally capitalists," and suggests that in the case of the *united nations* series (where all titles in the series are lower case), it "conveys the idea of equality."[8] These insights produce a conversation on language and translation, key elements in the artist's work. Gu suggests that his newest monument combines human and artificial nature: braids for the walls and ceiling and language (pseudo-characters) in the central column.

In a discussion of tradition Gu explains "if you do not know the tradition, how can you go against tradition."[9] This notion leads to the next section, *Tradition and Confrontation*, which includes an essay by Dr. Gan Xu and Wenda Gu's response to the destruction of his work by the artist Alexander Brener. In his essay Xu reveals how Wenda Gu's search for "*tushi*," or artistic schema, has informed his work. He examines how the artist's exceptional understanding of the past enables him to challenge traditional Chinese art such as ink painting, seal script, and calligraphy in an attempt to make them relevant to a twenty-first century global

audience. To reveal Gu's quest for "*tushi*," a contemporary interpretation of the ancient idea of "*tu*," Xu shows how Gu transforms the principles of "*tu*" as defined by the ninth century art historian Zhang Yuanyuan in his "On the Origins of Painting." In this work, Zhang Yuanyuan stated that:

> the word for depiction, '*tu*' contains three concepts. The first concept is the representation of principles, and hexagrams are examples of this concept. The second concept is the representation of knowledge. This concept is best realized in the writing and studying of Chinese characters. The third concept is the representation of forms, and this is achieved through painting.[10]

In the pseudo-character paintings, Xu suggests that "Gu reinterprets these concepts as: unknown principle, fragmented knowledge, and abstract form."[11] Xu continues,

> Gu's audacious explorations, his new techniques, his elimination of individual brush stoke, and unreadable Chinese characters have allowed him to create a new kind of Chinese ink painting: conceptualized abstract ink painting. Gu's new ideas have released Chinese landscape painting from its ivory tower and brought it into the realm of contemporary expression.[12]

Xu analyzes the early work and exposes the ways that it continues to inform the artist's most recent work. By confronting and undermining tradition, Gu redefines artistic traditions.

Just after opening in 1986, Gu's first solo show at the Gallery of the Artist's Association of Shangxi Province in Xi'an was shut down. According to Xu, "the Department of Propaganda of Shangxi Province deemed Gu's work unacceptable for public viewing."[13] Since the closing of this exhibition, Wenda Gu's art has raised critical questions of form and content in relation to the history of art. In 1996 the art world was shocked by the destruction of Gu's piece *united nations – sweden and russian monument: interpol* by Alexander Brener at the opening of the exhibition "Interpol" in Stockholm. The incident received international media coverage and Gu's written response was edited and published without permission in *Flash Art* and the book *Interpol: The Art Exhibition which Divided East and West.* Entitled "The Cultural War," the essay is published for the first time in its entirety in this volume. It reveals the artist's suspicions and premonition that he was being threatened and his immediate reaction to the incident. We learn that Gu decided not to sue as suggested by some Americans, not to dismantle the piece as suggested by a French critic, and not to request insurance money as some Russians suggested. For Gu the destruction of the piece added another layer of meaning to the work making it an icon of a cultural war.

In Wenda Gu's work, the body and fragments of the body (body materials as media) serve as a metaphor for the melding of different cultures through globalization. It is his recent concern with the body as material and object (hair, placenta, blood) that binds together his diasporan experience to the biological millennium just as his braids attempt to weave together ethnic and racial diversity into a unified entity. As all the essays in this book suggest, Wenda Gu's work is unique in its simultaneous critique and embrace of global society. If globalism intensifies ethnic and racial diversity, Gu's work and quest for a utopian ideal would suggest that in diversity there is unity. In this biological millenium, as proposed by Wenda Gu's work, diversity and unity will unite all humanity.

1 Danielle Chang, "United Nations–American Division," in *United Nations – American Monument* (New York: Space Untitled, 1995), np.

2 Jennifer Way, "Symposium Postscript," in *Wenda Gu: Art from Middle Kingdom to Biological Millennium*, ed. Mark H.C. Bessire (Cambridge: MIT Press, 2003).

3 Wenda Gu, "face the new millennium: the divine comedy of our times," in *Wenda Gu: Art from Middle Kingdom to Biological Millennium*, ed. Mark H.C. Bessire (Cambridge: MIT Press, 2003).

4 Ibid.

5 Ibid.

6 Gao Minglu, "Seeking a Model Universalism," in *Wenda Gu: Art from Middle Kingdom to Biological Millennium*, ed. Mark H.C. Bessire (Cambridge: MIT Press, 2003).

7 See Homi Bhabha, "The Third Space," *Identity, Community, Culture, Difference*, ed. Jonathan Rutherford (London: Lawrence and Wishart, 1990).

8 Wenda Gu, "face the new millennium: the divine comedy of our times," in *Wenda Gu: Art from Middle Kingdom to Biological Millennium*, ed. Mark H.C. Bessire (Cambridge: MIT Press, 2003).

9 David Cateforis, "Interview with Wenda Gu," in *Wenda Gu: Art from Middle Kingdom to Biological Millennium*, ed. Mark H.C. Bessire (Cambridge: MIT Press, 2003).

10 Zhang Yuanyuan, "On the Origins of Painting," in Li Dai Ming Hua Ji, reprinted in Susan Bush's *Early Chinese Texts on Painting* (Cambridge: Harvard University Press, 1985), 51.

11 Gan Xu, "Neo-Hexagram," in *Wenda Gu: Art from Middle Kingdom to Biological Millennium*, ed. Mark H.C. Bessire (Cambridge: MIT Press, 2003).

12 Ibid.

13 Ibid.

united nations series

Seeking a Model of Universalism: The *united nations* Series and Other Works

Gao Minglu

AS ONE OF THE LEADING ARTISTS FROM CHINA, Wenda Gu creates art using a variety of media, from traditional ink painting and calligraphy to conceptual art and installation works. Despite many formal changes in his work since the early 1980s, the presentation of a utopian ideal of universalism has remained a constant in the artist's work and is especially apparent in the *united nations* series. (fig. 1.1) Gu's work functions as visual forms of intelligence of humankind and models of universal culture.

Gu arrived at this philosophy when he was studying traditional ink painting in graduate school in the 1980s. He was the leading artist and pioneer of the contemporary Chinese ink painting movement that first emerged in the early eighties. Although he has seldom practiced traditional Chinese ink painting since he arrived in the West in 1987, many artists of the new generation are still strongly influenced by his work. The central concern of Gu's ink painting is to create an ideal form that can transcend both the stereotype of traditional literati painting (a dominant painting style and aesthetic principle in the later Chinese dynasties from the thirteenth century to the modern period) and Western modern art styles. He calls his ink painting, which combines traditional technique and Surrealist-like illusionary scenes "the model of intelligence of mankind" *(renlei linxing de tushi)*.[1] He thinks this intelligence amounts to the "world lit up by the light of eternal spirit" in the religious sense.[2] Gu's religious impetus is similar to the enthusiastic thought of many artists of the so-called Rationalistic Painting Group in the '85 Art Movement.[3] However, this metaphysical impulse is neither religious nor is it the eternal idealism of German classical philosophy. Rather, it is more of a humanistic and life philosophy. Wenda Gu, along with other avant-garde artists of the Rationalistic Painting Group of the '85 Art Movement, proclaimed an allegiance to the spirit of Nietzsche's Dionysus, Schopenhauer's will of power, and Freud's libido. Like other members of the movement, Gu became a quasi-philosopher, spending more time as a graduate student reading books on Eastern and Western philosophies, aesthetics, and religion than painting.[4]

He notes that "scientific and analytical philosophies are separate from man, and only Nietzsche's humanism has a strong impact, so there is expansionism in my painting."[5] This expansionism combines the philosophies of Nietzsche, Schopenhauer, Freud, and oriental mysticism. In the 1980s this kind of expansionism substantially liberated the thinking and imagination of the new generation of artists who had been restrained by decades of collectivism and class-consciousness. The appeal to grandness and masculinity of a semi-religious nature and surrealistic expansionism thus reflected the consciousness of Chinese modernity along with an enthusiastic devotion to a westernizing movement in the ideologically freer period of the eighties.

Fig. 1.1
united nations – man and space, 2000
Installation image from Utsunomiya
Museum of Art, Japan.

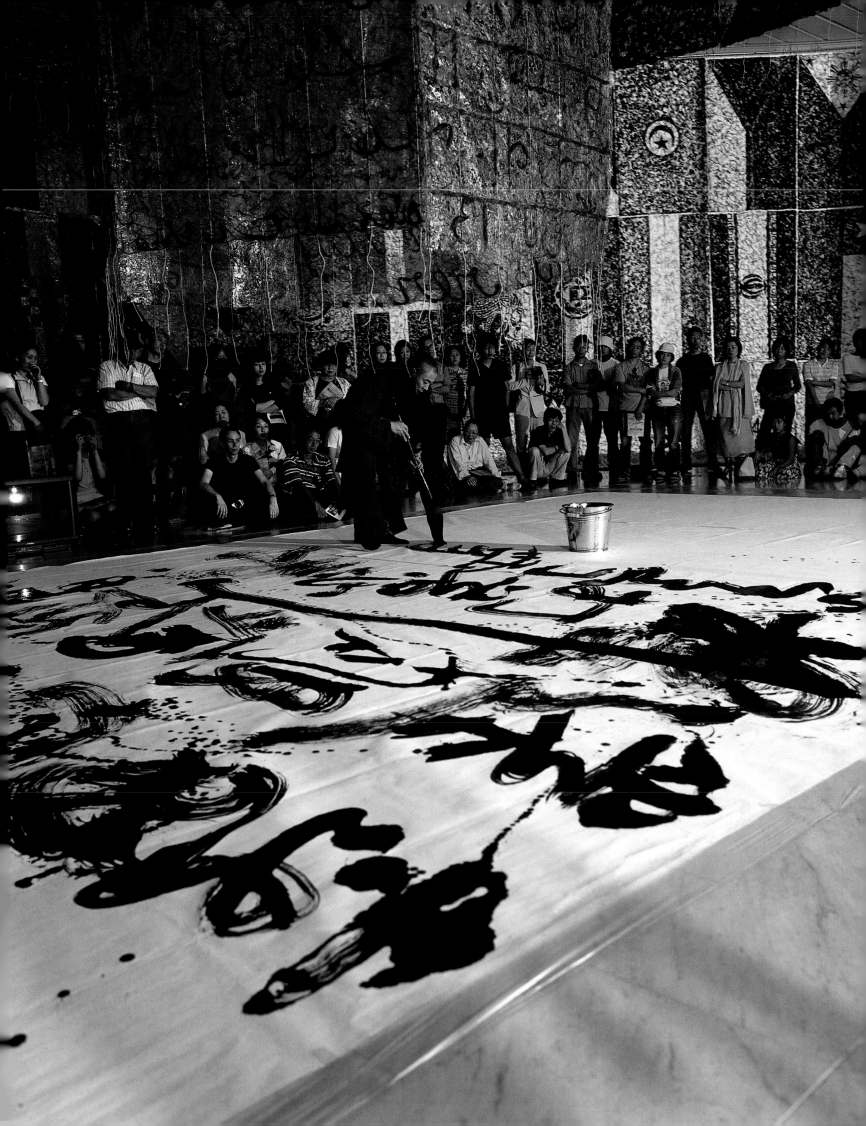

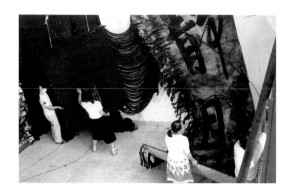

From 1983 to 1986 Gu created a series of works of "human intelligence" in ink and wash employing such motifs as totems, ancient cliffs, and imaginative cosmos views. The range of these works can be seen in such titles as *Diagram of Supreme Ultimate, Between Heaven and Earth, Sky and Ocean, Moon that Sleeps on Earth,* and *Human Body and Landscape.* The images and symbols used to depict the universe, nature, and human life are evoked through ink and wash as totems (fig. 1.2) (fig. 1.3). Moreover, Gu regards landscape as part of the universe and human body. Many of his works describe the human body as nature, with its hair, bones, and veins closely intertwined with forests and rivers; thus, in the work, man and nature share the spirit of the universe.

This kind of universalism is deeply rooted in Gu's thought and methodology. When he was in China he tended to regard himself as a cosmopolitan transcending all nations. He believes that "he is a member of the world, not of a nation. So cultural conservatism and national narrow-mindedness should be discarded."[6] At the time when a so called Cultural Fever (*wenhua re*) emerged in China in the mid-1980s, Gu was very pessimistic about national culture, believing that "the condition for producing first-class master artists is to get rid of narrow-mindedness and a cultural setting which cannot upgrade cultural quality in a short time."[7]

This attempt to transcend first the cultural ideology of one's own nation and then that of Western nations became the ultimate value in Gu's art. This is reflected not only in his early ink painting and installation works, but also in his later human body-based works such as *Mystery of Blood* and *Placenta Jars* (fig. 1.4) and the *united nations* series (fig. 1.5).

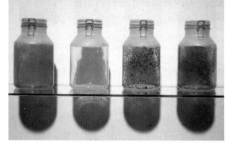

Fig. 1.4
Placenta Jars, 1990–95
Set of four jars with human placenta powder (normal, abnormal, aborted, still born), sealed with beeswax.

Bodily Material as Ready-Made: Totem and Monument of Man's Flesh and Soul

After moving to the United States, Gu created a number of installation works using human body materials. These served as his medium for the next ten years and became especially well known in his *united nations* series. He chose materials such as menstruation blood, placenta, and hair, which are deemed unclean and distanced as "waste" products in Western culture, but not necessarily in China where both hair and placenta are used in medicines. Gu began his first body material project with menstrual blood and personal letters donated by sixty female participants in 1989. The project culminated in the exhibition "2000 Natural Deaths," at San Francisco's Hatley Martin Gallery in 1990. Gu later created a similar piece, *Oedipus Refound #1: the Enigma of Blood,* which was exhibited in 1993 in the traveling exhibition "China's New Art, Post-1989" (fig. 1.6). The installation involves a minimalist display of used tampons and sanitary napkins juxtaposed with letters from the contributors. In the

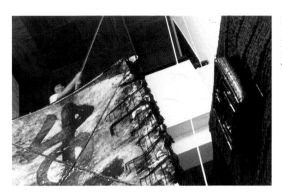

Fig. 1.2
Wisdom Comes From Tranquility, 1985
Mixed media woven installation.
Installed at 13th International Biennial of
Tapestry, Lausanne, Switzerland, 1987.

Fig. 1.3
*Tranquility Comes From Meditation:
Overlapping Characters*, 1984
Ink on paper in scroll mounting.
Collection of Hong Kong Museum
of Art.

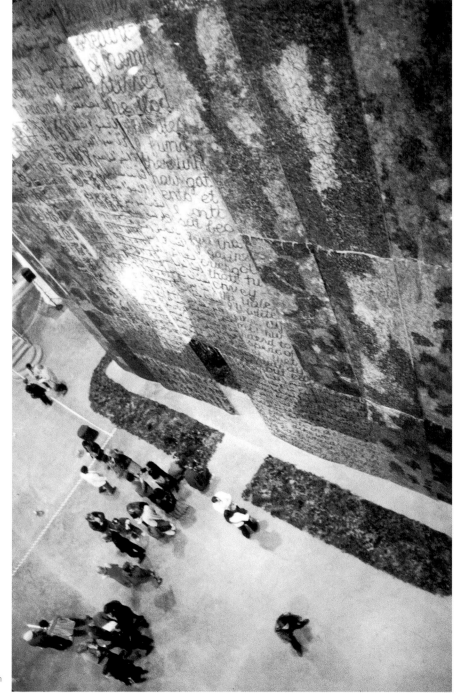

Fig. 1.5
united nations – africa monument: the world praying wall,
1997
Second Johannesburg Biennale, "Trade Routes: History
and Geography," Institute of Contemporary Art,
Johannesburg, South Africa.

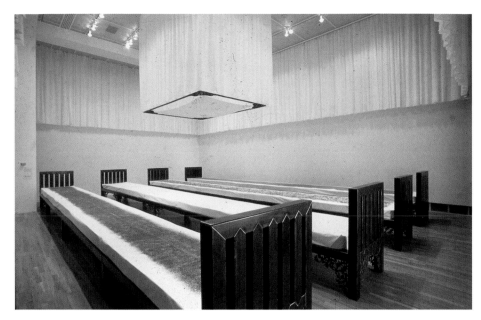

letters women from different countries describe their feelings about their monthly cycle both physically and spiritually. Gu treats this subject as a human phenomenon, a connection between a woman's monthly cycle of bleeding, the cycles of the moon, and four seasons of nature—not strictly as a gendered issue. In the same year, Gu developed this idea and made two more installation works in the Oedipus Refound series, including *Oedipus Refound #3: The Enigma Beyond Joy and Sin,* first displayed in 1993 at Ohio State University's Wexner Center for the Arts (fig. 1.7). In the work Gu put a row of four elongated beds in the gallery space. Placenta powder collected from Chinese hospitals is scattered on three elongated steel beds to symbolize normal, deformed, and stillborn babies. One of the beds, the second in the row of four, is empty to signify abortion.[8]

Used as artistic media, however, these substances are radical even in China. The complex meanings of these materials can be interpreted in racial, historical, cultural, and political terms, as many critics have done in relation to Gu's work. These critics touch sharply on the most sensitive issues of contemporary Western society and culture, such as cultural identity, racial politics, and gender issues.[9] But we cannot interpret Gu's effort to tug at a social nerve as simply a way to create a shock effect. His objective is to understand and reinterpret the common nature and the cultural history of mankind. Encouraging debate about his work, Gu tries to go beyond historical injustice, vice, and tragedy by turning such phenomena as menstruation into totem and hair into historical monument that can transcend the potential narrow-mindedness of human consciousness.

The artistic works made of human body materials, especially the *united nations* series, present an excellent cultural and geographic opportunity for the artist to interact with the people of more than twenty countries. It amounts to encyclopedic research similar to that of cultural anthropology. Gu explained in detail the aim, concept, strategy, method, and the content of different monuments of the *united nations* series in his essay "face the new millennium: the divine comedy of our times."[10] Splendid ideas and rich historical and cultural information abound in this paper; yet, I do not want to equate Gu's expressions with the specific meanings of his works, for the visual language and the written language belong to different systems. Words and image are not exactly matched to each other, particularly when a work made of human hair is installed as a "historical monument" in a specific country in the present context of a globalized world. The significance of visual form in Gu's *united nations* monuments goes far beyond his own or other's verbal interpretation. Gu's theoretical statements are, however, helpful in explaining his intention as distinct from the "original meanings" of the media, such as human hair. I would like to discuss some meanings of Gu's art in terms of the phe-

nomena of dislocation of identity and the misunderstanding between a specific cultural history in its own terms and Gu's interpretation of the history based on his utopian universalism.

Ready-made objects negate the illusion that artists can mirror the true reference by making an artistic object in two or three dimensional form. Gu's use of materials from the human body as art objects relates to the Duchampian notion of the ready-made. But each ready-made object has its own meaning, and the meaning of human bodily substances at once reminds one (artist, viewer, critic, etc.) of oneself or fellow creatures, thus relating to all humanity. As a result, the universal significance of these bodily materials supercedes their connection to the individuals from whom they derive. For example, when viewing the works, no one envisions the individuals who donated the menstrual paraphernalia, hair, or placenta.[11] In this way body material art differs from art performed by an artist in person. With the absence of the originating body, bodily materials represent media collected from nature but abstracted from an individual, living body. It is possible that Gu is aware of this significance and therefore he deemphasizes the individual and highlights the universal and categorized meaning of the bodily substances. It is from this point of view that Gu calls his use of body material "subject as subject" rather than "object as subject."[12] Perhaps what he intended by this is that bodily substances have always been objectified by human beings because they concern the subject consciousness of mankind; human substances are regarded as different from other materials, such as rock and wood, which are seen only as pure objects. With this in mind Gu makes statements on the anthropological meaning of superculture and racial identity in his works through human body materials. When he, as a male and an Asian male for that matter, set out to collect highly private substances from sixty women in sixteen countries, he attempted to examine the meaning of menstruation from the position of a human being deemphasizing gender difference, and not from the political and social viewpoint of a pro- or anti-feminist. The best example is the interpretation of Gu's "menstrual art" by Elinor Gadon, an art and cultural historian: "My own analysis of late paleolithic images and symbols suggest that the earliest rituals may have honored women's menstruation, celebrated by the whole community, men and women alike.... perhaps only a man outside the gender polemics of Western culture could transform the symbolism of the menstruation into a universal statement about the sanctity of life."[13]

Feminists (usually from the West) often challenge Gu by asking: how can you possibly know the psychological and physiological feelings of women? If he cannot, then his work might be read as a negation of women, a violation of their privacy, or at least indicate some form of disrespect? Is it an act of degradation for the artist to publicly expose the highly private substances and letters of women?[14] Gu can only defend himself by explaining in abstract terms the nature of life and death common to all mankind. Menstruation and placentas (normal, dying, abnormal, and aborted) are testimony to life's cycle, the eternal, philosophical, and silent presentation of life and death, soul and flesh. They are even more mysterious than any human debates on theology and philosophy. However, Gu's ignorance of women's experience cannot be explained away simply by these metaphysical defenses.

The best defenses and protests of this body of Gu's work are all from women. Maureen Martin, curator of the Hatley Martin Art Gallery, expressed in a letter to Gu her disgust and anger the first time she saw his exhibition proposal for *2000 Natural Deaths*. But by corresponding with other women, she realized that Gu's work had helped women to rediscover the original meaning of their menstruation: the symbol of sacrifice, the seed of life, a natural

rhythm, and the selfless contribution to the human species. Martin finally accepted Gu's proposal, and she wrote about what a transformational experience the exhibition was for her. The process enabled her to understand a more universal meaning of women's biological processes and to go beyond her internalized fear and shame.[15] Thus, menstruation was transformed from taboo substance into a totem of matriarchal society. But the rejection and protest against his 2000 *Natural Deaths* (or *Oedipus Refound #1: the Enigma of Blood*) showed that the above justification could only exist on an ideological and spiritual level. The political reality and certain prejudices made viewers of the work reluctant to see Gu as objective in relation to the subjectivities of women.

This dislocation can equally be applied to the later works of the *united nations* project in which Gu has suggested that the "identity of the local race and its culture is being 'othered' by me as the 'stranger'."[16] As a huge project Gu's *united nations* series was initially supposed to be exhibited as a "chapter of the u.n." in more than twenty countries. Currently it has been installed in Australia, Canada, China, France, Great Britain, Holland, Hong Kong, Israel, Italy, Japan, Poland, Republic of Korea, South Africa, Sweden, Taiwan, and the United States. This demonstrates Gu's courage as an artist; for most people, this utopian plan can only be found on paper, not in reality. Having worked on the project for ten years, he has encountered countless difficulties. Gu's ambition was perhaps to create a "United Nations" through art that can never be materialized in reality, using the hair of different races to set up historical monuments linking the history and culture of various regions on a level transcending specific cultures and races.[17] This impulse of seeking a universal structure of world history and culture can be traced back to his early ink paintings and will perhaps resonate throughout his artistic career. Although the utopian ideal cannot be realized, it constitutes the prime motivation and tension for his creative power.

It is then possible to see Gu inspired by a Nietzschean spirit of "superman" and empowered by the authority (symbolized by his objects) to interpret and design a history and culture in a united structure. Although he admits that he is an "other," a representative of another culture in relation to the cultural contexts of the specific *united nations* monuments, his duty-bound attitude of historical narration makes the works of his *united nations* resemble a purposeful imitation of the tone and behavior of cultural colonizers. His solemn declaration in writings and sincere involvement in action during the process of creation also invests this project with no less than a utopian nature.

An extremely difficult question has been raised by the *united nations* "monuments," because they are not architectural projects constructed in "permanent" physical form, nor a compilation of historical documents consisting of original ancient texts, but cultural events that take place simultaneously with an unpredictable local political environment in a contemporary, historical context. The meaning and fate of Gu's monuments of the *united nations* were determined not by past history, but by the collaborations and experience invested by the artist and other participants in the project. Gu and his monuments of the *united nations* are therefore only media, works produced in the unfolding of many accidental events, which cannot be prefabricated for the concept of transcending time and history. The real significance of the *united nations* can only be presented in the process, as it is a product of time. From this perspective, its process is not to establish monument, but rather to deconstruct monument no matter how deliberately or undeliberately predesignated by Gu himself.

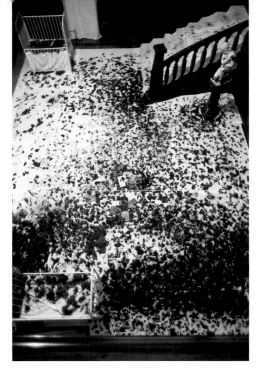

Fig 1.8
*united nations – poland monument:
hospitalized history museum, 1993*
Installation, "4th construction in
process," History Museum of Lodz and
The Artists Museum, Lodz, Poland.

As a result, the *united nations* recalls Roland Barthes' notion of "The Death of the Author."[18] While an author may create a "monument" as text inherent in his mind, it is at the same time being revised by a new, living, ever-changing "historical" text. Once the "monument" is finished, it will part company with Gu, the author; thus, the monument (made of human hair) is not subordinate to Wenda Gu himself, but belongs to its own circumstance, the original context of the monument (hair/subject). Instead of being a carrier of the author's expression, i.e. Gu himself, the hair is the author, because it speaks its own voice incorporating its own history and identity. A case in point is the *united nations – poland monument: hospitalized history museum* (fig. 1.8).[19] This project was part of the international, site-specific exhibition in Lodz, "4th Construction in Process" which took place October 1993. The work was exhibited at the Lodz History Museum where the local government also has its offices. In creating a "hospitalized museum," Gu turned the history museum into a hospital-like space where four metal hospital beds, history books, and blankets were arranged throughout the floor. Massive amounts of human hair collected from local barbershops was scattered everywhere. The hospital "scene" with its beds and blankets in conjunction with the medium of human hair evoked extreme sadness for local viewers, particularly elders, because of Lodz's proximity to Nazi concentration camps and the largest Jewish cemetery in the world. The reaction of local people to Gu's work caused the show to close in the afternoon of its opening day. As in other monuments of the *united nations* series, human hair is used to speak a message relating to history and context. The History Museum, the hair, and the hospital-like installation space all bound together, represent a version of the city's history. The symbolic meaning is logically perfect for Gu in a theoretical way, but it is also logically unacceptable for the local audience who are faced with an emotionally challenging memory of the city's history. In this case, everyone becomes an "author" or there is no author at all: Gu, the government, and local citizens all have the right to be the historical authors. Maybe the real value of the work does not lie in whether it has shown the nature of local cultural history, but in the experience of being "conquered," where Gu is playing the role of a cultural conqueror. And the core of the experience is not seeking agreement, but preserving difference, something fortuitous and impossible to predict.

In contrast, the *united nations – israel monument: holy land* seems more successful in terms of the control of the balance between the two subjects or "authors": the hair and Gu (fig. 1.9). In this installation, hair was glued to a series of massive rocks placed in the desert to symbolize the diaspora, the nature of Jewish culture and history. The hair and natural setting meld the history told in the Bible with modern history. Although the work speaks silently

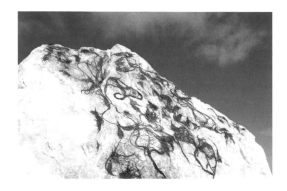

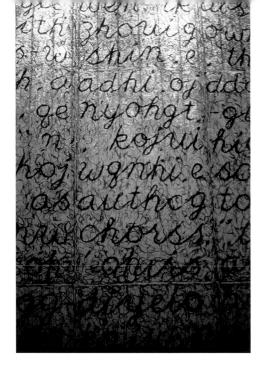

Fig. 1.10
united nations – vancouver monument: the metamorphosis, 1998 (detail) Installation, Morris and Helen Belkin Art Gallery, The University of British Columbia, Vancouver, British Columbia, Canada.

without any conceptual indications, it is endless, it is all-embracing. In this piece, Gu, as interpreter from a different culture and history, yields his own voice to the hair to make the hair speak its own history; yet, the original physical form of the hair is not immediately apparent. Instead, the hair is intimately bonded to the great land, symbolized by the rocks.

This raises the question of the relation between conceptual expression and aesthetic expression. When talking about his "language art" in the eighties, Gu said that any pre-designed conceptual expression should be replaced by aesthetic expression.[20] In a number of works from the *united nations* series, he uses hair to form meaningless words on transparent curtains (fig. 1.10). On the top, these plain curtains, which resemble graceful calligraphic and ink and wash works, create three-dimensional, temple-like spaces. The viewers, overwhelmed by the solemn and harmonious atmosphere, do not have the same disquieting feeling they might have had when seeing the hair before it is formed into characters. Another dislocation has been enacted here by Gu, by forcing the viewers to fall into his aesthetic "trap," or to jump into what he calls the process of aesthetic expression *(shenmei chenshu)*. In the meantime, the real speaker, namely the "local dialect" of the local subject (the hair) is forgotten (fig. 1.11). The "voice" of the hair, the real "subject," is subordinate to the aesthetic expression and pictorial design; this has been hidden in the cultural symbol, as is evident with the use of hair to form the American stars and stripes in the *united nations: usa monument #1: post cmoellotniinaglpiostm.* Thus, aesthetic expression gives rise to the disappearance of the real subject—the hair.

The *united nations* series evokes the interaction of a myriad of cultural and historical understandings and the overlapping dislocation of different identities (local and foreign, author and audience). The complexities of interpretations constitute the significance of the *united nations.* Gu, however, may not anticipate this significance; his overriding ambition is to configure a utopian universal structure through all of his art projects. Although Gu accepts the reality of the audience misunderstanding his work, the potential for misreadings does not disturb his idealism of seeking an encyclopedic interpretation of the world. Wenda Gu will continue to seek a utopian universal of humanity in all his work.

1 See Wenda Gu, "Notes on Art," *China Art Journal (zhongguo meishu bao)*, No. 9 (1985): 2; and Wenda Gu, "Notes on Art," *Artists* No. 1 (1985): 8.

2 Ibid.

3 See my essay "Guanyu Lixing Huihua" (A Discussion on the Rationalistic Painting), *Meishu (Art Monthly)* (August 1986). Also see Julia Andrews and Gao Minglu, "The Avant-Garde's Challenge to Official Art," in *Urban Spaces in Contemporary China: The Potential for Autonomy and Community in Post-Mao China*, ed. Deborah S. Davis (Cambridge: Cambridge University Press, 1995), 221–278.

4 Fei Dawei, "Interview with Gu Wenda," *Meishu (Art Monthly)* (July 1986): 53–56, 63.

5 Ibid.

6 Gu Wenda, unpublished letter to Gao Minglu, 3 October 1986.

7 Ibid.

8 See Zhou Yan, "Gu Wenda's Oedipus" in Julia Andrews and Gao Minglu, *Fragmented Memory: The Chinese Avant-Garde in Exile* (Columbus: Wexner Center for the Arts, the Ohio State University, 1993), 20–22.

9 For instance, Tim Martin, "Silent Energy," *Third Text* (Winter 1993–94): 91–94; Linda Jaivin, "Gu Wenda, Tao and the Art of Aesthetic Line Maintenance," *Art and Asia Pacific* No.2 (1994): 42–47; Kim Levin, "Construction in Process IV at Lodz," *Asian Art News* (Jan./Feb. 1994): 70–71.

10 This paper was originally titled "The Holy Comedy of Our Times: On The *united nations* Art Project and its Times and Environment."

11 Kim Levin discusses the more universal significance of hair in an article on Wenda Gu: "Power is inherent in those slender outgrowths of the epidermis, those pigmented filaments that are among the most animalistic and intimate elements of the human body. Not all hair is public, but as psychoanalysts well know, the most innocuous remark about a beard, mustache, or hair style is a loaded and coded comment from which can be deciphered all manner of information about libido, super ego, and sexuality. Hair can be a signifier not only of virility and femininity but of race, ethnicity, and age. And as history can attest—from the pigtail of China's final dynasty to the powdered wig in monarchist France, from the military crewcut to the rebellious Hippie mane or the militant Afro, from the Punk Mohawk to skinhead hairlessness—how we style our scalps has since time immemorial singled allegiances and complicities in the political and spiritual realms." Kim Levin, "Split Hairs: Gu Wenda's Basic Project and Misunderstanding of Objects," in "United Nations–Italian Division," (Milan, Italy: Enrico Gariboldi Arte Contemporanea, 1994), np.

12 In his unpublished writing, "Oedipus Refound No. 5: United Nations," Gu wrote, "Art history has been about the object as medium representing subject matter, as in paintings or ready-mades. The only way to avoid having the object represent the subject matter is to make the subject represent subject matter, which I do by using pure human body materials to represent the subject. By transforming the body materials into powders, the resulting form no longer carries any association with normal body functions. Unlike recent trends in performance and body art, timeless."

13 Elinor Gadon, "Gu Wenda–2000 Natural Deaths: Artist as Provocature,"*Vox Art* (Spring 1990): 20.

14 For further questions of this kind see Peter Selz, "Wenda Gu: Provocative Artist Comes to the West Coast," *Vox Art* (Spring 1990): 9.

15 Maureen Martin, Letter to Wenda Gu.

16 Wenda Gu, "face the millennium: the divine comedy of our times, a thesis on the *united nations* art project and its time and environment," in *Wenda Gu: Art From Middle Kingdom to Biological Millennium*, ed. Mark H.C. Bessire (Cambridge: MIT Press, 2003).

17 Ibid.

18 Roland Barthes, "Death of the Author," in *Image, Music, Text*, ed. by Stephen Heath (New York: Noonday Press, 1977), 142–148.

19 This piece was originally named *Oedipus Refound No.4: Hospitalized History Museum*.

20 He said that we do not need to explore the logical meaning of words, but should "do it from the aesthetic perspective." He believes that words do not carry meaning in the real sense of the term from the very beginning. See Wenda Gu, "Notes on Art," *China Art Journal (zhongguo meishu bao)* No. 9 (1985): 2; and Wenda Gu, "Notes on Art," *Artists* No. 1 (1985): 8. In order to get rid of this idea, people need intuition and aesthetic judgment. "The words that are called 'aesthetic process' are a relief for people to escape from the blind and fanatic efforts of seeking after the 'inner truth' of nature." Wenda Gu, "Words Not Stated," partially published in *Chinese Art Newspaper (zhongguo meishu bao)* (14 January 1987): 2.

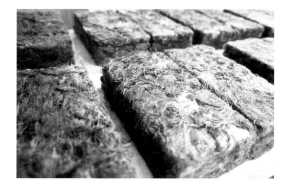

Fig. 1.11
Hair Bricks, 1985

face the new millennium: the divine comedy of our times
a thesis on the *united nations* art project and its time and environment[1]

Wenda Gu

introduction: an ongoing worldwide art project: *united nations* (1993–)

united nations is an ongoing, worldwide art project initiated early in 1992. from that point until late 1993, i developed the original concept and created an executive plan forming a complex strategy and methodology. during this long meditative period, i had immense doubts concerning my personal abilities to successfully develop and execute this conceptually, physically, timely, politically, and racially difficult art project. however i firmly maintained my vision as i clearly foresaw the profound nature and challenge of this project for me and for related races and their civilizations. i also felt that as a result of the inordinate risks that i would be taking with the *united nations* project, it could provide an extraordinary opportunity for me as an artist.

during its duration, the *united nations* art project will travel throughout five continents, to approximately twenty different countries which I have selected due to their historical and political importance. by utilizing the hair of the local living population, i strongly relate to the historical and cultural contexts to create monumental installations and land art to capture each country's identity. the monuments draw from profound events in each country's history. these installations are each individual national monuments of the *united nations* series which explores such notions as transculturalism, transnationalism, and hybridization that will be manifest in the final ceremony of the project. constructed in the twenty-first century, the final monument will be a giant wall composed of pure human hair integrated from all of the monuments in the series. the woven human hair and world psuedo-languages will co-exist on the wall as a great "utopia" of the unification of mankind, a utopia which probably can never exist in our reality but will be fully realized in the art world. paradoxically, the human wall will not only maintain ethnic identities, but also a co-existence of different cultures through the creation of pseudo world languages incorporated into the hair wall. from china's great wall to the berlin wall, walls have been a metaphor of separation, but the implications of the *united nations* art project will be a true unification of mankind. at the final realization of *united nations,* there will be thousands and thousands of different living races present on the hair wall, supported by many cultural institutions, local barbershops, and most of all, living populations around the world.

the following are excerpts from monique sartor's and kim levin's essays in the catalogue for *united nations – italian division* (renamed *united nations – italy monument: god and children*) which was exhibited in milan at enrico gariboldi arte contemporanea in 1994:

This new issue leads to new artistic issues, provoked by the expansion of a transcultural reality in our world. Once again, mankind is entering a new age, a new historical time, which now can be actually defined as 'planetary,' and Wenda Gu's project *united nations* is clearly symptomatic, maybe in a temporary anticipation, of the entering of this new conception and elaboration of culture and cultural differences, that he punctually defines as 'transculturalism'.[2]

Is this another dawning of the age of Aquarius? A multicultural update on the altruistic impulse that over decades has spawned such artistic events as 'the family of the man' and 'we are the world'? or is it a reexamination of the late twentieth century's intensified and rapidly mutating concept of ethnicity and nationalism?[3]

concept, strategy, methodology: otherness/alienation/difference, bio/geo/cultural fusion
the monuments of the *united nations* series become a forum, a physical and psychological space that invites a conversation on the many cultural and artistic issues of our times, which are of growing intensity in our global reality. from the beginning, the project has attempted to be a three-dimensional mirror reflecting global/bio/geo/culturally shifting environments. from the long developmental process of the project's globalization, its aim is to sum up all of the possible phenomena resulting from the monuments and unite them, bringing them to our common destiny based upon our modern humanity.

it is such a special journey to create the worldwide art project *united nations*. a journey that has developed through cultural, political, ethnic, and artistic experiences: as a red guard who painted revolutionary posters during mao's cultural revolution; for more than ten years working in china; and sixteen years in the rest of the world as an individual artist. encountering diverse races and world cultures while reshaping their monuments, this path has given me a chance to confront what i have always been fascinated with: the egyptian pyramids; the myths of africa; the roman empire; the american adventure; the berlin wall; and china's silk road and great wall. these spirits have always been the sources of my inspiration.

this concept has brought about several intense dramas along the project's journey in different countries. i like to equate some of my experiences to two famous chinese historical references. once when china was made up of many individual countries, confucius wanted to publicize his doctrine throughout the land; he traveled around these various countries spreading his idea of how to govern until his beliefs were advocated. mao repeated this strategy in his red army's infamous military milestone known as, "the twenty-five thousand kilometer long march," through endless grasslands attempting to escape the pursuit of the formal party's army. along the way, he convinced thousands and thousands of peasants to believe and support his revolution. thus he explained, "the long march is a propaganda team; it is like a seeder...." these two historical references serve as an even more important metaphoric methodology for today's bio/geo/cultural environment.

with the *united nations* project and its many monuments, i want to push the opposite extremes: personal and political, local and global, and timeliness and timelessness. based on rapid global/bio/geo/cultural transitions that are fast approaching our new millennium, the conception, strategy, and methodology of *united nations* sets up several formulas.

#1 the entire project is divided into two parts: national monuments and the *united nations* final monument.

#2 each national monument is divided into two parts: local people's hair and local historical context (concept).

#3 it provides direct physical contact, interaction, integration, and confrontation with the local population (collecting hair) and their cultural histories (conceptual reference). instead of imagining or reading about cultures and then working from that information in the private studio, i strongly believe that actual physical experiences are far more authentic and important than literary interpretations.

#4 "i" as the initiator and executor. my bio/geo/cultural identity becomes the device that shapes the cultural dialogues, confrontations, and possible battles. this position constantly creates "who i am" to "who i am not" whenever i am buried in a monument with the exception of the *united nations* china monument. it also provides an international "expatriate" for everyone to relate to in every corner of our planet.

all four formulas have created an absolutely authentic situation which precisely fits our bio/geo/cultural transition which goes beyond "otherization," "regionalization," "transculturalization," and so on. under this conceptual working process, the identity of the local race and its culture is being "otherized" by me as the "stranger." at the same time, my own identity is being "otherized" and in so doing, merges with the "strangers" and their culture: a double "otherness."

one of the striking challenges of the *united nations* project is that it uniquely delivers an intense historical and cultural, psychological paradox for me and the local audience. when the local audience is before the monument, composed of their hair and in their historical context, there is on one side a deep sense of national pride, and on the other a feeling that their culture is being "invaded" and "occupied" by a "stranger." this brings about a deep contradictory and paradoxical dialogue and a redefinition of the "self" between the local viewers and my position as the creator that is very significant and intriguing. an unusual interaction is unveiled. thus, as one art critic explained in a positive tone, the "*united nations* project is parodying the role of the cultural colonialist."[4] as the whole working process charts its course with its extremely diverse races and cultural environments, the intellectual, and physical working situations will be defined as: "in" and "out"; "inwards" and "outwards"; "integration" and "separation"; "identity" and "otherness"; "respect" and "attack"; and "paradox" and "harmony."

in one particular instance, a *united nations* audience member suggested, "it is our people's hair, it should be done by our hands." these simple words clearly present both sides as the local culture and i are "otherized," just like being in a pure "oxygen box"; both sides become identity–less on a psychological level through the creation of the new. it also leaves a very strong desire to redefine identities — a wonderful and exciting paradox. there is the contrast between this singular body material, "hair" and plural racial "identities" throughout the whole project; and yet, this single body material will be transformed into "multi-cultured hair." i call this a "great simplicity" which will transcend to a "universal identity." it is great because of its diverse richness; it is simple because it uses the single material of human hair.

moreover, the *united nations* national monuments are not totally separate entities. they

are like a "chain" with each successive monument building upon the previous ones. each becomes more complex and diverse eventually reaching a finalization that will unite all of the national monuments. occasionally i "link" two or three of the monuments together to heighten the disparities concerning certain world issues. for instance, the combined swedish and russian monument addressed the building confrontation between eastern and western europe in the post-cold war era as part of stockholm's international exhibition "interpol" (1996). a triple-focused egyptian/chinese/italian monument could make strong reference to three distinct religious and cultural milestones of civilizations. and a mighty china – usa coupling could broach the paramount ideological and sociological structural oppositions between two world powers. ultimately however, all of these monuments and their respective concerns will blend together in the american based finale of the *united nations* project.

"subject represents subject": human body as battleground, human body material as conviction

united nations is challenged by two conceptual sources: myths of the human body and multi-civilization. i believe that these two factors have been generating new human perspectives and subverting our traditional practices. in reaching the end of our modern society and facing the new millennium, we are committed not only to cultural conflicts such as west versus east in bio/geo/cultural transitions, but even more significantly, we become increasingly amazed and frightened by our bio-science and genetic research which now has the potential to confront us with an artificially generated new species, including an "artificial human." we are driven by our nature even as we call into question the ethical and moral characteristics of that nature.

sixty years ago in 1932, aldous huxley published his shocking book *brave new world*, and in 1993 andrew kimbrell published *the human body shop; the engineering and marketing of life*; both books open up the brilliant and darker sides of "modern existence to the full light of public scrutiny."[5] In the foreword to *the human body shop*, jeremy rifkin suggests that,

> Today, Huxley's vision is fast becoming commonplace. Engineering principles and mass production techniques are rushing head-long into the interior regions of the biological kingdom, invading the once sacred texts of life. The genetic code has been broken and scientists are rearranging the very blueprints of life. They are inserting, deleting, recombining, editing and programming genetic sequences within and between species, laying the foundation for a second creation—an artificial evolution designed with market forces and commercial objectives in mind. We have traded away our very souls for the going price of our own parts in the global marketplace. Global corporations are swarming over the human body, expropriating every available organ, tissue, and gene. It is now up to us to perform the exorcism, to free ourselves from the grip of the fast approaching brave new world.[6]

the first instance of this cross-species organ transplantation was in 1984 with the celebrated case of baby fae who received the heart of a baboon in a futile attempt to save her life. six years later, immunologist dr. j. michael mccune began a series of successful experiments in which he transplanted human fetal tissues and organs such as the thymus, liver, and lymph nodes into mice born without immune systems. in only a few days, the organ subparts and

tissues grew in the mice, engendering them with cells of the human immune system. named "humanized mice" they were then infected with diseases such as leukemia or h.i.v. so that the resulting viruses could be carefully studied. transplantation within our own species has reached new questionable depths with two cases in which women desired to use their own fetal tissue for medical purposes. in one case, a woman proposed being artificially inseminated by her father so the genetically identical cells could be used to treat his alzheimer's disease. in a related instance, a woman wanted to abort her own fetus in order to use the pancreas cells to treat her severe diabetic condition.

in 1995, a controversial event was reported in *time* magazine (november 27) when a baby mouse was given a human ear. it described how a mouse's engineered ear appeared publicly as part of the university of massachusetts medical center's twenty-fifth anniversary exhibition, "tissue engineering? ears to you." there was also a report on the return to the genesis of eden that appeared in *new scientist* (january 31) 1998. it explained that roger short of the royal women's hospital in melbourne, one of the world's leading reproductive biologists, applied for funding to transplant cells from human testes into those of mice with the aim to create mice that produce human sperm. furthermore, the recent successful science experiments of mammal cloning, brain transplants, and so on have predicted that human cloning is close at hand, leading towards the creation of artificial humans.

history tells us that we as humans are the center of the universe. from this standpoint, human research and knowledge are directed outwards; we manipulate, even mistreat everything from our human-centric position. lately, our outward intention has generated crisis besides benefits; looking inward became a trend, reaching back to our body, a great unknown myth. the material and substantial world is authenticity and priority; human knowledge is always secondary to the body.

since 1988, i have turned my artistic focus to the human body and its primal substance. the first of this series of art works is *oedipus refound*.[7] within this series, I have chosen to work with particular human body materials which convey highly charged cultural and political significances and taboos. while I understand that any kind of artistic medium has no unique identity today, by elevating the material human body, it has been my intent to transcend it to an extreme global level. *oedipus refound #1: the enigma of blood* was a collaboration involving sixty women from sixteen countries. each woman contributed the used sanitary napkins and tampons from one month's cycle with deeply personal writings regarding menstruation. this piece has generated astonishing and thought-provoking critiques and controversies; it also crosses cultural borders as people have described it as "hitting the core of human existence." following *oedipus refound #1* were *oedipus refound #2, enigma of birth, oedipus refound #3, enigma beyond joy and sin* all of which used whole human placenta as well as ground placenta powder (collected through a friend working in a maternity hospital in china). i categorized them into normal, abnormal, aborted, and still born placenta and pure placenta powders. these pieces narrate a polarized multicultural concern. the use of this material addresses highly charged issues in the west, but in china, its significance is elevated as the placenta is a precious, medicinal substance. in a discussion of this body of work johnson chang wrote:

> Unlike the use of other impersonal materials, human substance in itself has rich cultural and symbolic connotations. As such, not only does it refer to the work as signifier but is itself the signified.[8]

i wrote about the *oedipus refound* series in 1991. these works are dedicated to her, him, us, and our times. the oedipus myth is one of the most representative ancient allegories about our nature, knowledge, and being. these works intend to define us: we are the modern oedipus, caught in the chaos of the modern enigma. from our blind indulgence since ancient times we are still looking; our knowledge is still extending, and the chaotic enigma of the modern oedipus still continues.

since 1989, the concept of this series utilizes special human body materials as the subject. pure human body materials have no element of visual or linguistic illusion in themselves. they are the antithesis of art as object exhibited in museums and galleries. they are as real as the people who look at them and therefore can penetrate us with a deep sense of spiritual presence. therefore i call them, "silent-selves." each type of human body material that i use in the work passes an unusual deconstructive process; because of this, i also call it, "post-life."

the concept of the "thinking body" as opposed to the "thinking mind" deconstructs and abstracts the human body material from the normal system of the body. this has profound implications on the notions of "essence of body" and "essence of spirituality" and challenges our ideas regarding birth and death. my working methods invade and transcend the "silent selves" and "post-life" beyond convention, morality, mortality, religion, and civilization on the whole.

aside from social, political, sexual, and religious considerations, the art historical significance lies in my elimination of representation in art. whereas art history has traditionally been about an object represented through a medium, in my investigations of this concept, the only materials which escape the notion of the art historical object are those of the human body. human nature is the ultimate and only "subject" in the universe. danielle chang has suggested:

> To speak of Gu's work strictly as a metaphor for body politics would be telling only half of the story. For him – as for Kiki Smith, Lorna Simpson, Robert Gober – the body is certainly a battleground. Yet, in his work, the combatant strategy is concealed from us. For all its emphasis on contemporary debates, this art retains a rich, nonpolemical ambiguity. Gu uses body material both as subject and medium, whereas Kiki Smith whose art has often been mentioned in relation to his, works with non-body materials to evoke human forms.... however, by selecting actual bodily growth, Gu escapes the traditional artistic practice of using a medium solely as a vehicle to convey representation.[9]

in his essay for the exhibition "fragmented memory: the chinese avant-garde," zhou yan discussed the relationship between subject and object: "The separation and opposition between subject and object melts in the shared experience of viewers and those who contributed the original material, and in the shared identity of the physical and psychological and spiritual."[10]

in a description of my work in the "heart of darkness" exhibition at the kröller–müller museum, els van der plas wrote,

Five cradles were lined on the bottom with different kinds of placenta powder. A glass plate protected the inside of the cradle from curious fingers. The middle cradle, which contains no powder, displayed a sign with the message that this baby was aborted; a rather shocking statement. With the empty cradle, symbolizing death, and with the placenta powder, Wenda confronted the visitor with the conflicts between nature and artificial society. The placenta powder as well as the hair are in a way excrement, in the sense that they come from the body. The vulnerability of these human substances and at the same time the association with violence (showing hair without a body) harassed the visitors and made them recognize their own nakedness. Wenda applied the medicine which is made from "giving birth." The concept of the "cycles of life" was also presented by symbols of giving birth, dying, and burying.[11]

as every national monument in the *united nations* project is a large scale architectural work constructed of pure local human hair, each work requires huge amounts of shorn hair. a long period of time is needed to collect the local hair and the process usually involves the participation of about twenty to forty barbershops over a three to four month duration. this specific working process provides a concept: mountains of human waste are transformed into local cultural monuments. when the local audience and i are before the "hair" monuments, it is as if the waste material is reincarnated with human spirituality.

there is a fascinating effect which creates a psychological and physical impact when large amounts of human hair become solid hair bricks, hair curtain walls, hair carpets and so on. it is an absolute process of reincarnation: from "body waste" to "bio/cultural monument." in stockholm, the färgfabriken center for contemporary art and architecture used a local factory's facilities to produce human hair products. imagine the process: living people's outgrowth goes through inanimate machines to be "pressed," "toasted," and "cut" into hair bricks and carpet forms. i feel the concept goes beyond our language's capacity to define its precise meanings. it is far deeper than simply "body recycling or casting" the human "soul" into hair bricks or hair carpets. this strange combination of real human substances processed by man-made machines makes the traditional art mediums such as wood, metal, stone, etc. seem much less expressive to say the least. i call it, "absolute body obsession."

the human body myth is as equally infinite as the universal myth. hence, human body material is a signifier which does not necessarily need language's assistance to convey certain meanings as most non-human materials do. when human body materials are reincarnated as an art creation, the significance comes from the inside of the body materials. the difference between using human body materials and non-human objects creates opposing definitions, such as "internal" versus "external." the human body materials' "internal definition" parallels the viewers' psychological and physical conditions. when viewers behold the works with human body materials, they are literally encountering themselves. on the contrary, non-human objective materials are inherently distanced from viewers. this psychological and physical gap therefore needs linguistic assistance to create a bridge between the object and subject, between inhuman objective material and the viewing audience.

in addition to my concepts on the use of the human body material, i feel that the body is privileged in yet another way. i constantly battle against our "ready made knowledge," our "convention." i discussed this controversy in a letter regarding my installation, *oedipus refound #3: enigma beyond joy and sin.* the following is an excerpt:

The placenta has been used and continues to be used in the West for commercial products such as make-up. "Cruelty and warmth" are mere expressions of the artistic value of a work and of human existence. Nobody criticizes the Greek writer Sophocles as a cruel person because he created the tragedy "Oedipus the King." Nowadays, no cultured person would criticize or react against Shakespeare for having written tragedies like "Hamlet," "Macbeth," "King Lear," or "Othello," as cruelty is a structural part of human nature, before and beyond any moralistic judgement. I suppose you well know that there is no evil without good. Such a kind of intellectual or emotional separation is artificial, it is just an illusion. Trying to avoid, not to see, not to recognize it, becomes structurally a sort of deviation from the understanding of human beings' natural process of life, and it is, in the end, a kind of expression of spiritual weakness and cowardice, as well as of a one-sided and restricted approach to life. This attitude becomes also a denial of the relativity of any so called "truth" or "value," and it is in itself unnatural, that is to say contradicting nature in itself.... Sophocles and Shakespeare are actually rightly respected as passionate persons loving life, knowledge, and insightfully able to express human existence, "misunderstanding," and "blindness," while representing human "cruelty" as a natural and structural element in life.[12]

the human body material contains enormous meanings and myth. the metaphor concerns birth, death, and all the enigmatic, unsolved questions in life. the discovery of using human body material in art unveiled the edges between our shocking reality and conventional knowledge which has created a particular "reality" we believe in, the illusionistic ready-made values and faiths.

as a striking result of the *oedipus refound* series' deep involvement with human body materials, i have found myself in the position of being a strong defender of our reality, without believing in illusionistic values and transposed faiths. this has often been rejected by current political correctness. the responses the work receives are usually ones of great extremes such as "hate" or "love"; either the audience leaves with exceptional inner impressions or difficult conflicts. we can clearly see that an audience may rediscover many issues and pose many questions; i too ask many questions which remain unanswered enigmatically by my viewing audience and me. a challenge can provoke a "shocking" response if it contains intelligence and deliberation; this "shocking" phenomenon evolves from various sources, which is the essence of "shocking," while "shocking" is actually only the phenomenon.

the confrontation of enormous enigmatic connotations in the human body material itself (the "internal definition") and the intense reactions, elaborations, and misunderstandings from the viewing public (the"external definition") give rise to an enigmatic complexity between consciousness and unconsciousness which almost becomes an unsolvable predicament. because of the human body products' beauty, sensitivity, and potentially fear inducing relation to the viewer, the call of birth and death, and the fear of waste material, the overall reactions to this work range from severe "repulsion" and "disgust" to puzzling queries, then ultimately recognition — "it is us."

the appreciation, interpretation of a piece of art from the centric human being, from looking out from the objective universe to looking in on "ourselves" brings about deep misunderstandings which is what mankind's knowledge is all about. there is battle; and there is conviction which we apply to ourselves.

"hair-itage" — vast human hair ocean: universal identity in the *united nations* project
the *united nations* art project is committed to a single human body material – pure human
hair. hair is a signifier and metaphor extremely rich in history, civilization, science, ethnicity,
timing, and even economics. the project's diverse journey brings one single nation's identity
(one national monument) to the identities of multiple nations (as many as twenty national
monuments) to human universal identity (unified national monuments for the final ceremo-
ny of the *united nations* project). this human body outgrowth or "waste" throughout the *unit-
ed nations* project becomes the great human "hair-itage."[13] it becomes a geo/national/cultural
identity "melting pot."

for some native americans hair was and still is considered as "the location of the soul"
and a vital human force. saint's locks are considered holy relics, worshiped and preserved by
the catholic church. if hair is shorn or cut it implies renunciation and sacrifice. historically
the free growth of hair has projected and asserted power and superiority and royalty. in some
cultures and historical periods it has represented a challenge to social limits and laws consti-
tuting the state organization (american hippies and beatniks). in her essay on my *united
nations* monument in italy, kim levin viewed hair in a universal light, suggesting that "it can
be an allusion to the power of the main question concerning the enigma of birth and death,
probably shared by the same mankind with a universe 'created' by the explosion known as
the 'big bang' and destined to die, according to the law of entropy."[14] the real power of *united
nations* is that it is not only an artistic representation, it embodies living people's presence
through a wall of hair.

kim levin and danielle chang have both suggested the potential symbolic nature of hair
in the context of the *united nations* project. kim levin has posited:

> Power is inherent in those slender outgrowths of the epidermis, those pigmented
> filaments that are among the most animalistic and intimate elements of the human
> body. Not all hair is public, but as psychoanalysts well know, the most innocuous
> remark about a beard, mustache, or hairstyle is a loaded and coded comment from
> which can be deciphered all manner of information about libido, superego, and sex-
> uality. Hair can be a signifier not only of virility and femininity but also of race, eth-
> nicity and age. And as history can attest — from the pigtail of China's final dynasty
> to the powdered wig in monarchist France, from the military crewcut to the rebel-
> lious hippie mane or the militant afro, from the punk mohawk to skinhead hair-
> lessness — how we style our scalps has since time immemorial singled allegiances
> and complicities in the political and spiritual realms.[15]

the following is danielle chang's interpretation:

> Like teeth and nails, hair remains intact after it is separated from the human body.
> Alone, each hair strand contains enough DNA to unlock our individual genetic make-
> up. Like a fingerprint, it can be held as evidence at the scene of a crime.[16]

**fusion of human nature (hair) with artificial nature (language): fusion of different races
(hair) with different cultures (languages)**
a double conceptual game is played by faking ancient chinese seal script, the oldest form of
chinese language which was codified by the first emperor of china, qing shi huang. it is

unreadable for both chinese and non-chinese; it is also unidentifiable whether the script is real or fake to both chinese and non-chinese audiences. the concept of the unidentified chinese language could be translated by chinese as the mythos of lost history; it can also be interpreted by non-chinese as misunderstandings of exotic culture. in general, the miswritten language symbolizes "misunderstanding" as the essence of our knowledge concerning the universe and material world. yet, the pseudo-scripts help us reach infinity and eternity by imagining the universe which is out of reach of human knowledge (language). furthermore, faking language is a way to express fear, anxiety, and a distrust of our knowledge, and places human languages in a predicament of absurdity and irony.

juxtaposing and interweaving pseudo-english, chinese, hindi, and arabic languages not only introduces the misunderstandings within a single culture but also symbolically unveils the conflicts of "co-existence" of bio/geo/cultural multiplicities. on the other hand, "multiplicities" are not a new thing after centuries of bio/geo/cultural exchange. the truth is, there is not "purity" in the world. it is indeed a fantasy of self awareness and the fear of losing oneself in another. however, experiencing an other culture does not only enrich the self, it simultaneously "others" oneself as well. in the face of this co-existence of fake languages, english speakers cannot read the english and chinese people cannot recognize the chinese, and so on. in fact to risk losing self originality and history is also to reconstruct the self by opening up to the influence of others, or maintaining a virtual purity of self by refusing others' influences. this is not a new issue, but it is intensified in daily practice in our era. abstracting the traditional definitions from existing languages repositions us in an unprecedented, unknown world. the coexistence of multiple pseudo-languages then prays for our future.

delving into diverse cultures, capturing national identities: profoundness at the final ceremony of *united nations*

once upon a time there was an old man who desired to remove a high mountain. he told this to his wife and children. they laughed at him and said, "how could this be possible? are you crazy?!" the old man said, "it is possible. we will shovel one piece after one piece, day by day, year by year we will continue to shovel. after a while, the mountain will become smaller and smaller. if we can't finish, our grandchildren will continue, generation after generation. no matter how high the mountain is, it must be removed." this is an ancient fable from chinese folklore.

in the beginning of 1993, i decided to act upon my ideas concerning the *united nations* art project. i felt its realization could be a profound symbol of our new global bio/geo culture in our present historical moment. i would not be satisfied to simply collect hair from different parts of the world and then complete the project. i unconsciously knew there were greater depths to explore including an intriguing idea that came to me; i would make national monuments in many strategic countries around the world and then unify them in a final ceremony of the *united nations* project.

this deliberation brought about a conceptual strategic method; i believe that a strong methodology is a binding hinge to any project. from this framework, i have a clear working structure allowing me to build national monuments throughout the long process. these individual monuments are the bio/geo/historical cultural signifiers to the *united nations* project. this concept constantly presents confrontations with diverse local people and their

psycho/physical histories and cultures. with the national events' intense multiplicity in terms of phenomenological issues, it is hardly a conceivable contingency. it is with bio/geo culture in the making that i use the chinese fable; the challenge and the inspiration are the elevations of my ability. the contingent difficulties are integral parts of the conception. at times i am breathless thinking about how i will shape these national monuments in such diverse civilizations.

brave mankind, brave new world: *united nations* art project is brought to the historical moment: rewriting the definition of "america" and "american"
in 1993, a *time* magazine cover story proclaimed that, "our colors are changing." in 1994, *time* once again predicted "a rebirth of a nation" with a female portrait on the cover generated from a mix of several races: middle eastern, italian, african, vietnamese, anglo-saxon, chinese, and hispanic, telling the story of how immigrants are shaping the world's first multi-cultural society: the new race of america. from a california buddhist temple to new york's statue of liberty; from chinatown to disneyland; from harlem to miami… the multi-bio/geo/cultural integration has been created and is creating a brave new race in the world.

conceptually, new york city is the ideal location to finalize the ceremony of the art project *united nations*, as migration has shaped america and new york city in particular. six thousand years ago, native americans migrated to this wilderness from asia across siberia. christopher columbus brought euro-caucasian settlements to this wonderland. africans brought to america have had a major influence on american culture. the chinese built american railroads. this legendary land, built on hardship and tragedy, has become a dream full of hope, chance, and bio/geo/cultural conflicts, a dream without precedent in mankind's history. following are two astonishing numbers: the norwegian-american population is larger than the population of norway and the population of the netherlands is smaller than that of dutch-americans. biological intermixing is far more authentic and essential than multi-cultural exchange. the definition of "american" in the future will not be of a single racial identity. being american in the future will be a brave new racial identity. this will be an astonishing reality of our future.

addendum: project description of first *united nations* project: *united nations – italian division* (renamed *united nations – italy monument: god and children*)
this exhibition of a pure italian hair temple took place in the fall of 1994 after more than six months of hair collection throughout italy which included hair from milan's fashion school and italian military bases in venice. it required an entire summer to construct the temple in venice and then it was transported and displayed in milan. curated by italian art and cultural critic, monique sartor, and supported by enrico gariboldi arte comtemporanea, it was the first official national monument created under the title of *united nations*.

it will remain one of the most important national monuments not only because it was the beginning of the *united nations* project, but because from an historical and cultural point of view, caucasian civilization can possibly be traced back to roman heritage. moreover, as the center of the dominant catholic church, the creation of a temple becomes all the more poignant.

the hair is a rich multi-signifier in this giant hair temple. in the central area of the installation, i constructed a metamorphic roman column of pure italian hair, which was hollow on

the inside. on the floor inside the column, i scattered hair taken from the heads of the inhabitants of the vatican. in front of the column, i created a large italian hair garden. the responses from the milanese audience brought to my attention a significant point of view. even though i am the creator of this local monument, i remain a constant stranger to all the local races and their histories and cultures. this brings up a unique psychological complex: when the local audience is proud of my efforts regarding their race and its legacy, i receive absolute admiration and praise. however, at the same time they see me as a foreign intruder which automatically distances me from them, thereby setting up my efforts as an attack upon something which is their own. thus this psychological complexity puts the local audience, my work, and me in a very strange, alienated triad in which all three parties are symptomatic of an unidentifiable "otherness." this "alienated otherness" is indefinable. it is definitely different than the "otherness" from the hierarchical, new internationalism which places all kinds of internationalized regional, cultural phenomenon under the category of "otherness" and treats it otherwise. this unidentifiable "alienated otherness" is stimulated solely by the national monuments. first of all, even though most of the national monuments are built on the basis of pure hair from one race within its historical and cultural context, it is constructed by an "outsider," and becomes something else which is neither my own nor the local audiences. because of this, the work distances itself from its own local audience and of course even though i created it, it is not my own. this significant, unidentifiable "alienated otherness" is not only the bio/geo/cultural "otherness," but a psychological space over the so-called bio/geo/cultural alienation and otherness. this unique psychological space made from the national monuments is exactly what i predicted and hoped to create. it symbolizes our multiplicity in a bio/geo/cultural psychological space rather than a physical one.

1 This is an updated version of Wenda Gu's (1998) thesis statement on the *united nations* project "The Divine Comedy of Our Times," which was originally written in 1995. The artist chose to present his written words entirely in lower case.

2 Monique Sartor, "United Nations," in *United Nations – Italian Division* (Milan, Italy: Enrico Gariboldi Arte Contemporanea, 1994), n.p.

3 Kim Levin, "Splitting Hairs: Wenda Gu's Primal Project and Material Misunderstandings," in *United Nations – Italian Division* (Milan, Italy: Enrico Gariboldi Arte Contemporanea, 1994), n.p.

4 Danielle Chang, "United Nations–American Division," in *United Nations – American Monument* (New York: Space Untitled, 1995), n.p.

5 Jeremy Rifkin, Foreword to *The Human Body Shop*, Andrew Kimbrell (San Francisco: Harper Collins, 1993).

6 Ibid.

7 The original title of this work was *2000 Natural Deaths*. It was exhibited in 1990 at the Hatley Martin Gallery, San Francisco, California, and was curated by Dr. Peter Selz and Ms. Katherine Cook.

8 Johnson Chang, "The Other Face," *Asian Art News* (July/August, 1995): 41–43.

9 Danielle Chang.

10 Zhou Yan, "Wenda Gu's Oedipus," in *Fragmented Memory: The Chinese Avant-Garde in Exile* (Columbus, Ohio: Wexner Center for the Arts, The Ohio State University, 1993), 21.

11 Els van der Plas, "Heart of Darkness," *Art and Asia Pacific* 2, 3 (1995): 118–119.

12 Wenda Gu, Written correspondence to Wexner Center for the Arts, 1993.

13 James Servin (Associated Press), "Global Hairballs: Sculpture Celebrates Culture of Nations," *Palm Beach Post* (May 7, 1995), 6D.

14 Levin.

15 Ibid.

16 Danielle Chang.

united nations, road trip map 1994

Art," San Francisco Museum of Modern Art, San Francisco, California, U.S.A.

1998
united nations – china monument: temple of heaven
"Inside Out: New Chinese Art," P.S. 1 Contemporary Art Center and Asia Society Galleries, New York, New York, U.S.A.; Museo de Arte Contemporáneo, Monterrey, Mexico; Tacoma Art Museum and the Henry Art Gallery, Seattle, Washington, U.S.A.; National Gallery of Australia, Canberra, Australia; Hong Kong Museum of Art, Hong Kong, China.

united nations – vancouver monument: the metamorphosis
Site-specific installation with performance *Confucius Diary*, Morris and Helen Belkin Art Gallery, The University of British Columbia, Vancouver, British Columbia, Canada.

1997
united nations – taiwan monument: the mythos of lost dynasties
Site-specific installation with performance *Blackness*, Hanart Gallery, Taipei, Taiwan.

united nations – hong kong monument: the historical clash
Site-specific installation for "Hong Kong Handover," Hanart TZ Gallery, Hong Kong, China.

united nations – africa monument: the world praying wall
Site-specific installation with collaborative performance with choreographer Nomsa Manaka, Second Johannesburg Biennale, "Trade Routes: History and Geography," Institute of Contemporary Art, Johannesburg, South Africa.

1996
united nations – usa monument #2: dreamerica
Steinbaum Krauss Gallery, New York, New York, U.S.A.; National Museum of Contemporary Art, Seoul; Songe Museum of Contemporary Art, Republic of Korea.

united nations – sweden and russia monument: interpol
Site-specific installation, "Interpol," Färgfabriken Center for Contemporary Art and Architecture, Stockholm, Sweden.

united nations – britain monument: the maze
Angel Row Gallery, Nottingham; Camerawork Gallery, London, England.

1995
united nations – usa monument #1: post-cmoellotniinagl-piostm
Site-specific installation, Space Untitled Gallery, New York, New York, U.S.A.

united nations – israel monument: the holy land
Permanent land art project in Mitzpe Ramon Desert, "5th Construction in Process," Israeli Cultural Ministry and the Artists' Museum, Tel Aviv, Israel.

1994
united nations – italy monument: god and children
Site-specific installation, Enrico Gariboldi Arte Contemporanea, Milan, Italy.

united nations – holland monument: v.o.c. – w.i.c.
Site-specific installation, "Heart of Darkness," The Kröller-Müller Museum, Otterlo, Netherlands.

1993
united nations – poland monument: hospitalized history museum
Site-specific installation, "4th construction in process," History Museum of Lodz and The Artists Museum, Lodz, Poland.

{united 7561 kilometers, Texas 2003}

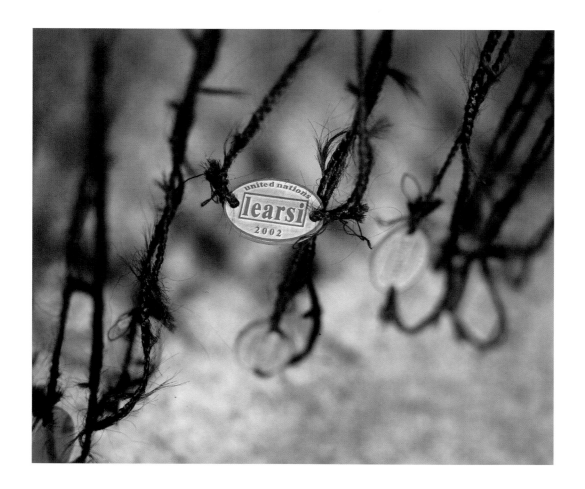

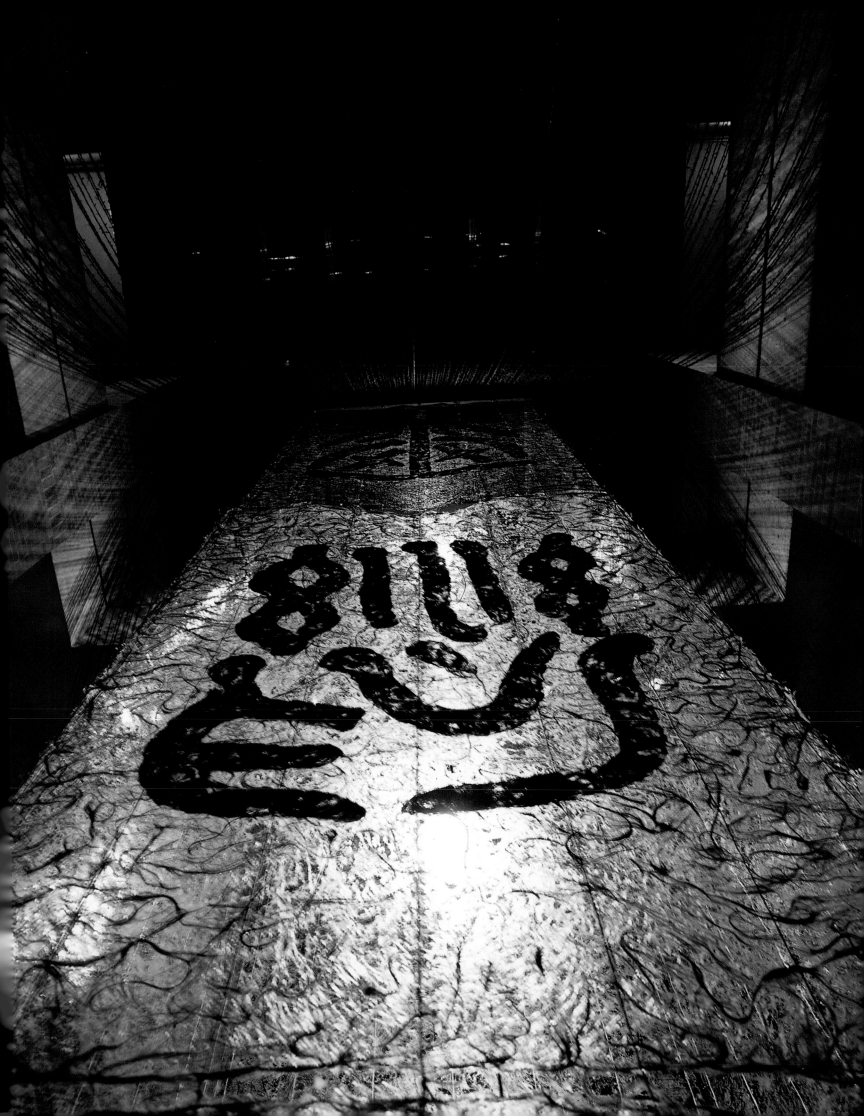

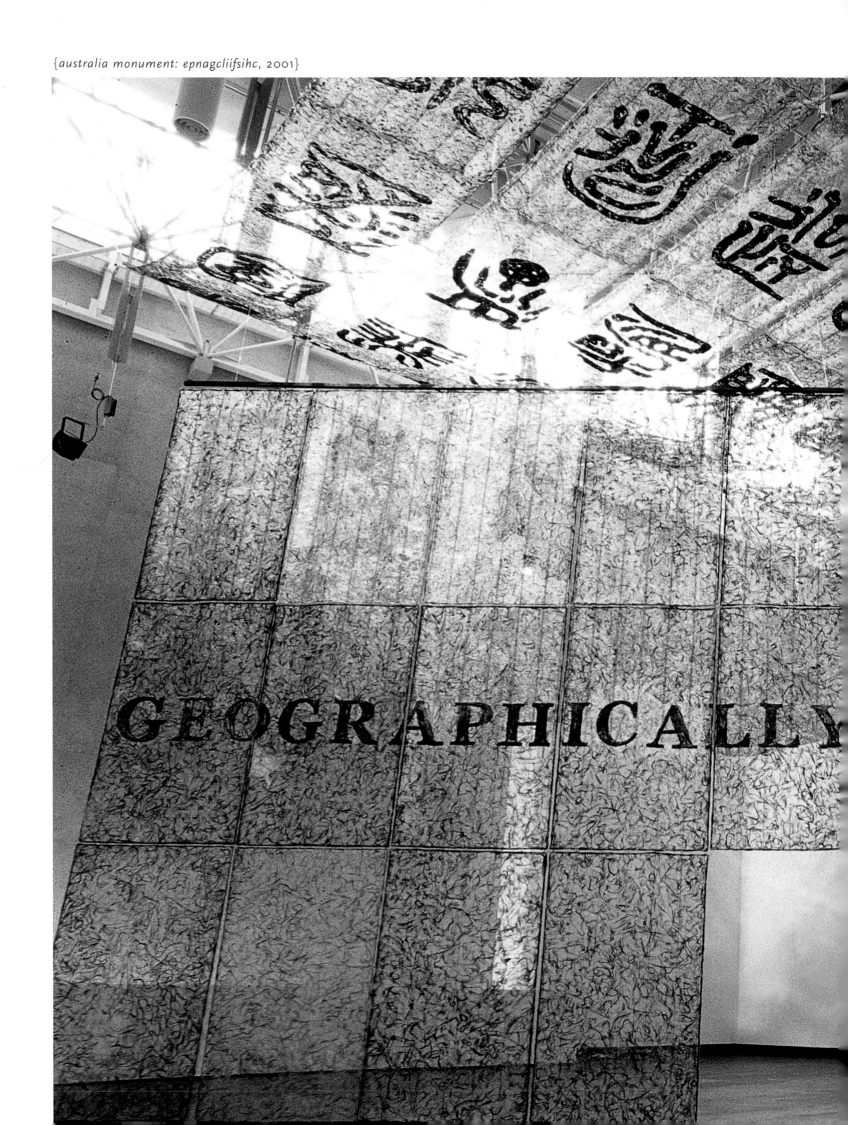

{*australia monument: epnagcliifsihc, 2001*}

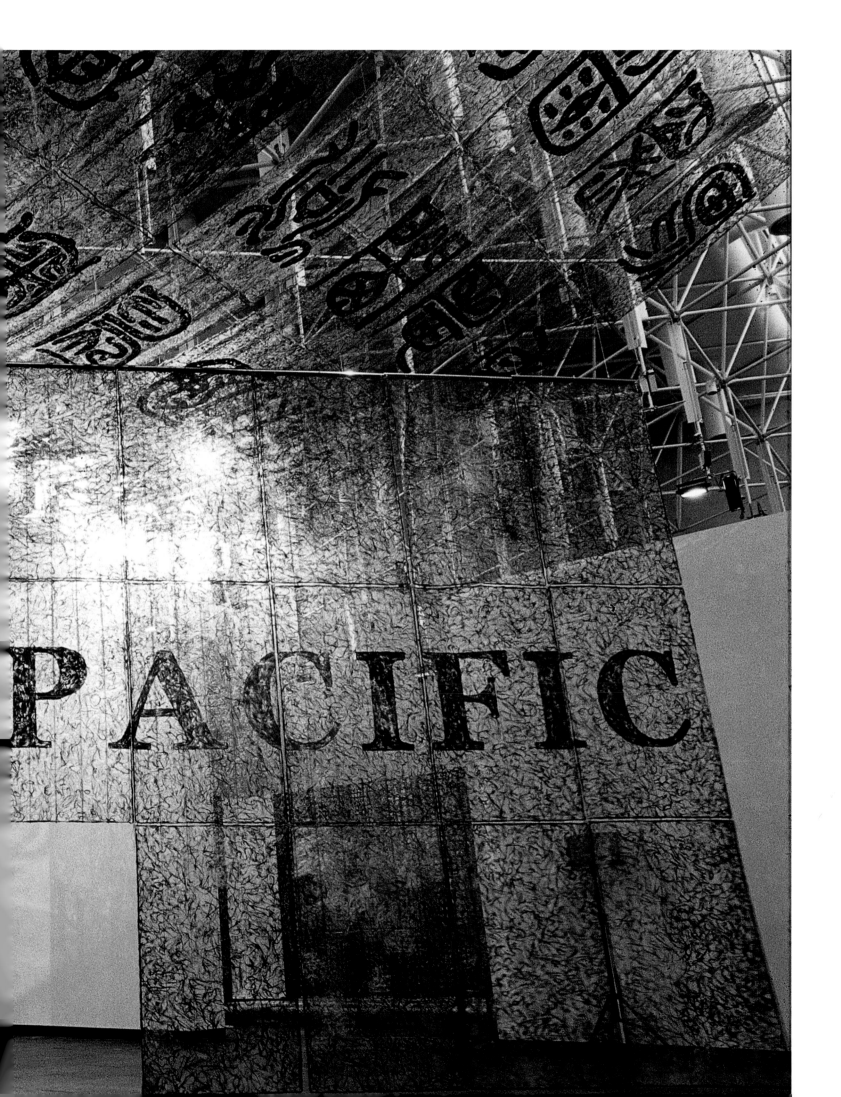

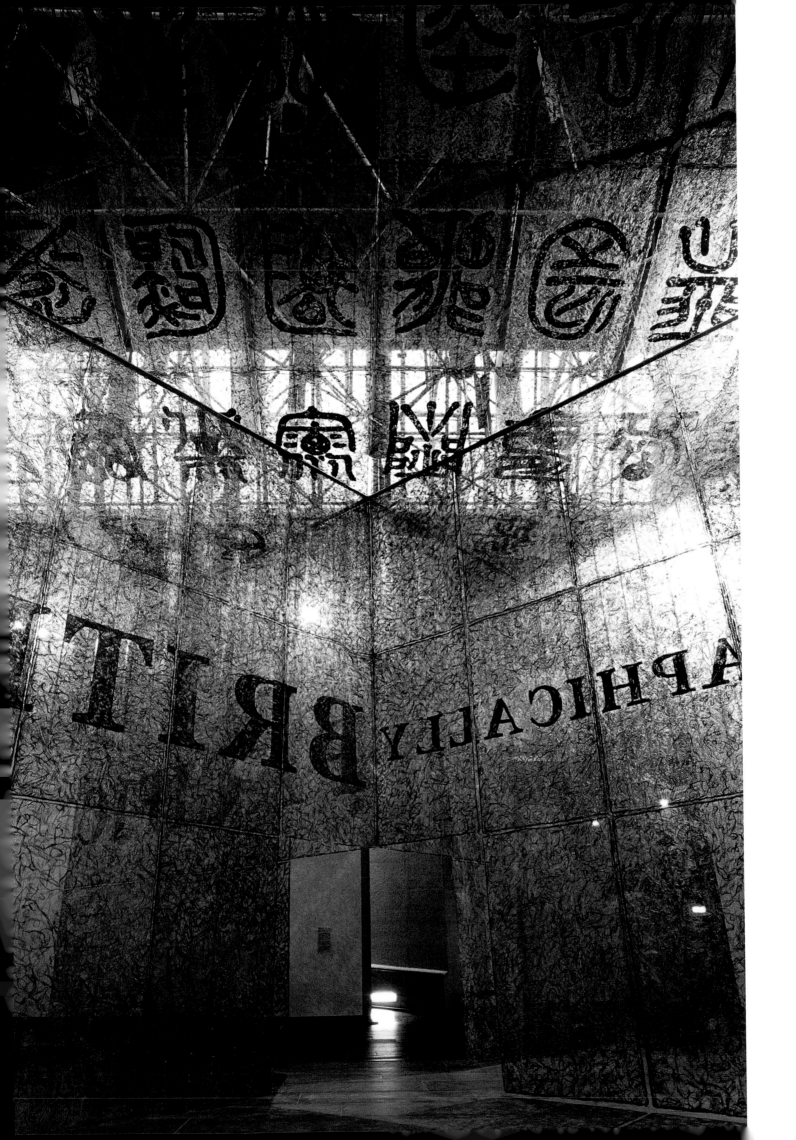

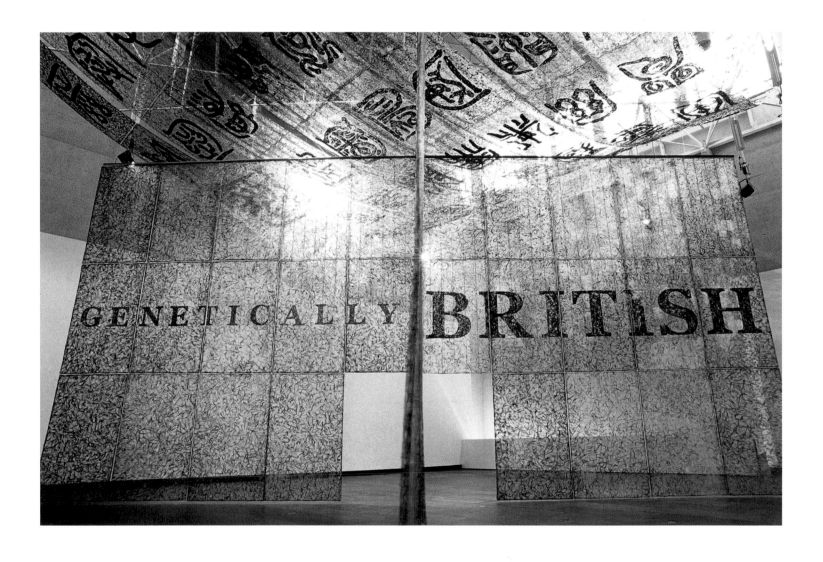

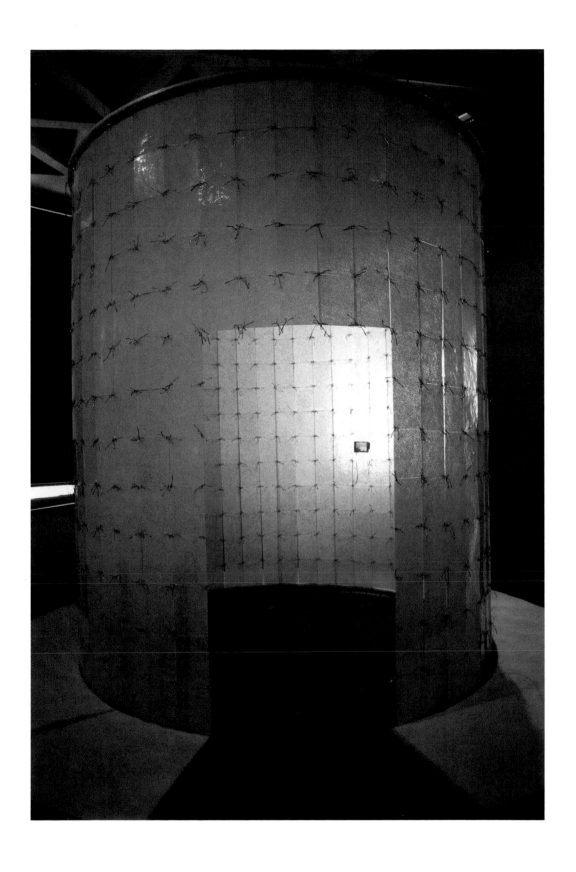

{*man and space*, Kwangju 2000}

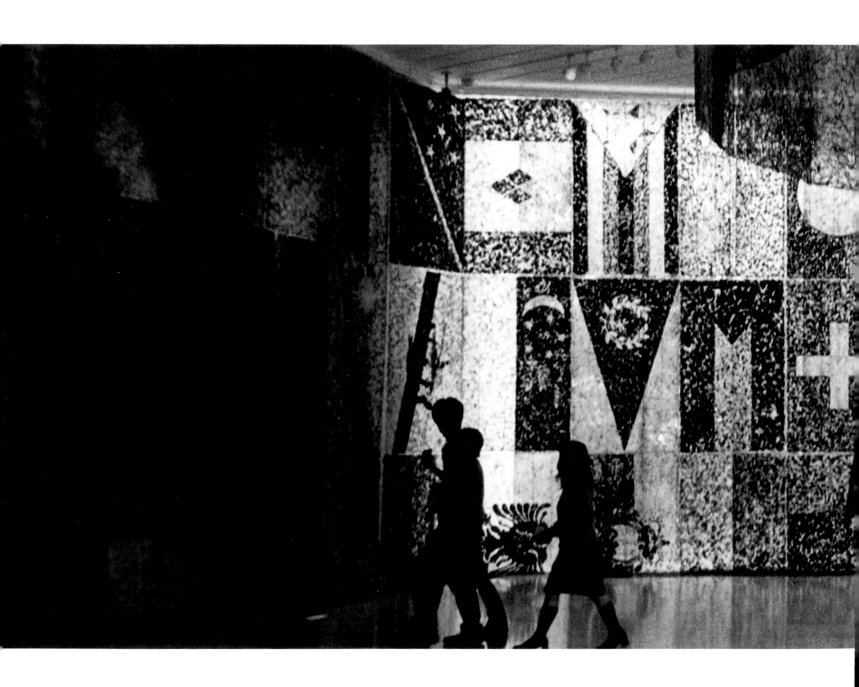

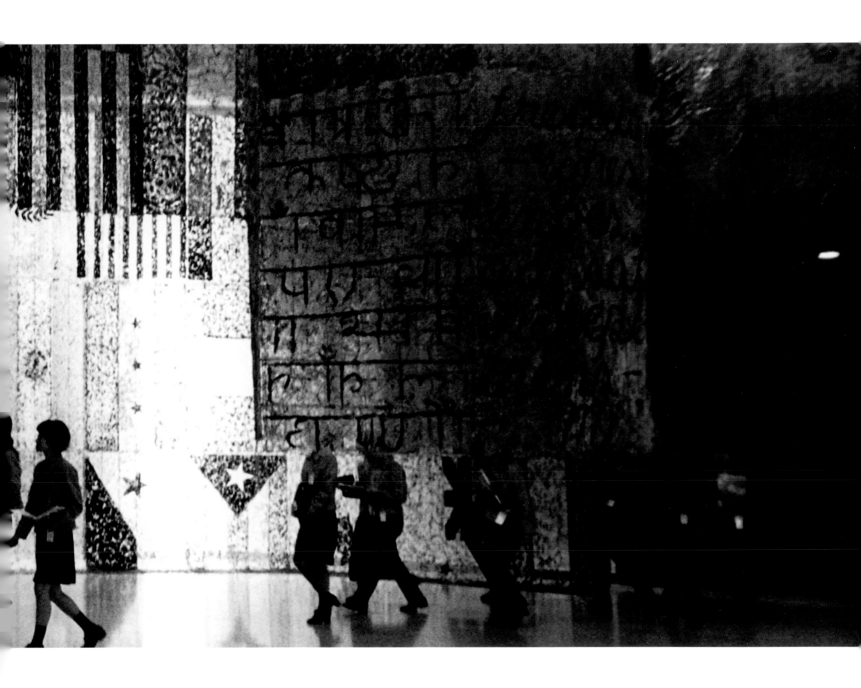

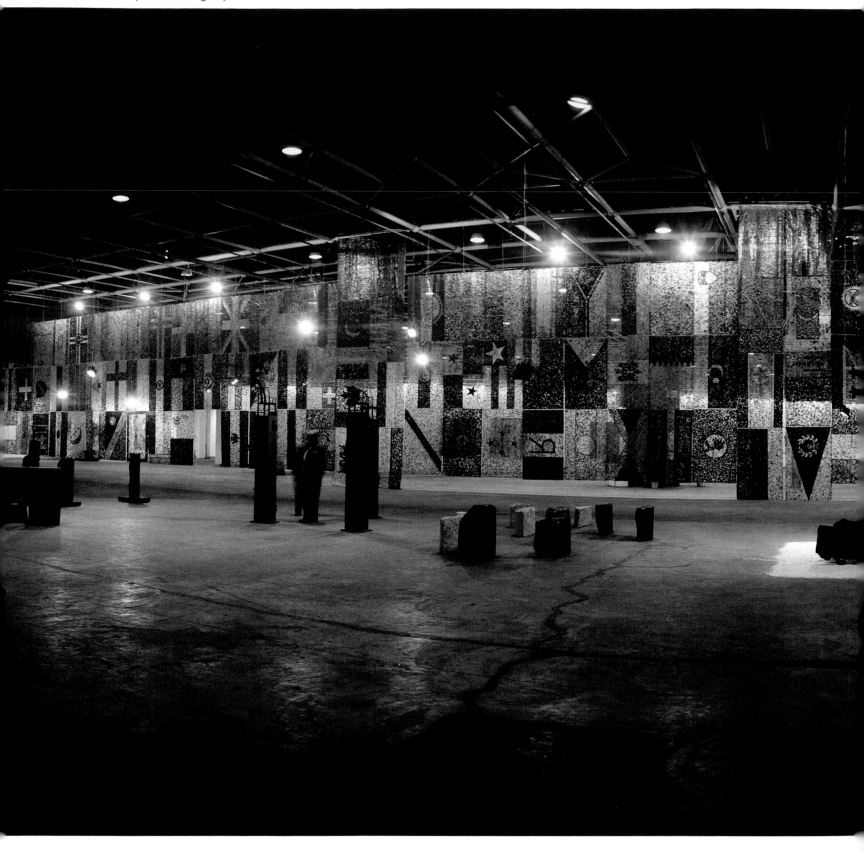

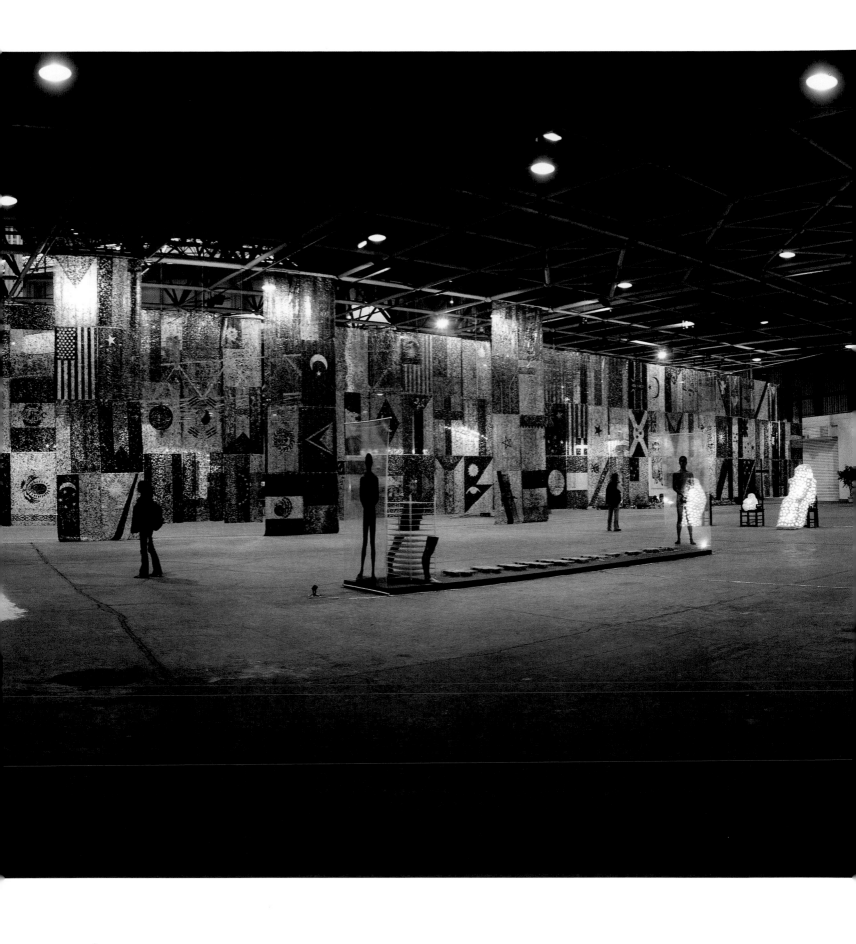

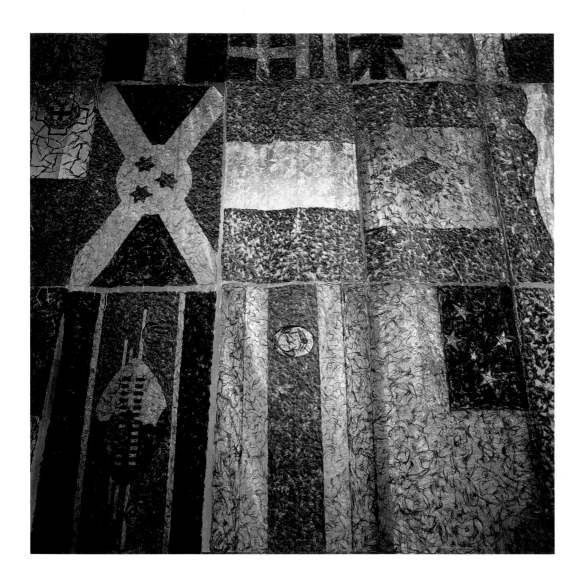

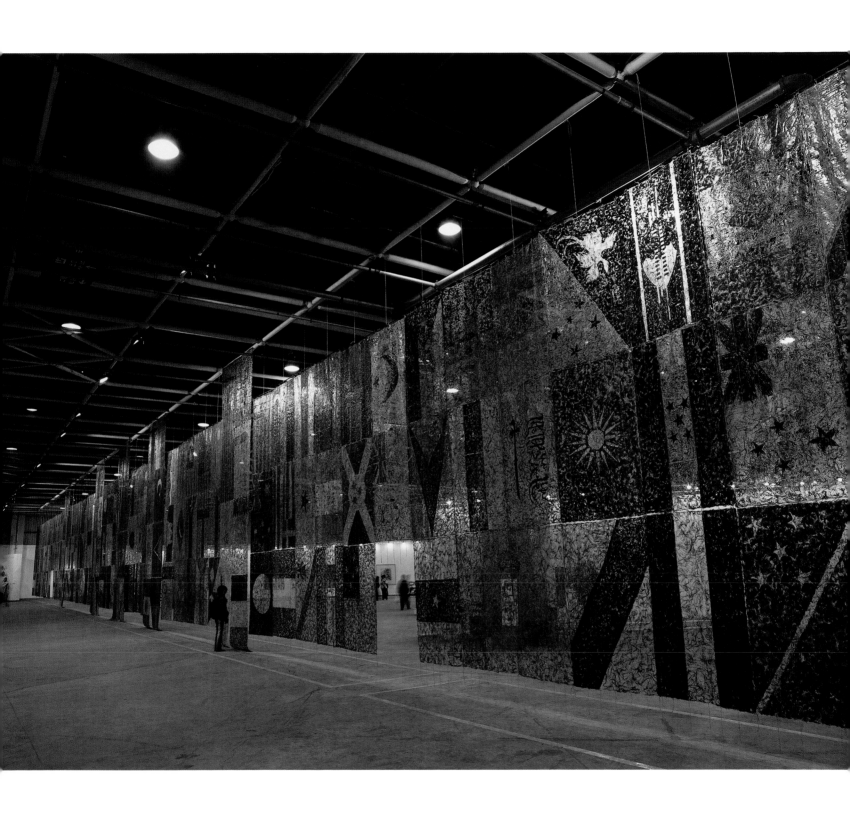

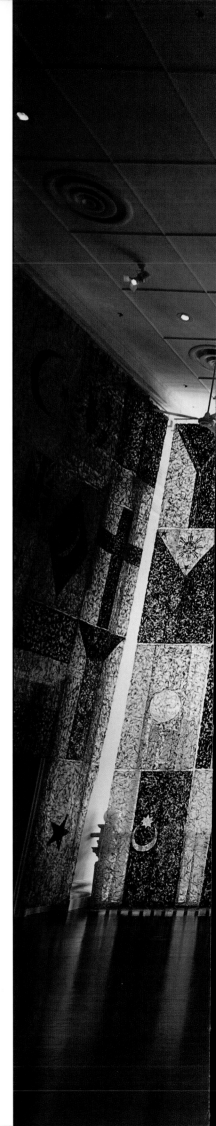

{man and space, Singapore}

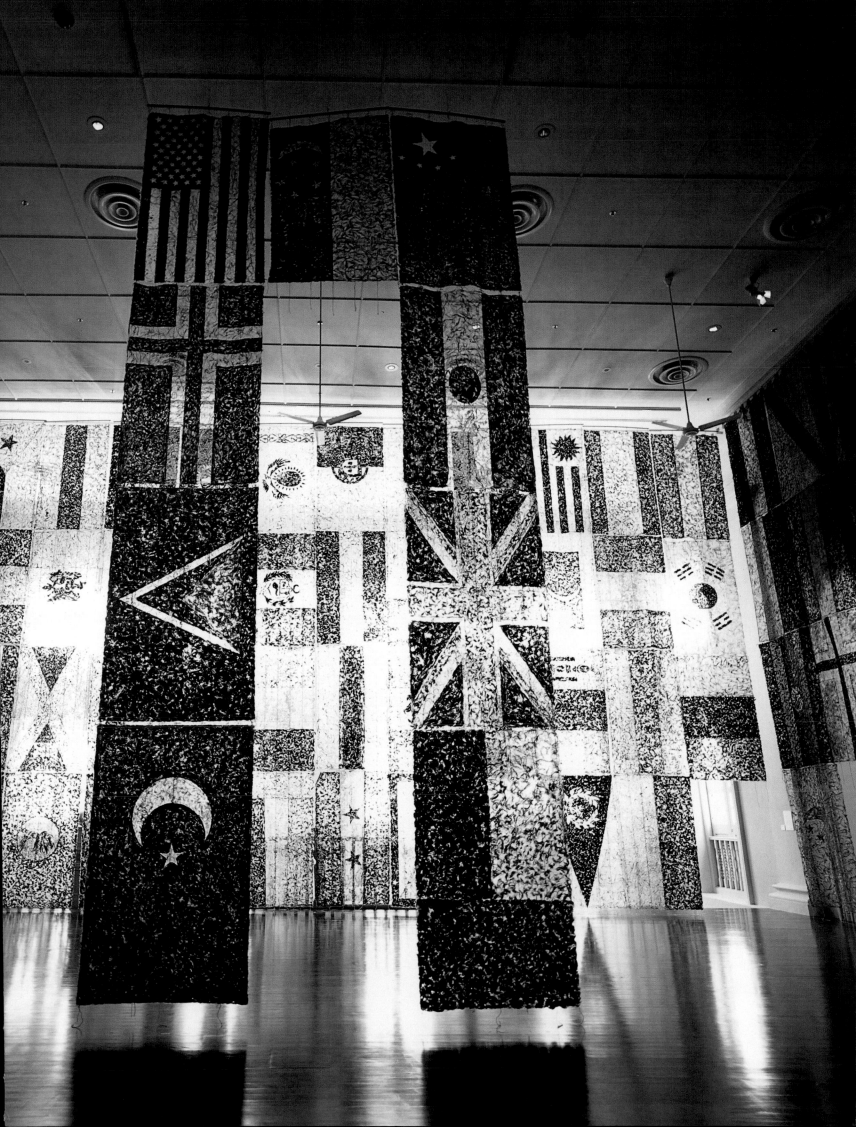

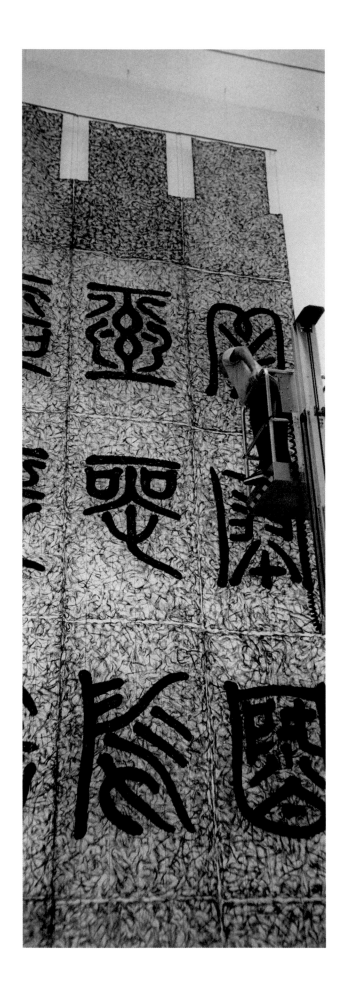
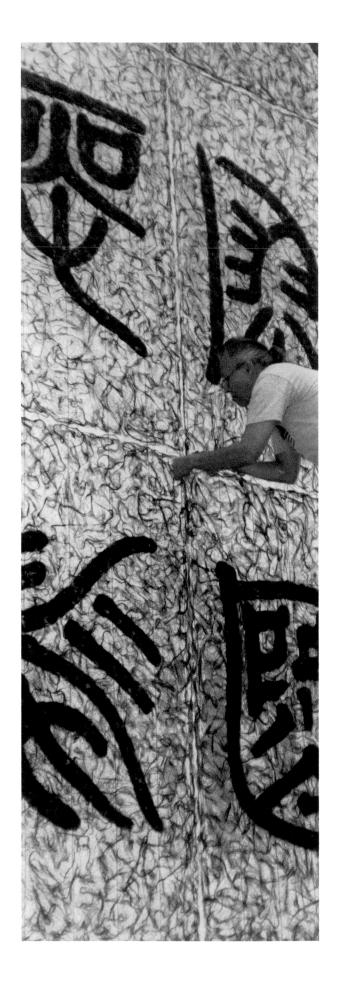

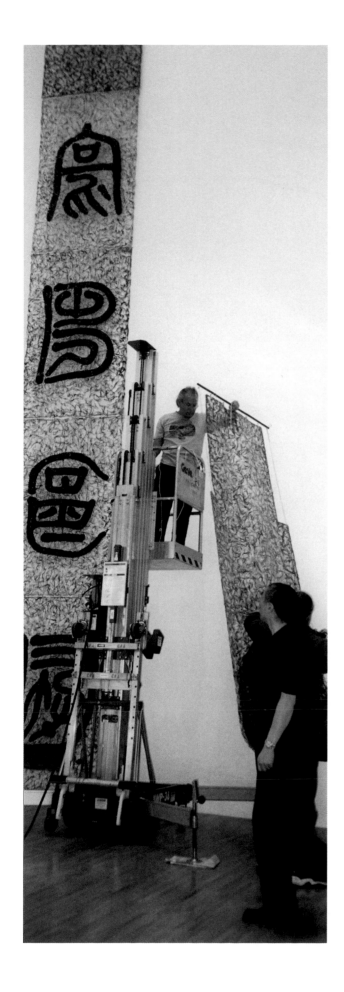

{*temple of exoticisms,* Lyon 2000}

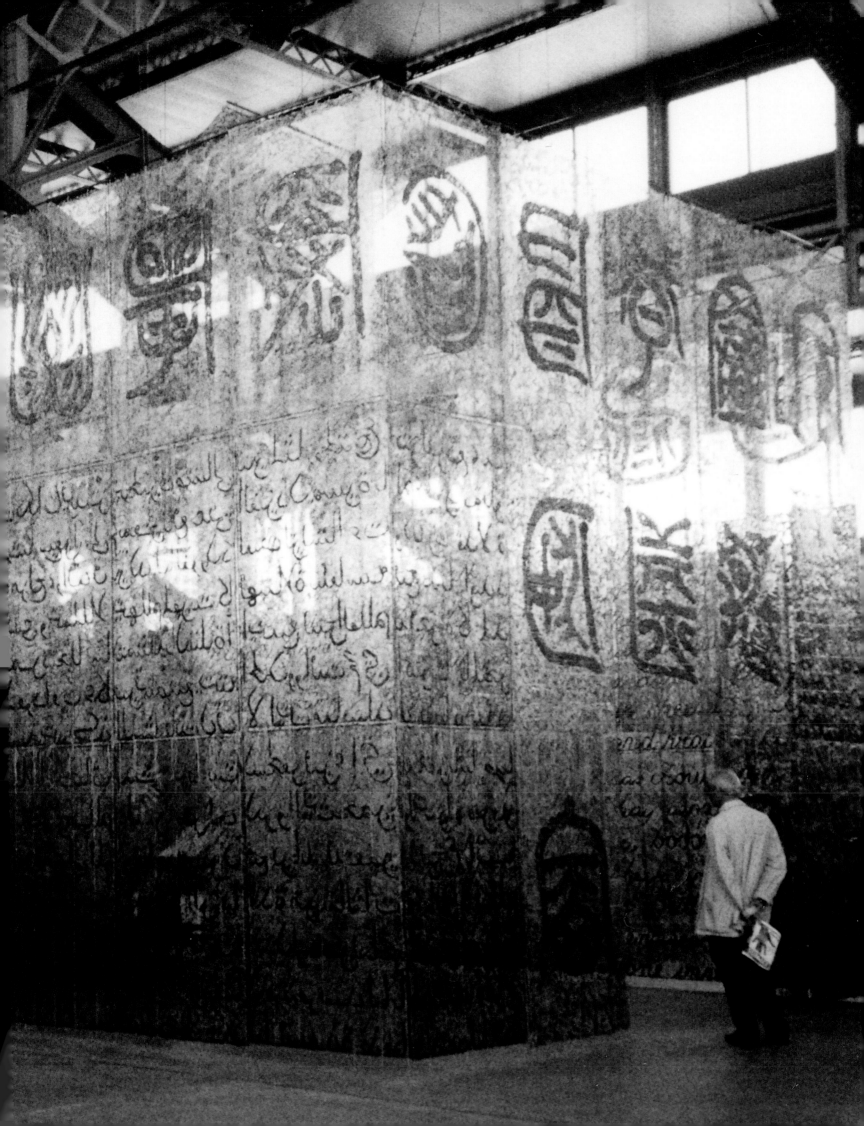

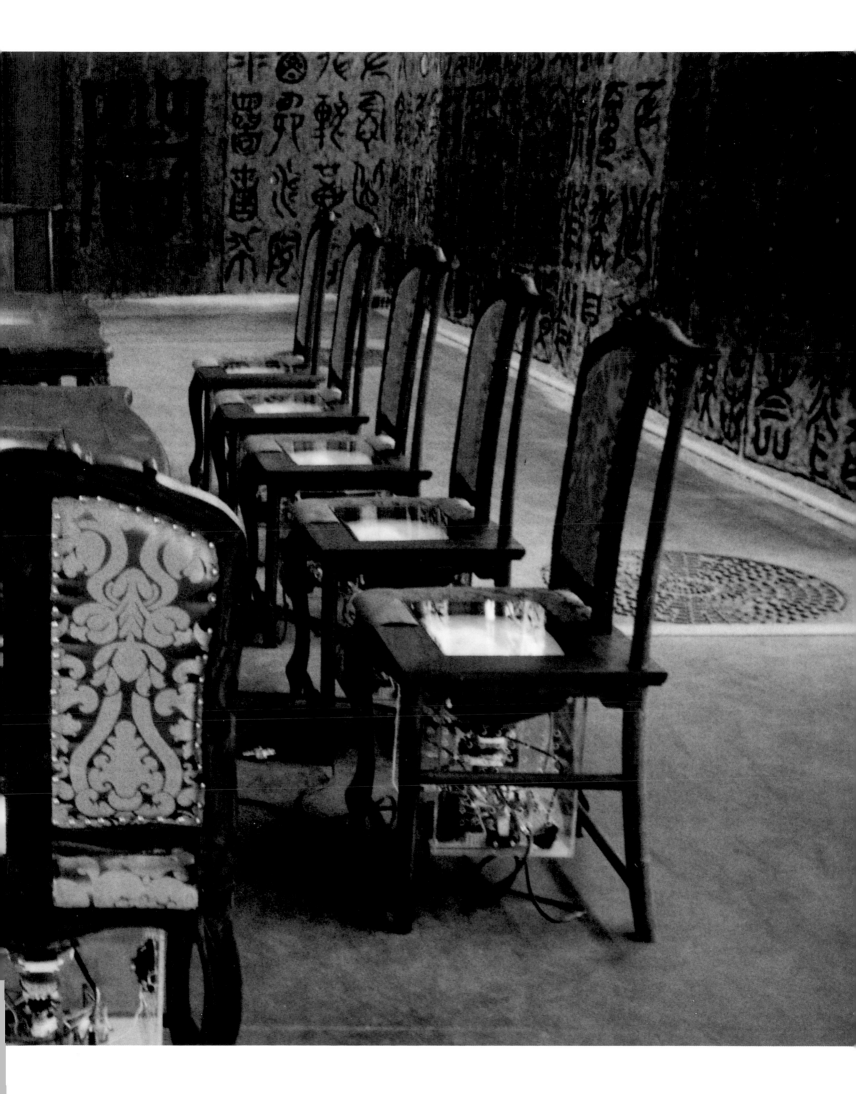

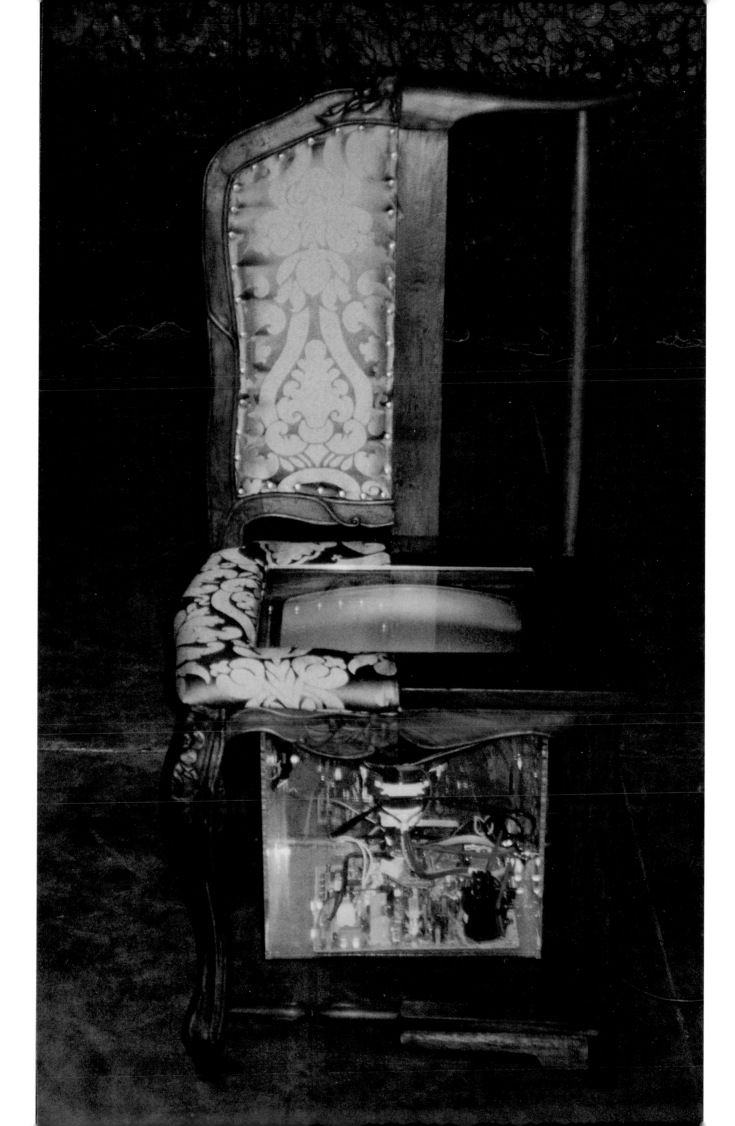

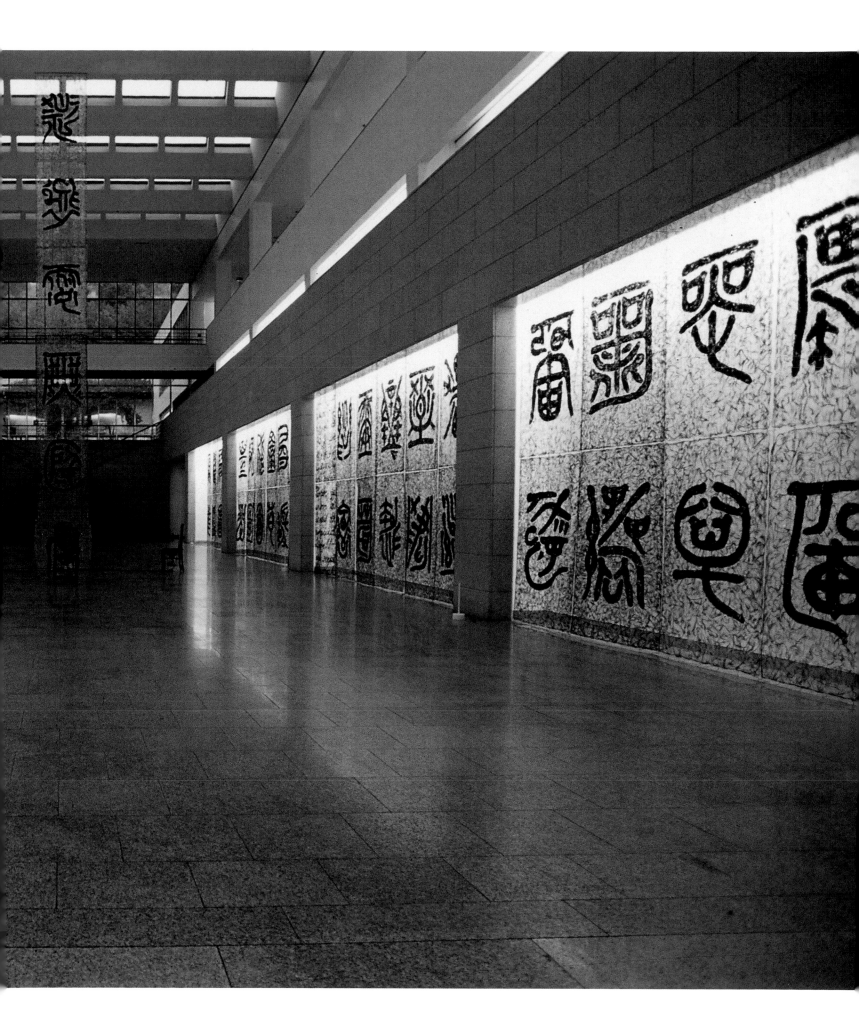

{*babel of the millennium*, California 2000}

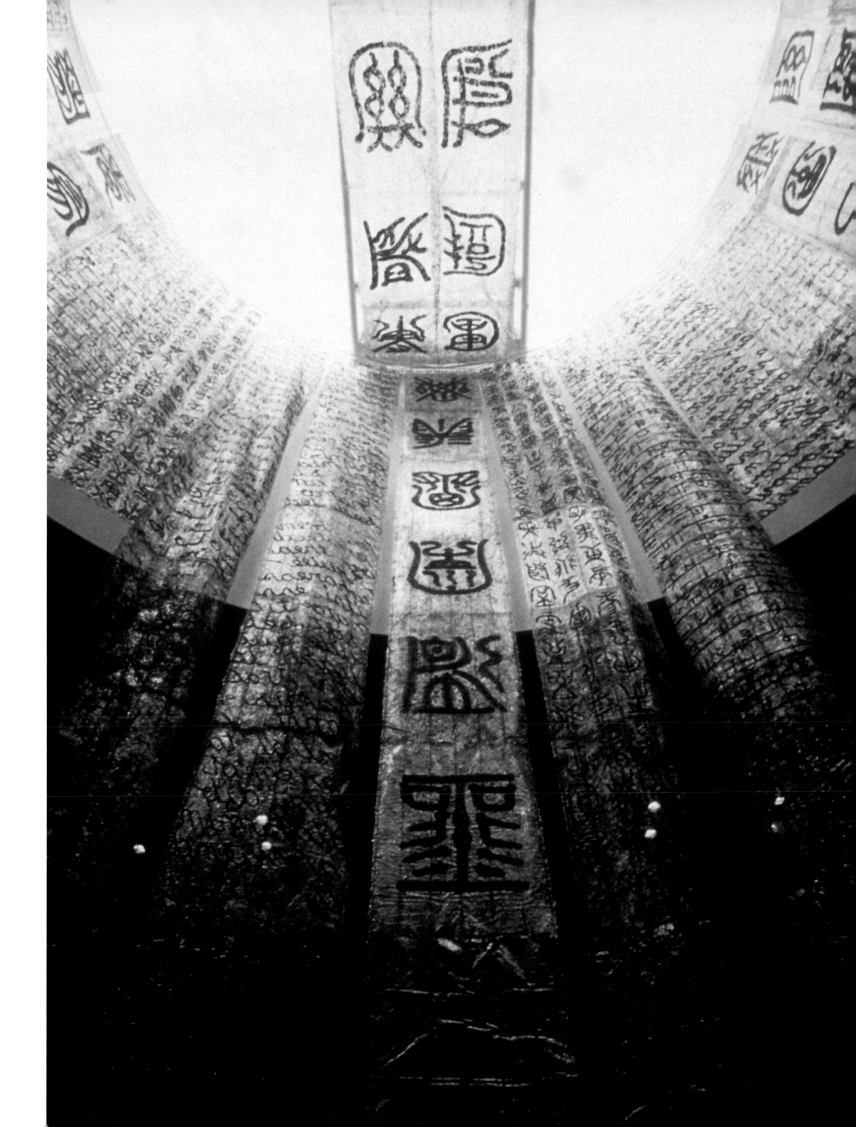

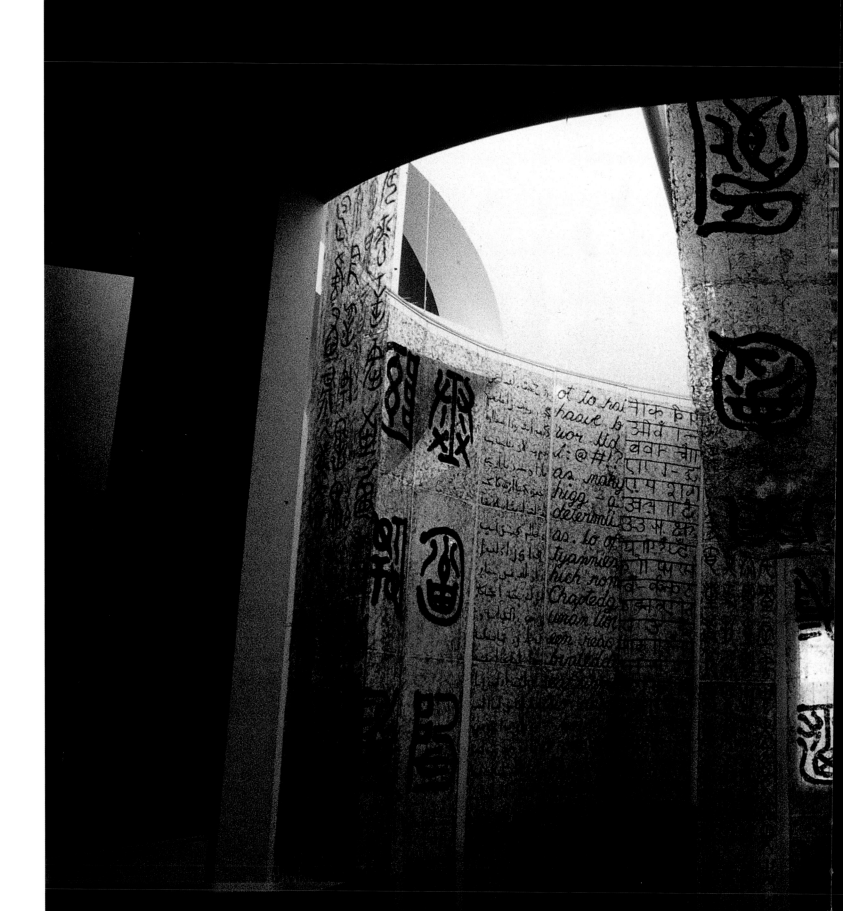

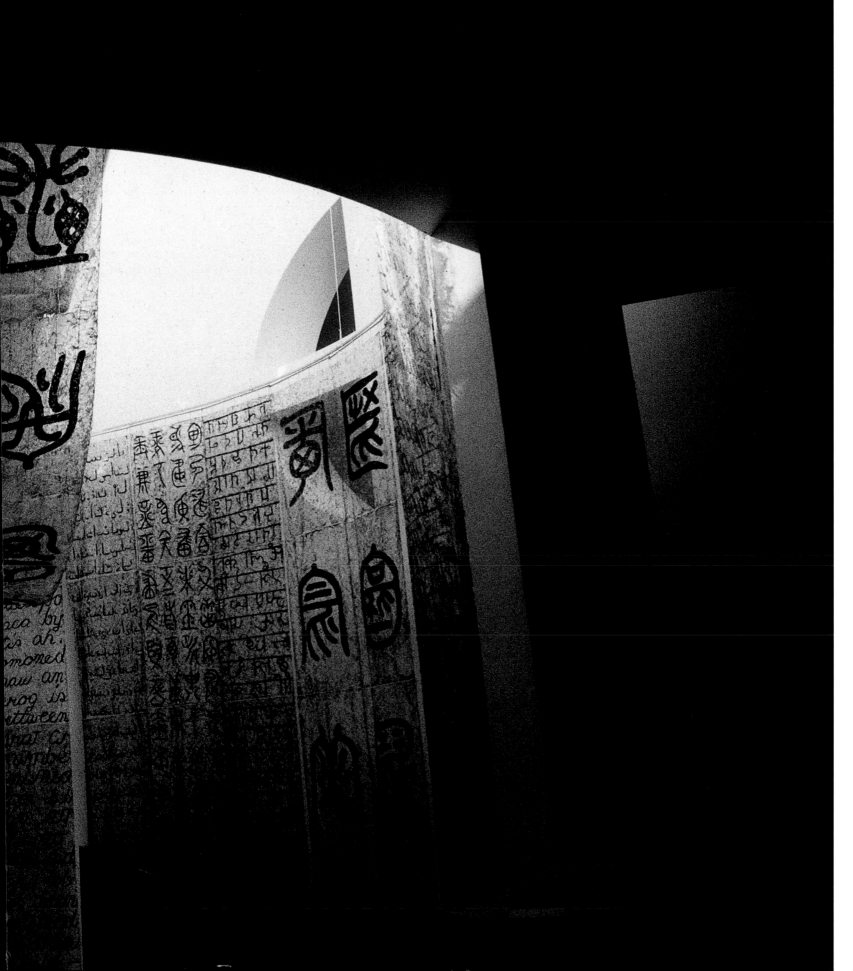

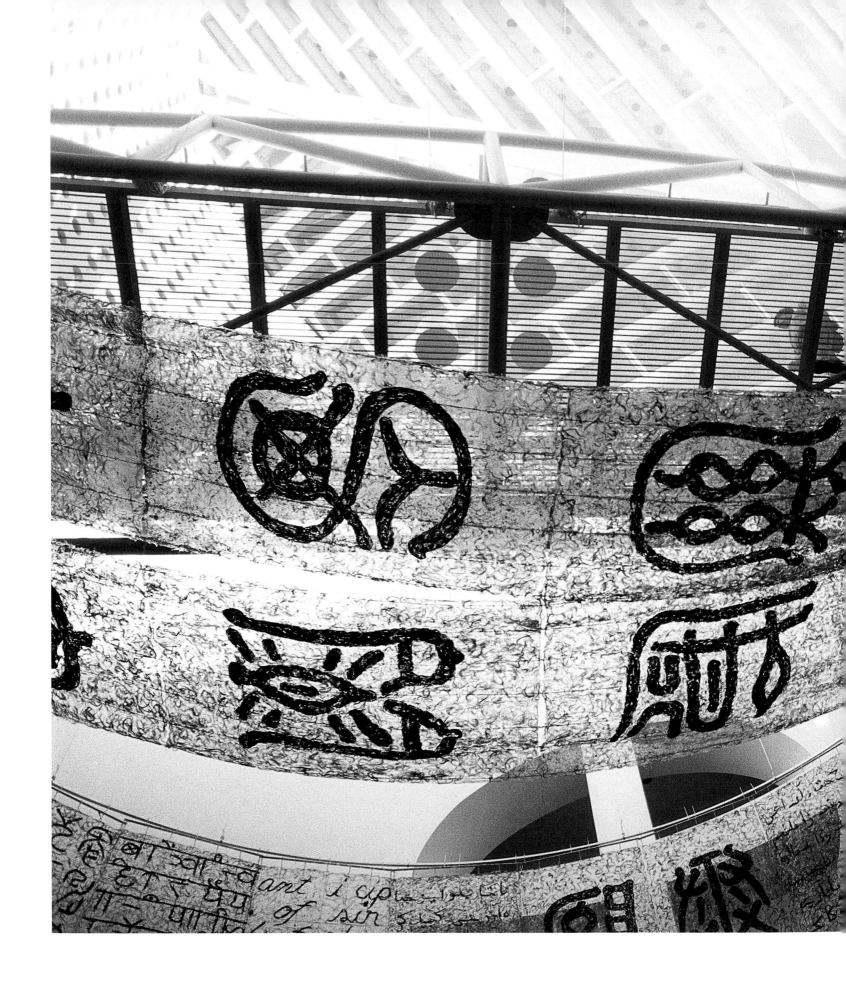

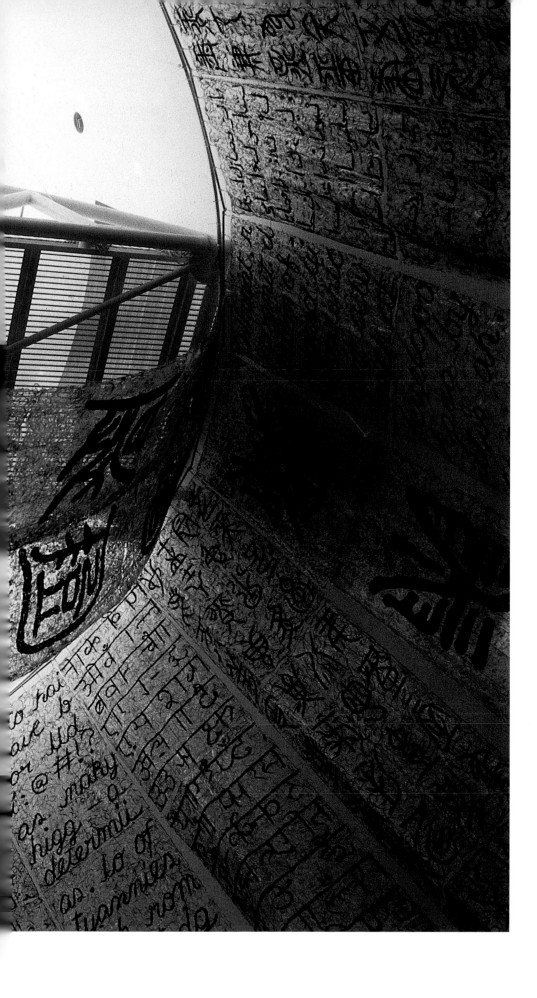

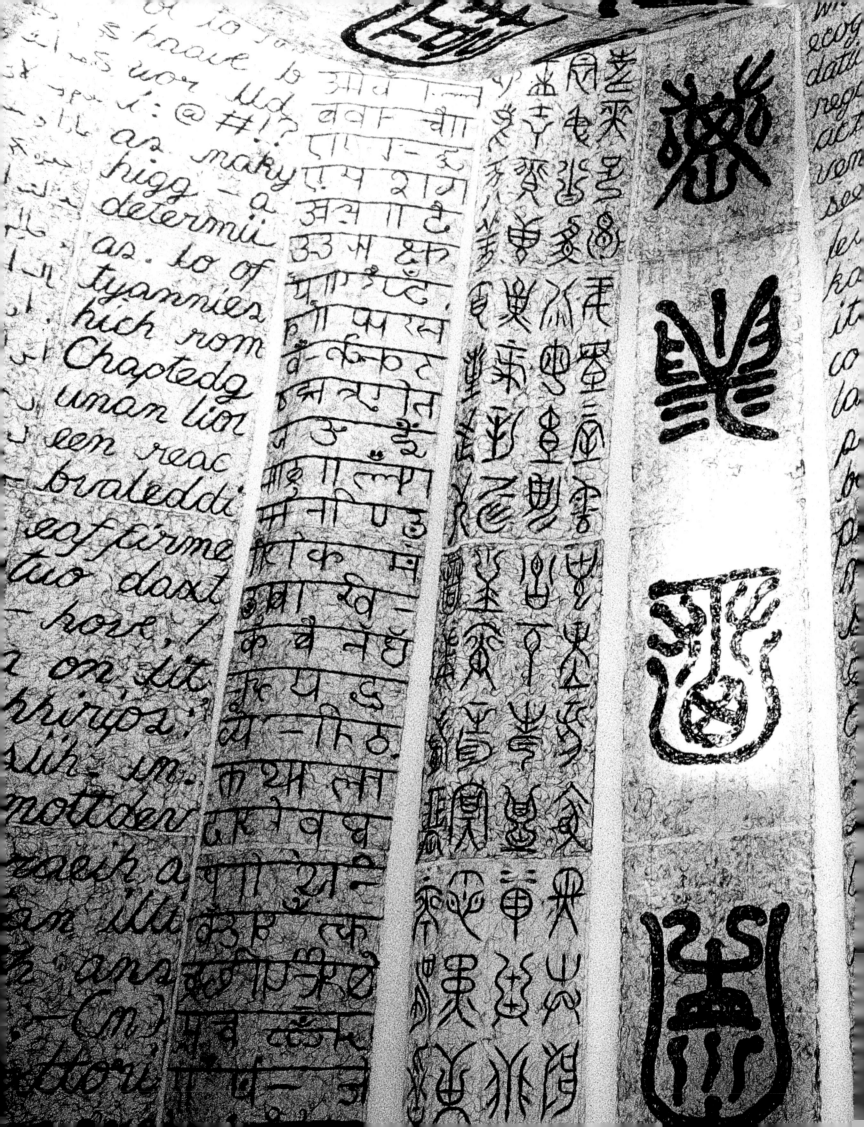

ai
ith
w
at
po
by
nh.
ned
an
is
een
as
nbe
nia
si
an
no
led
tob
been
stecd
thea
tée —

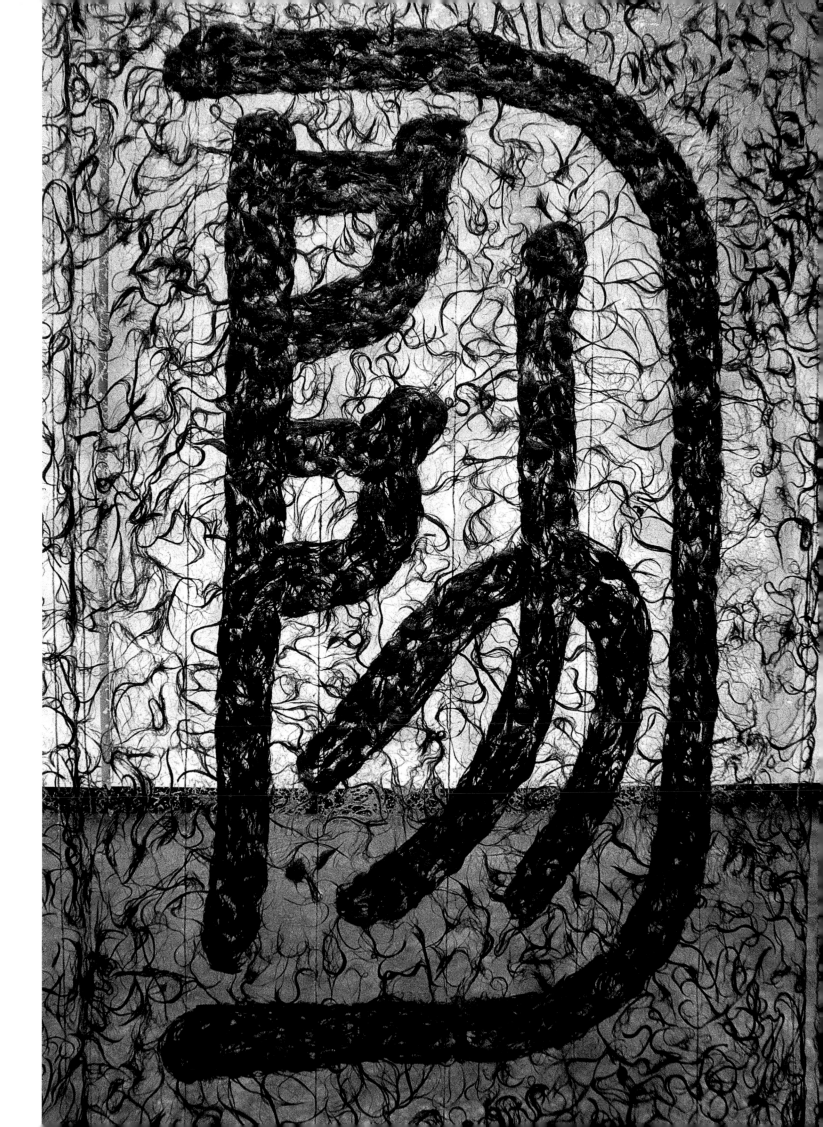

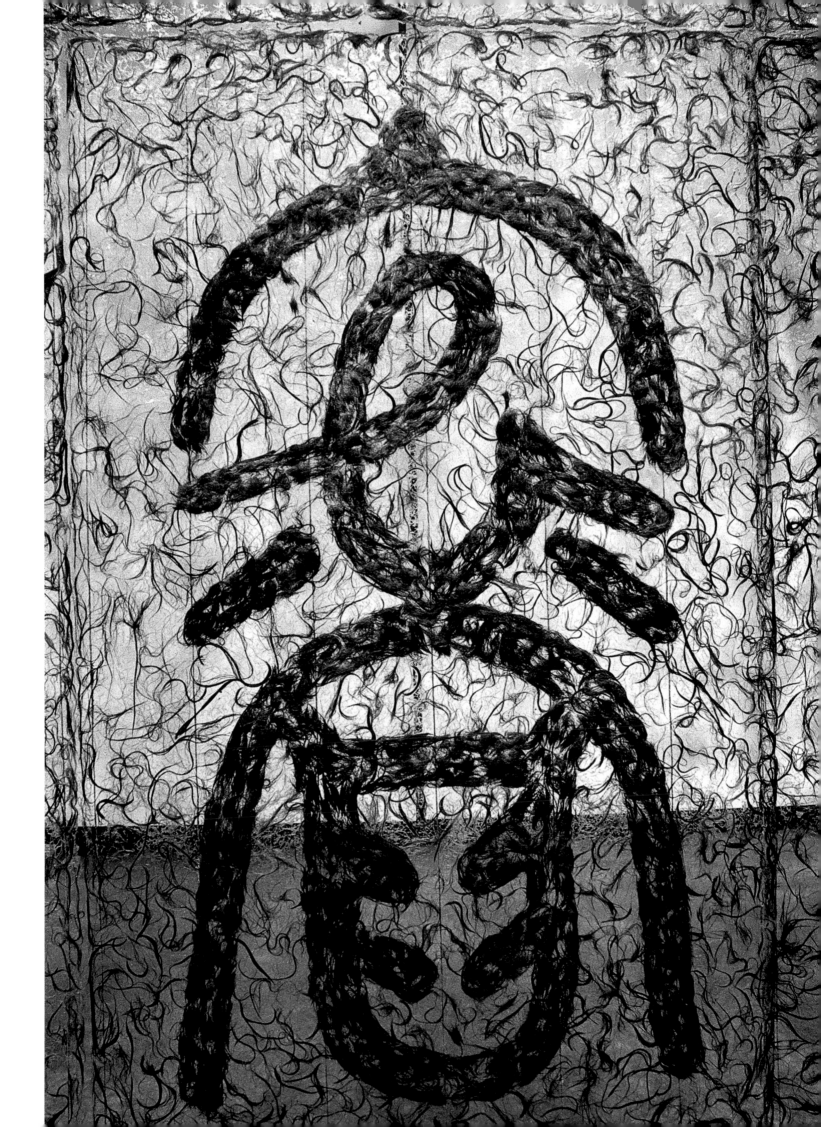

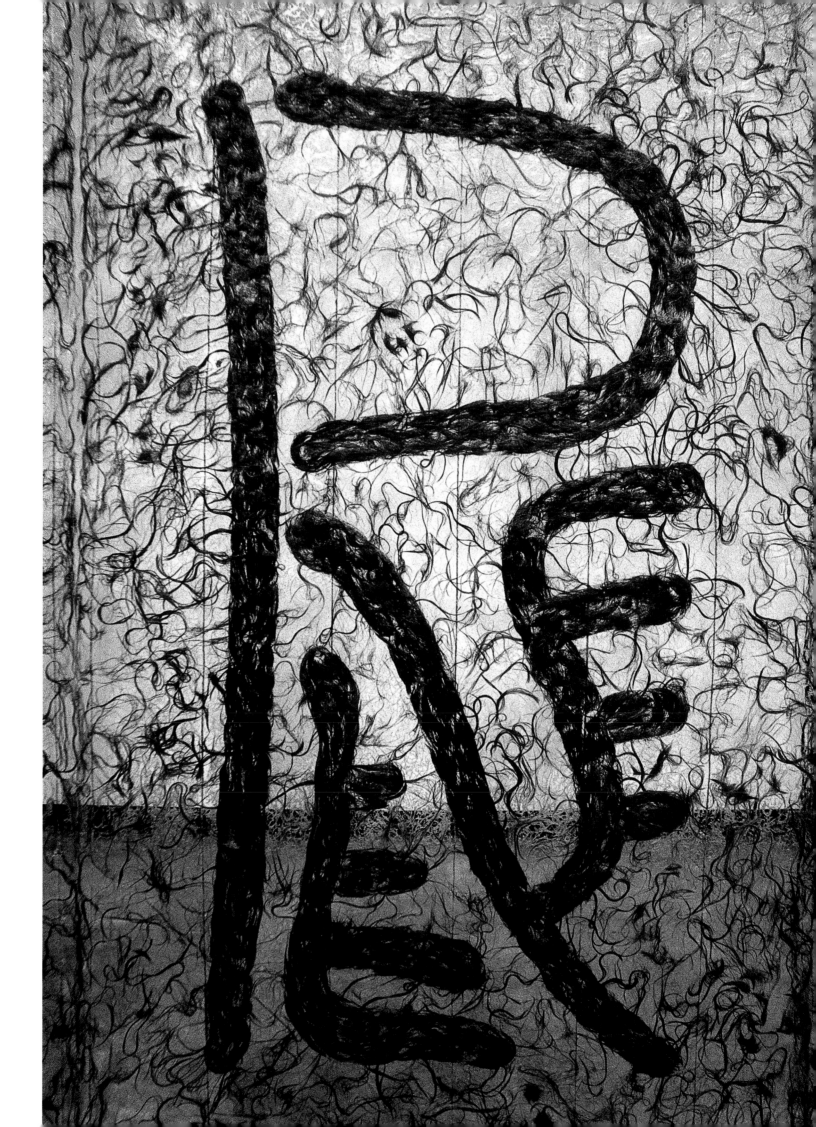

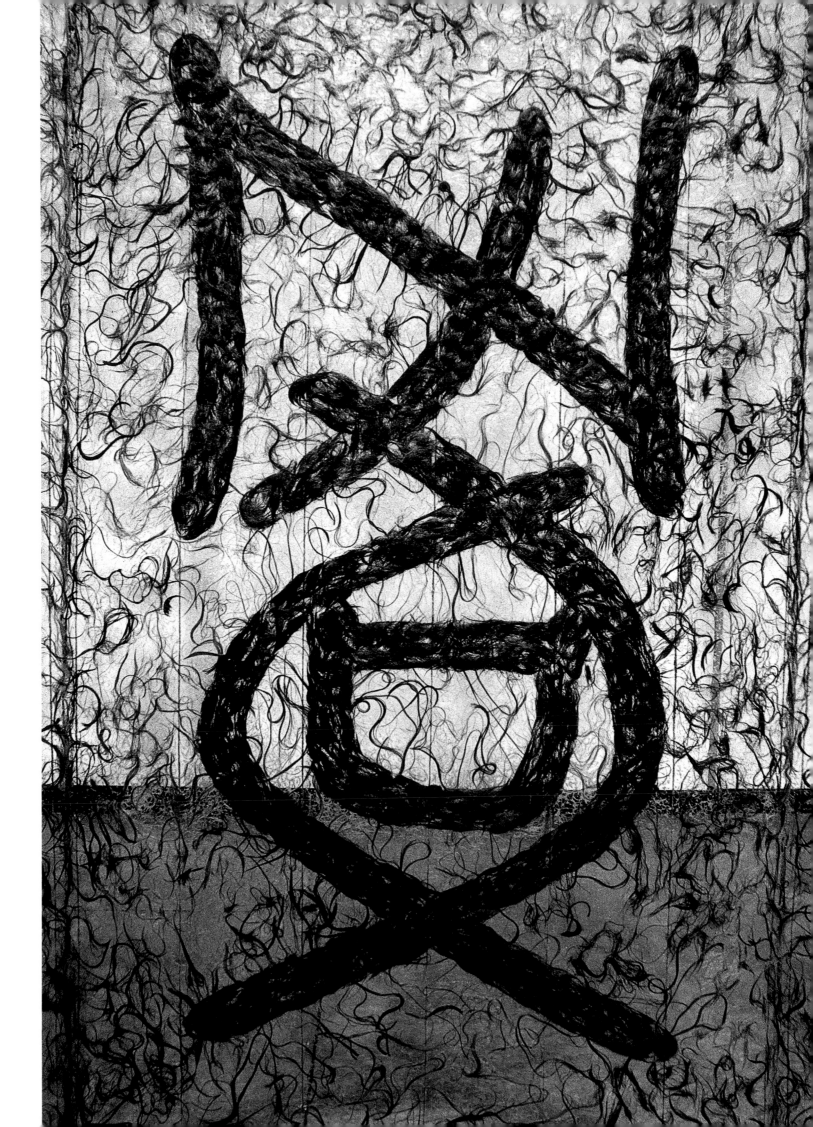

{*china monument: temple of heaven*, New York 1998}

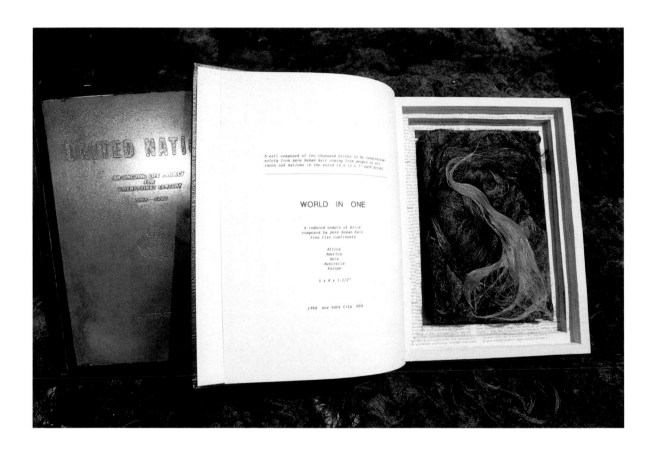

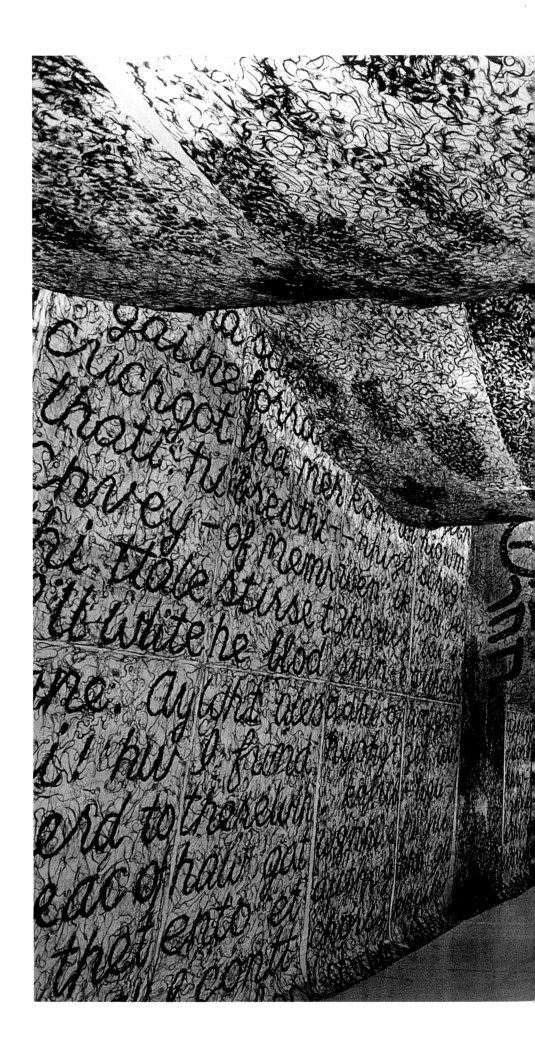

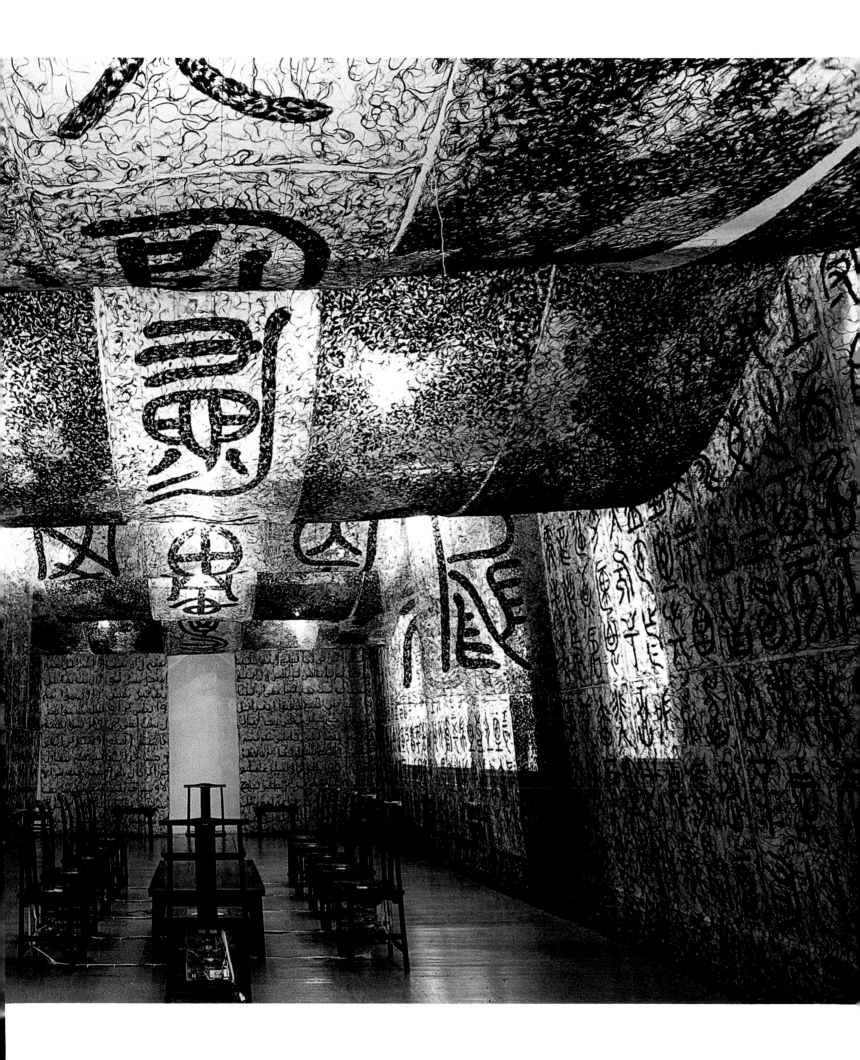

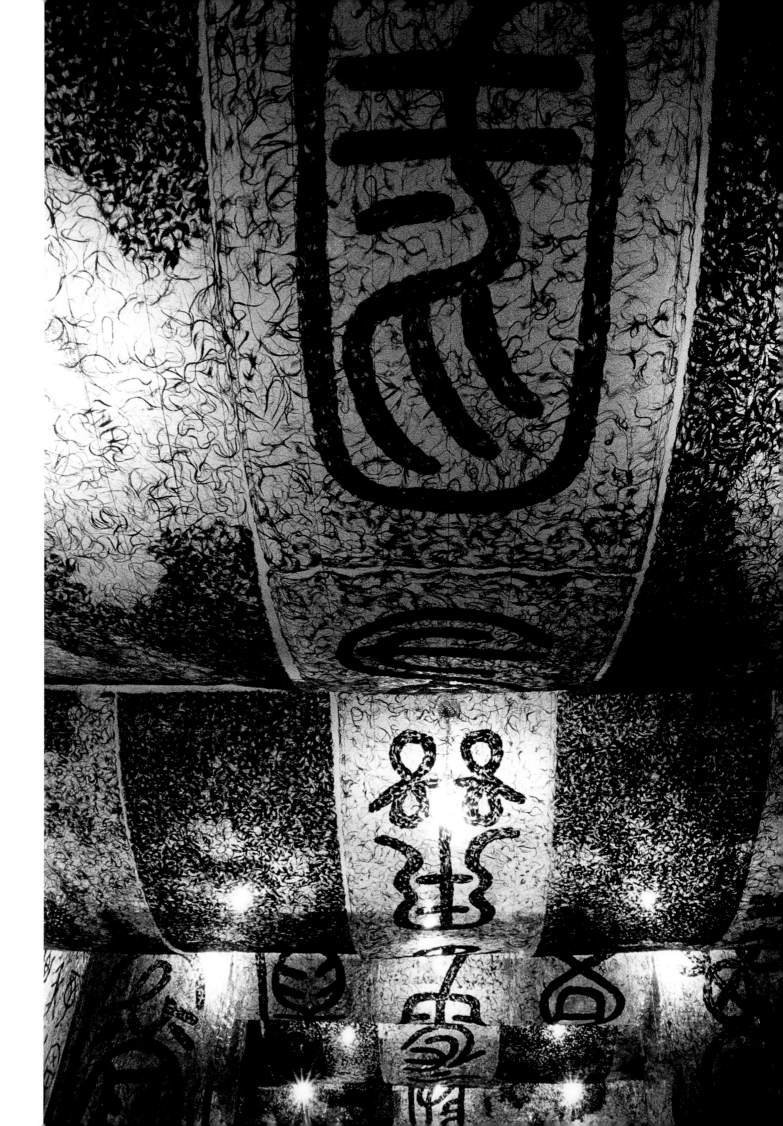

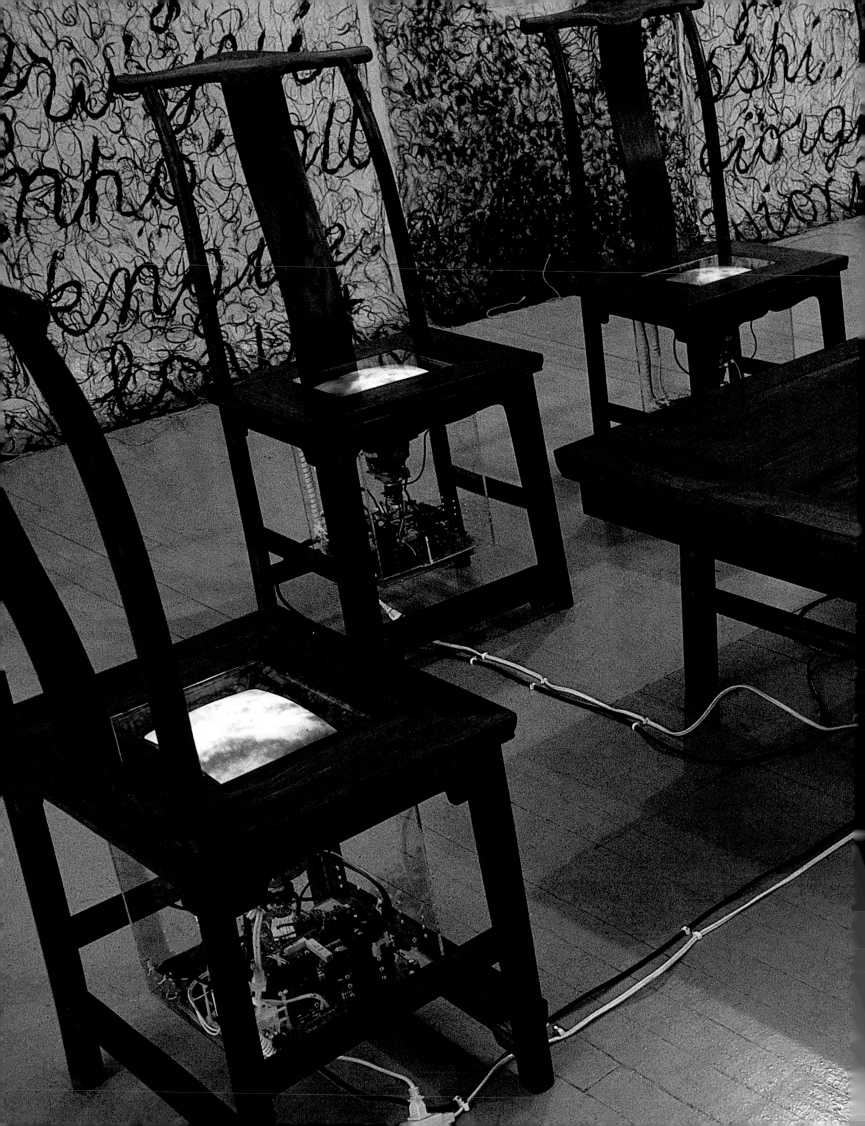

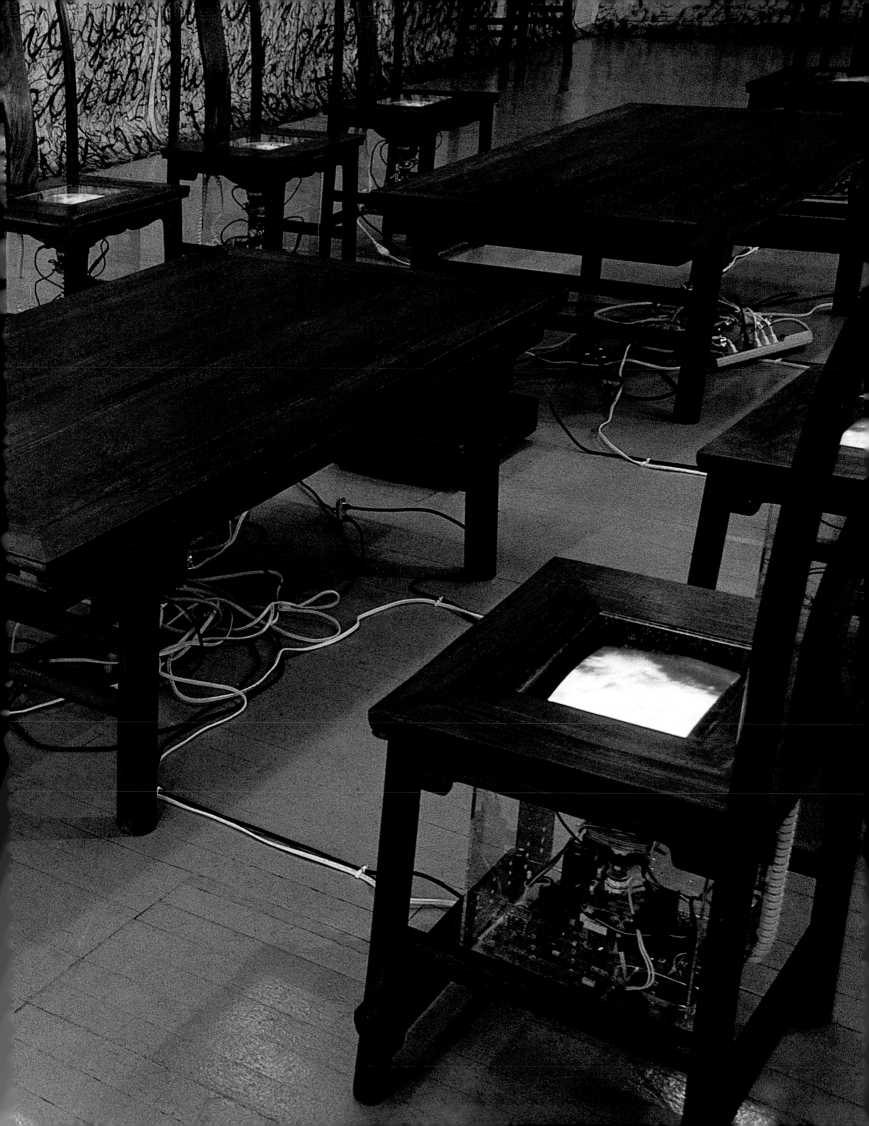

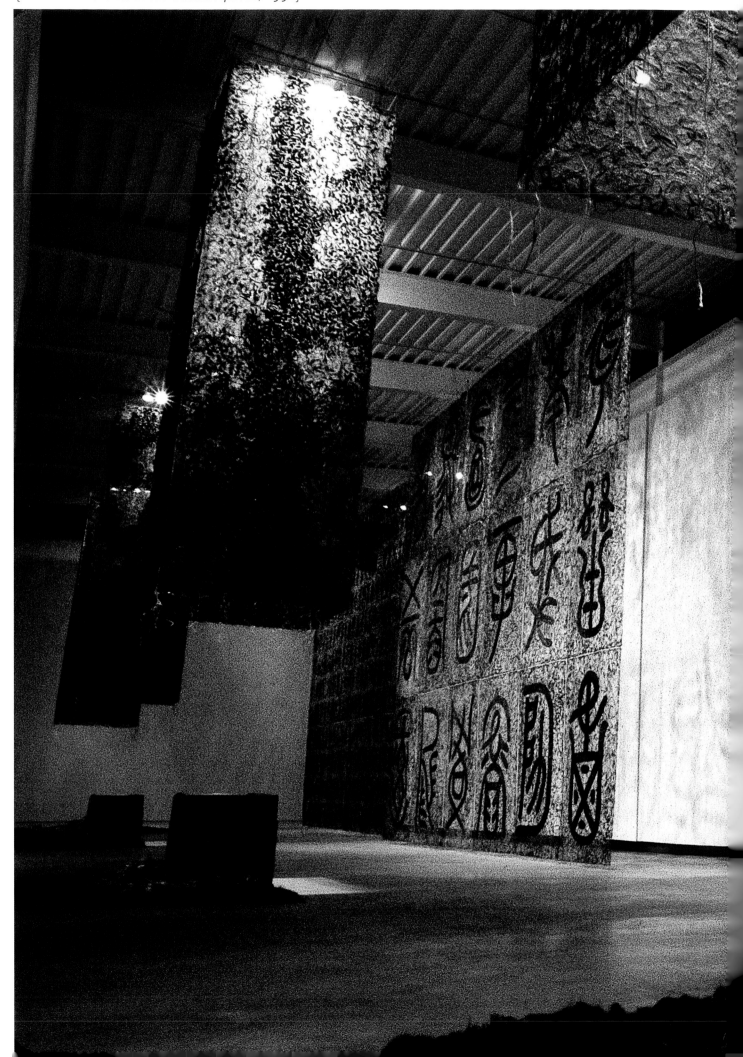

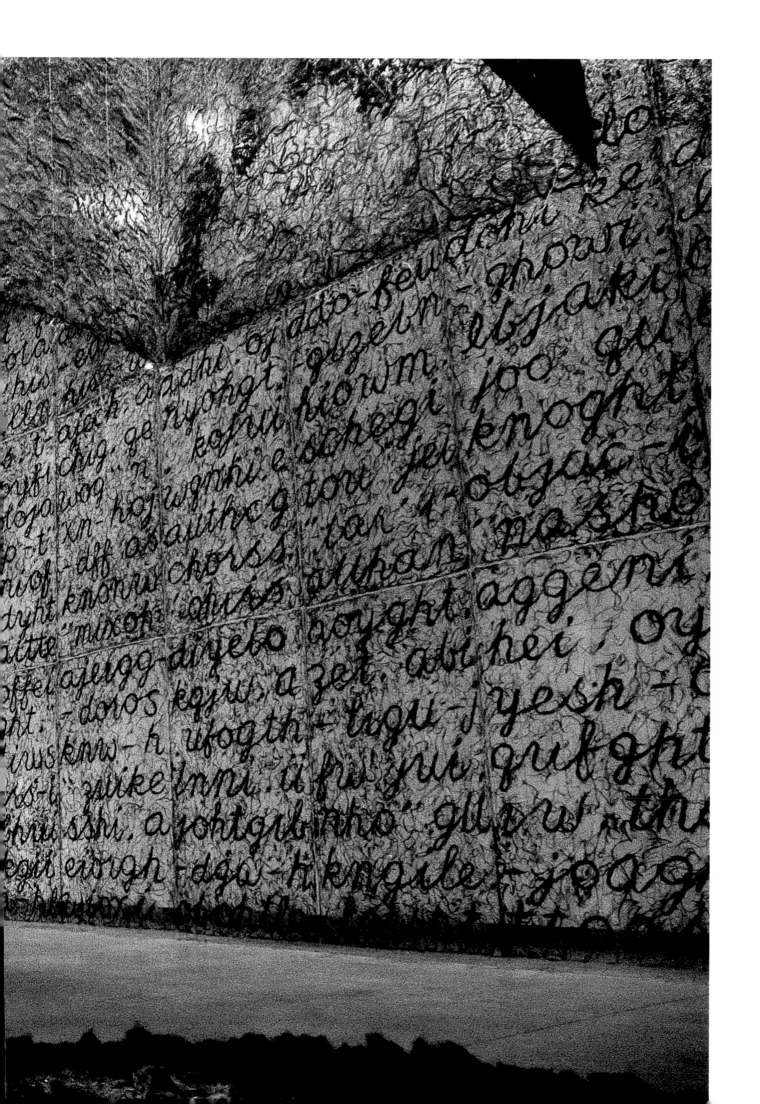

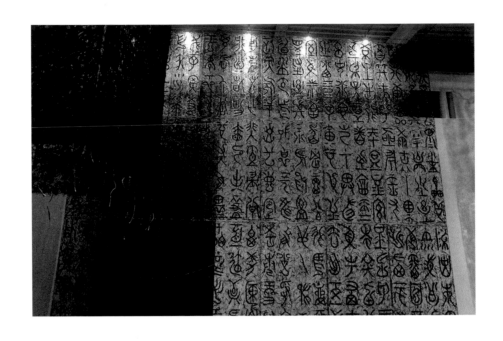

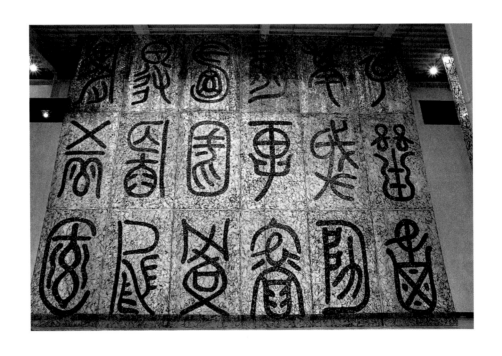

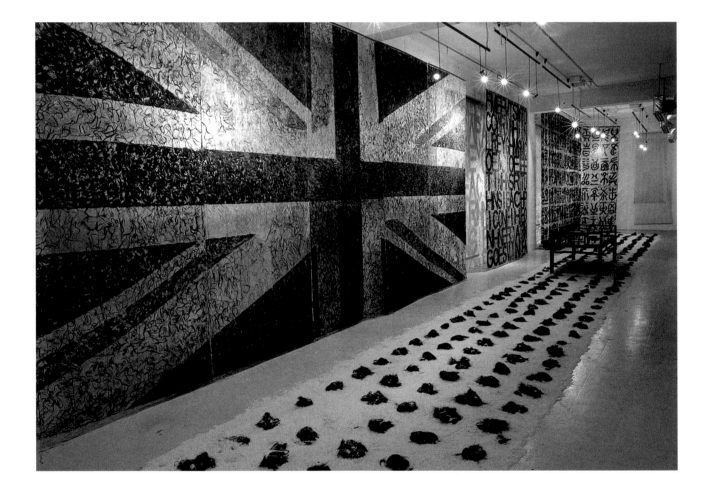

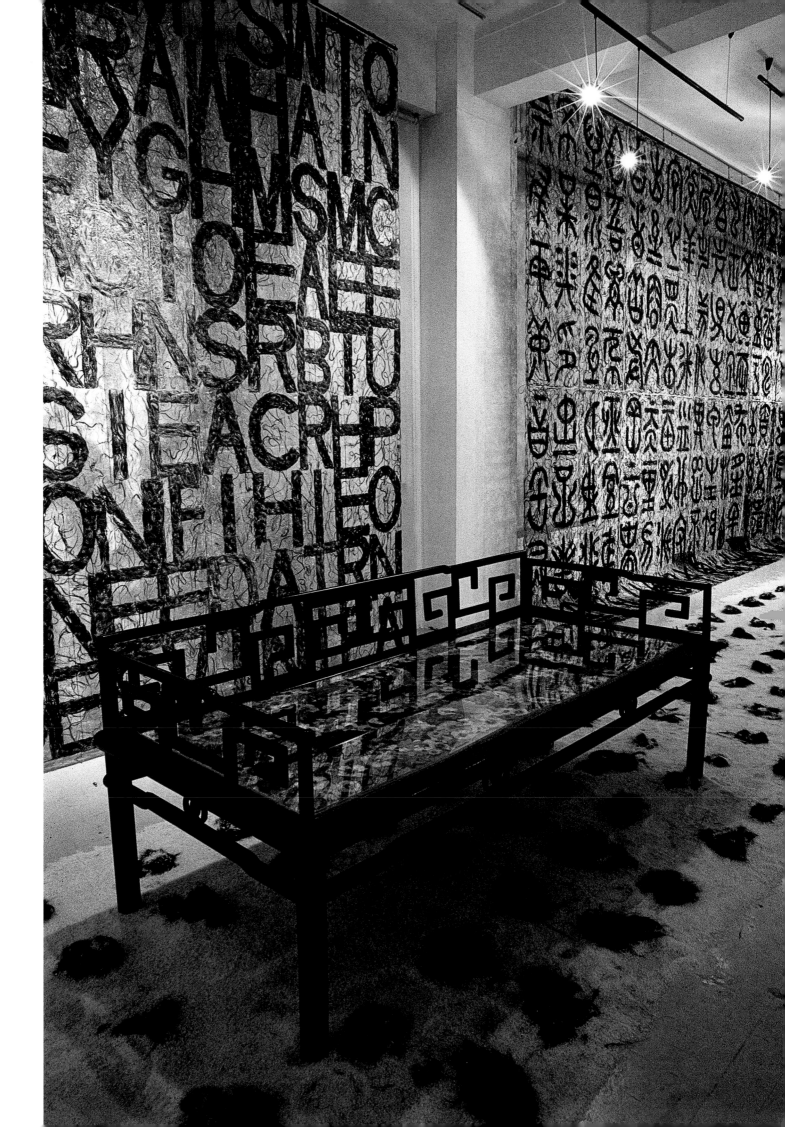

{*africa monument: the world praying wall, 1997*}

{*africa monument: the world praying wall, 1997*}

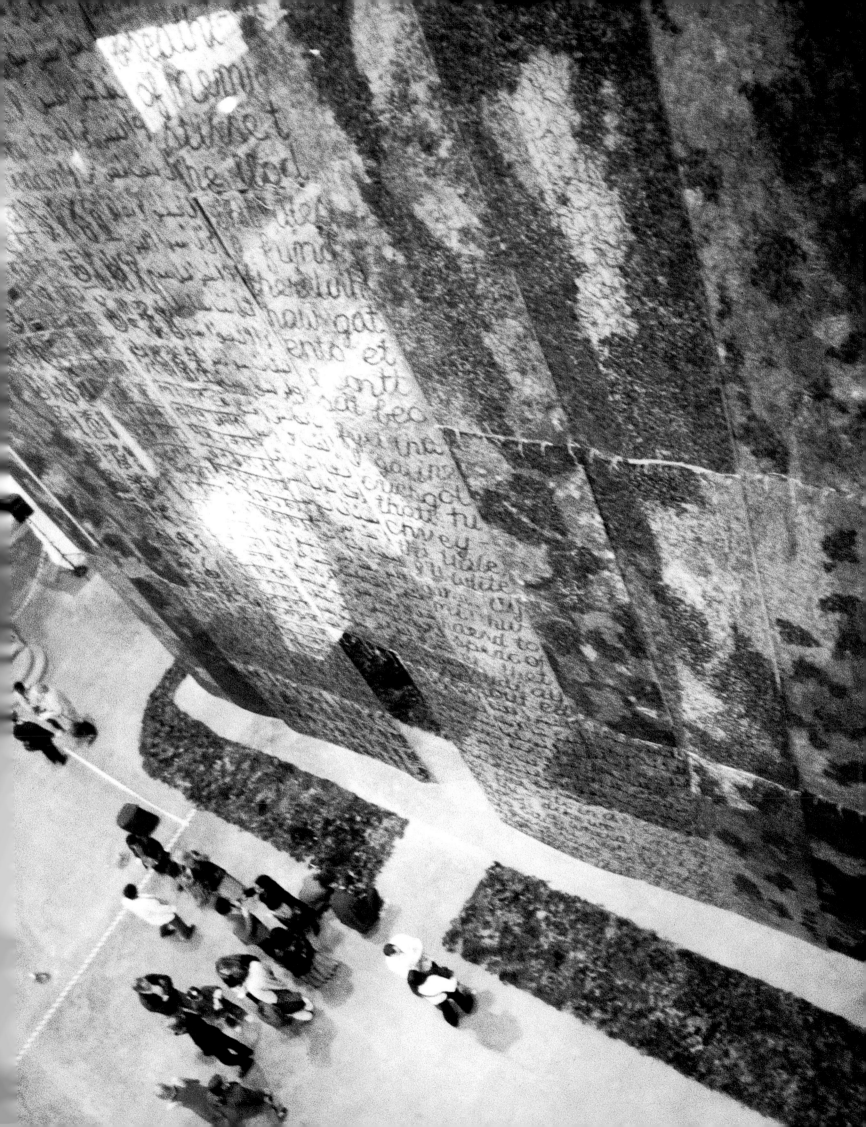

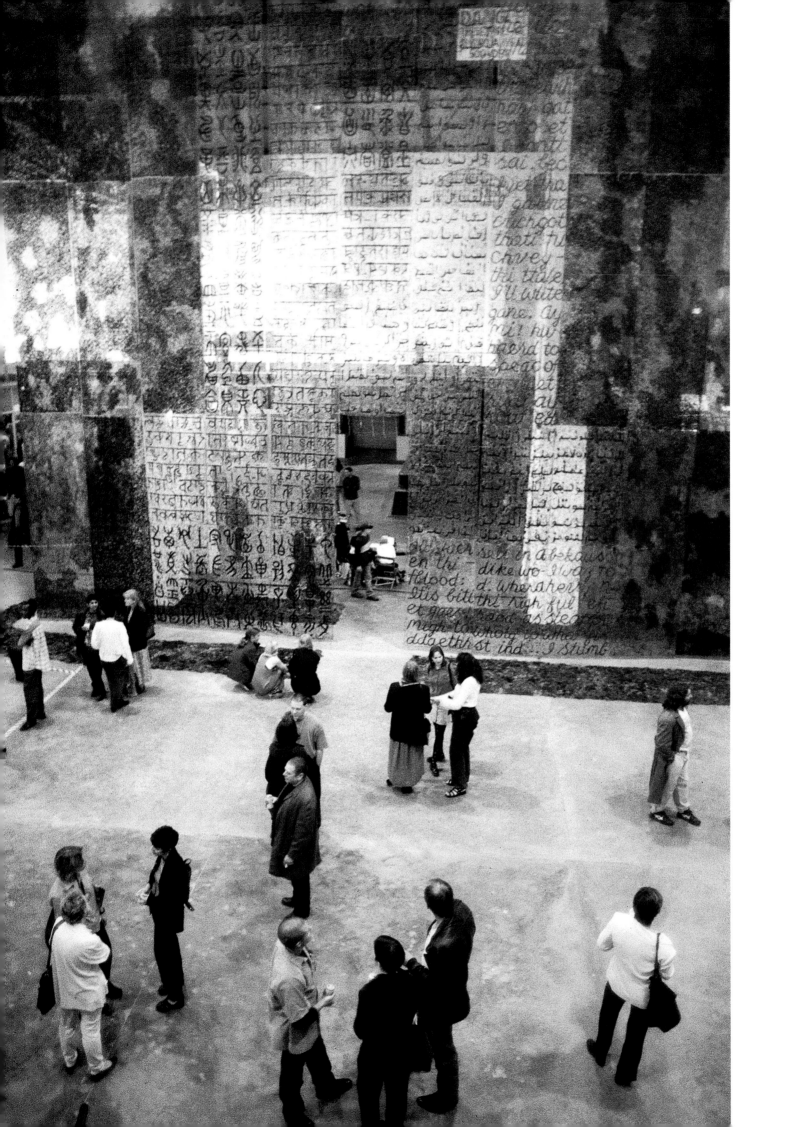

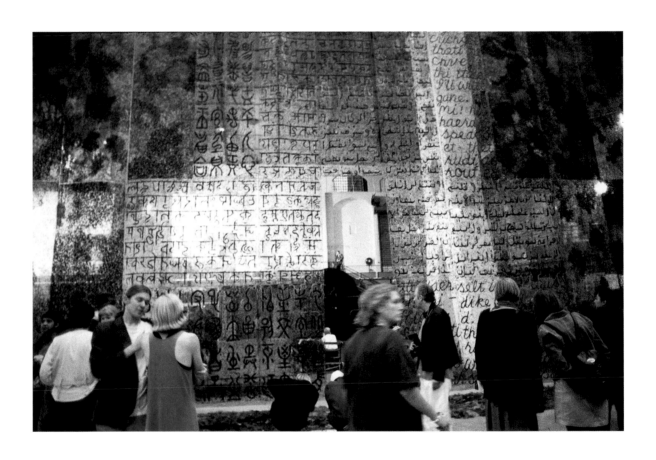

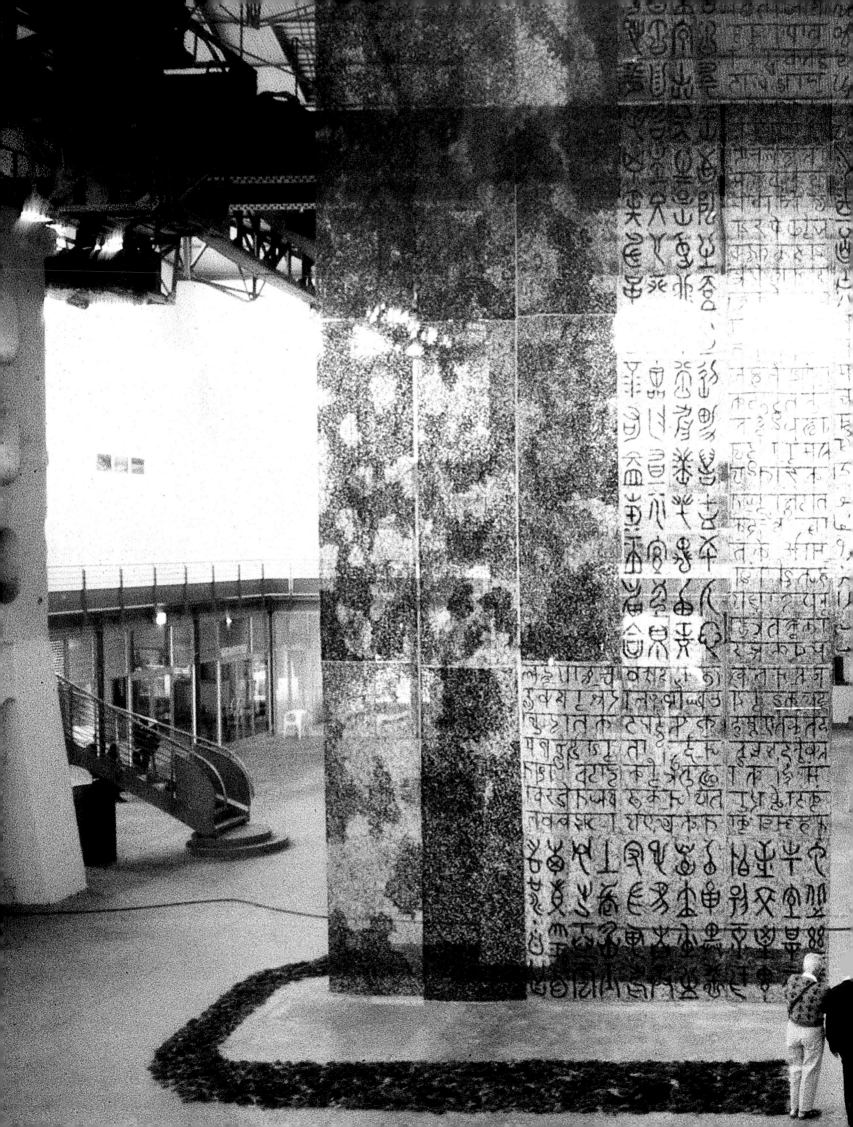

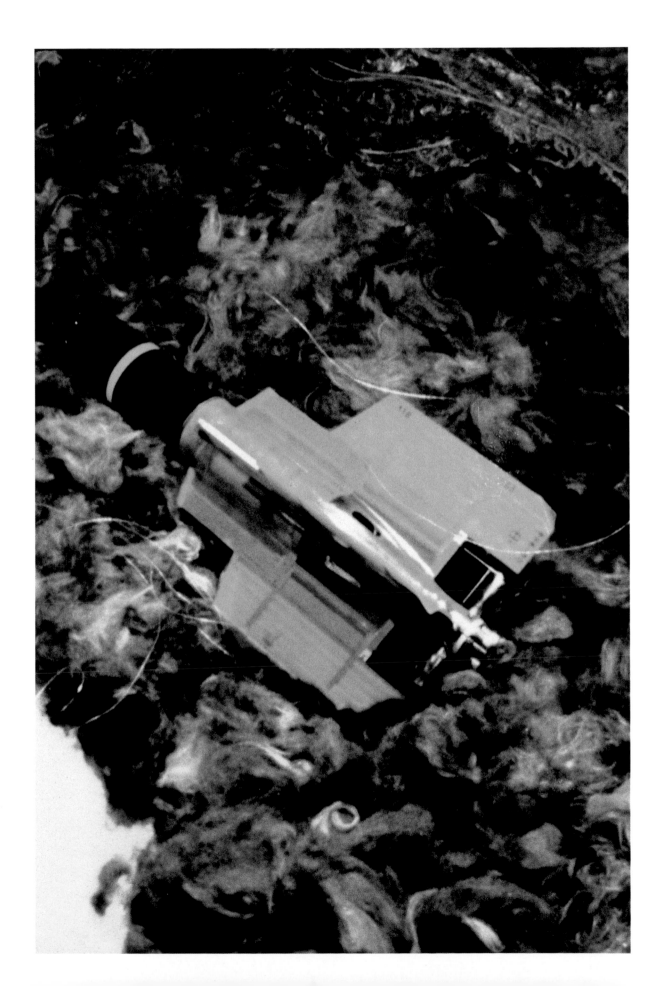

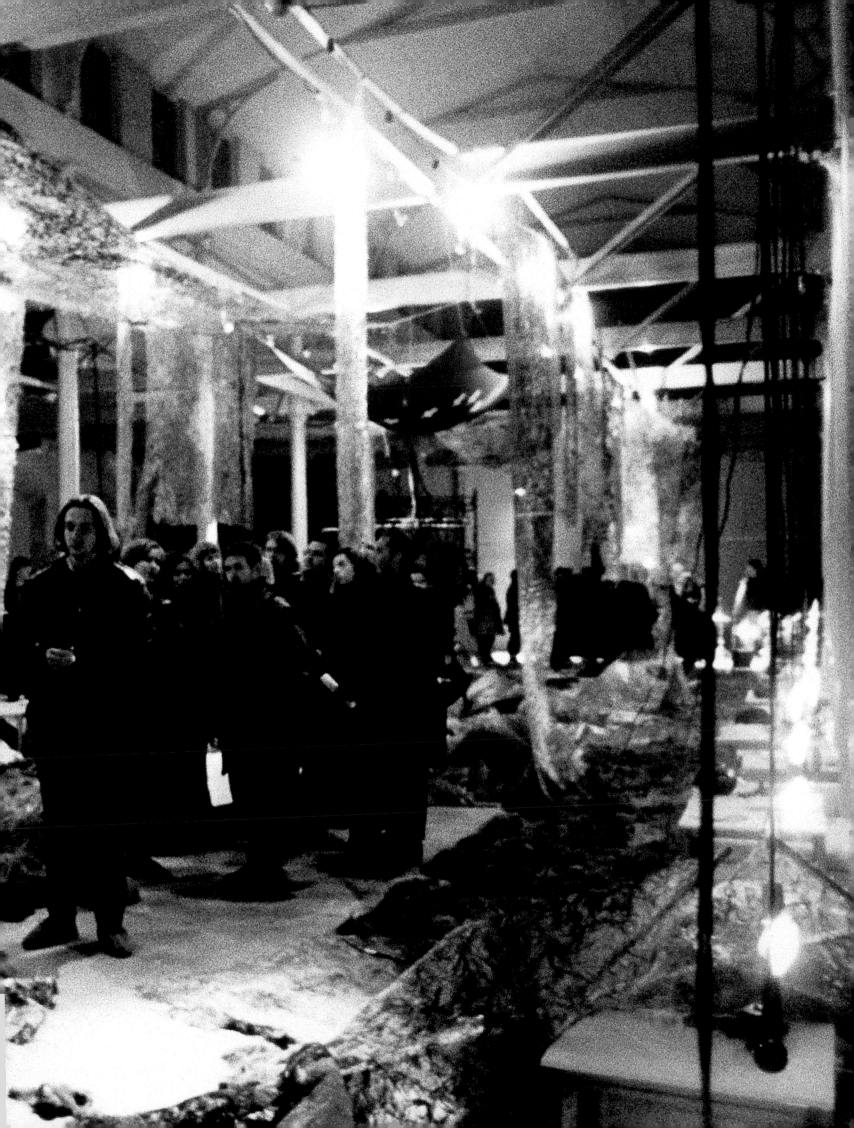

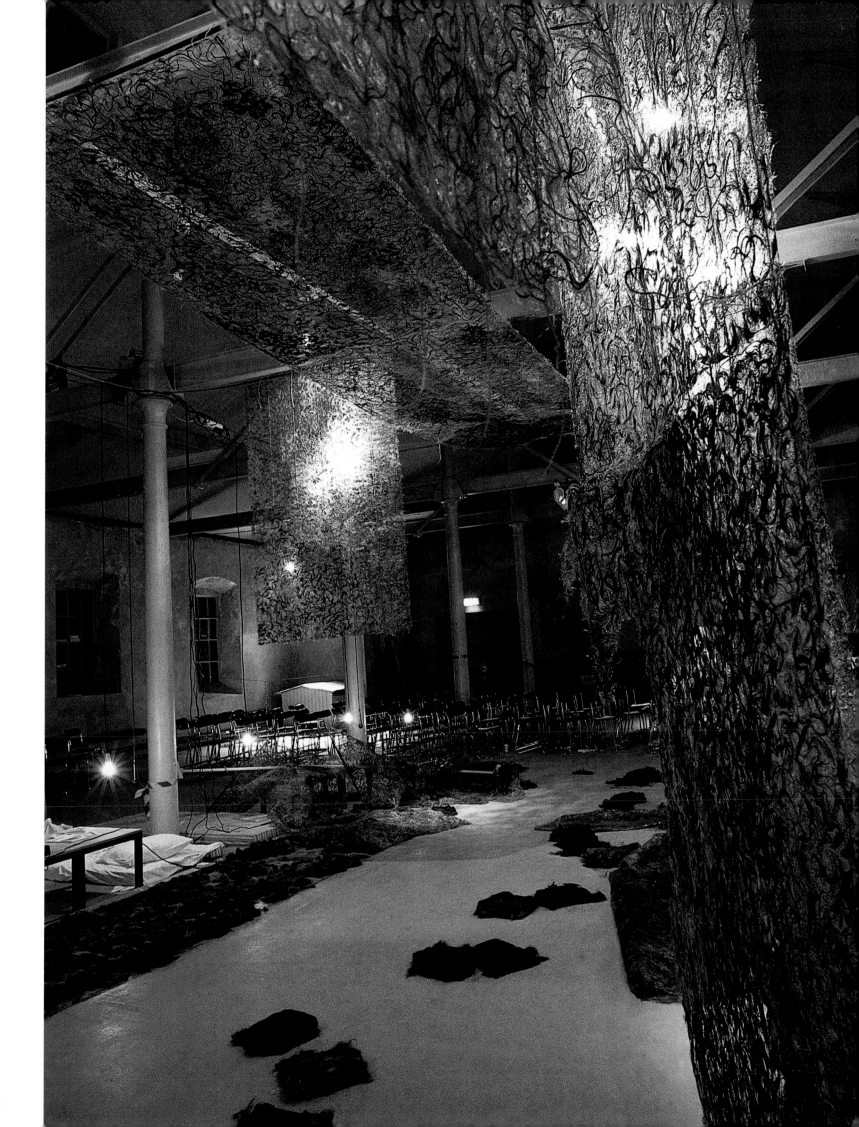

{britain monument: the maze, 1996}

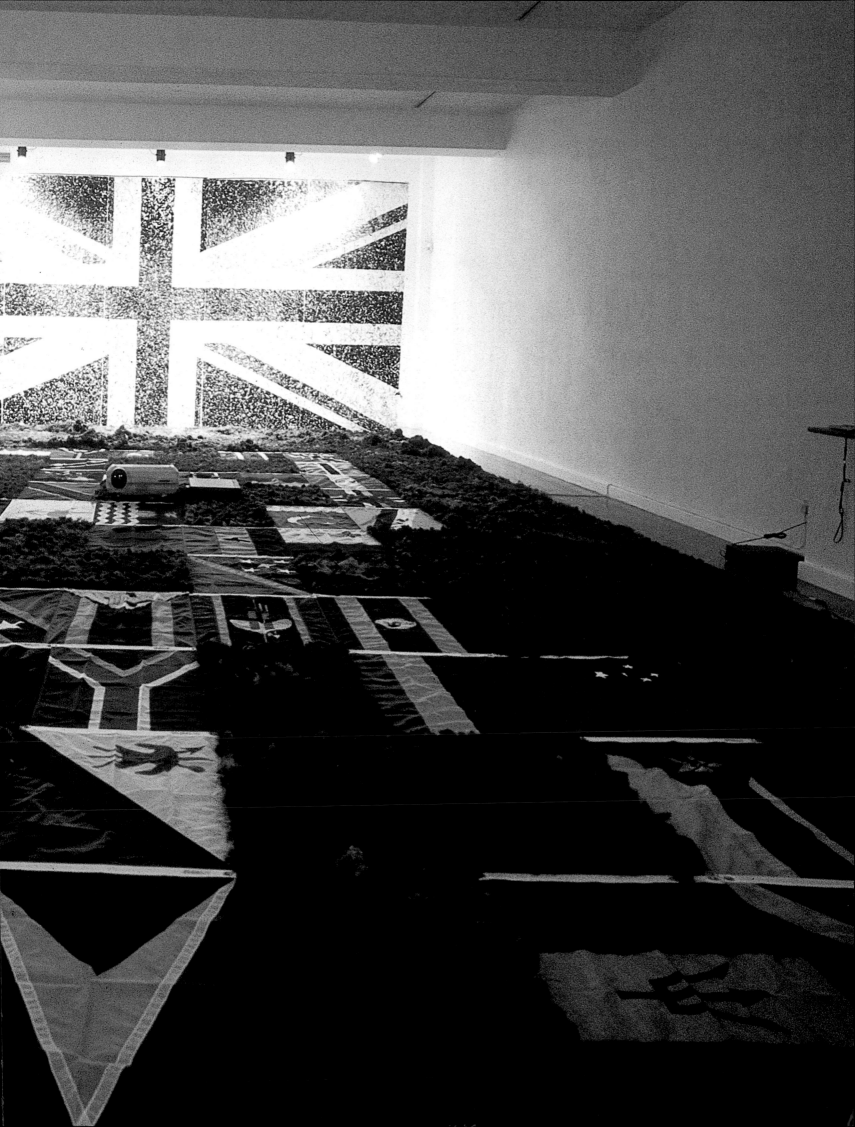

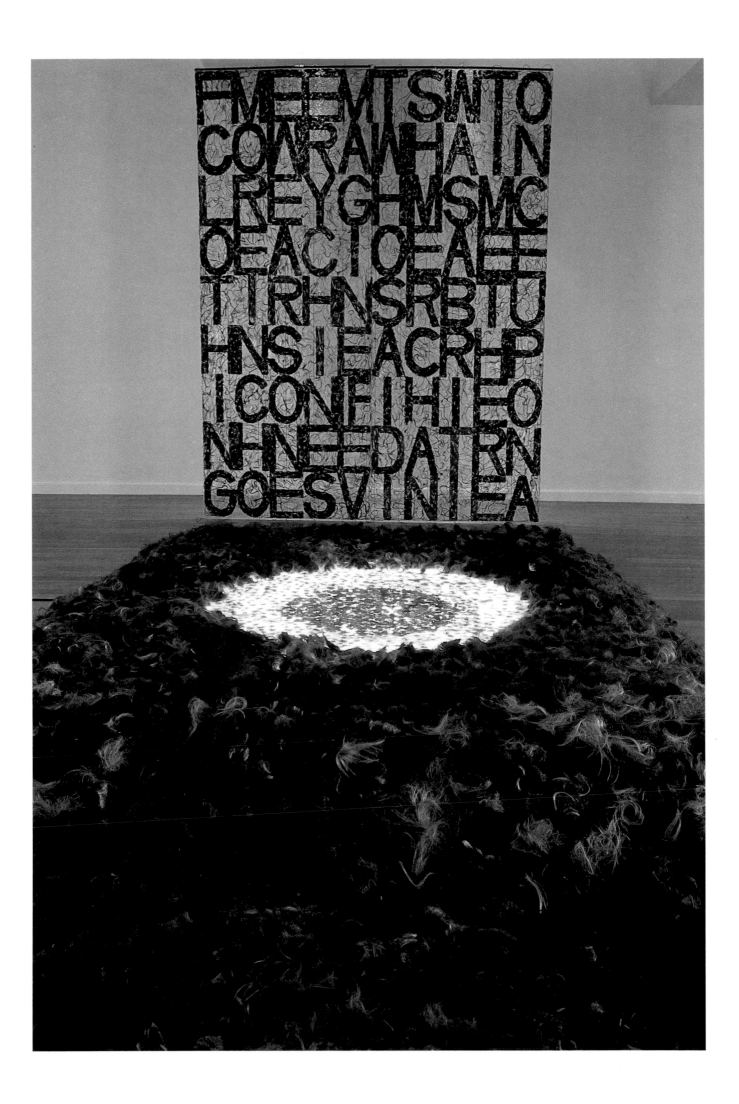

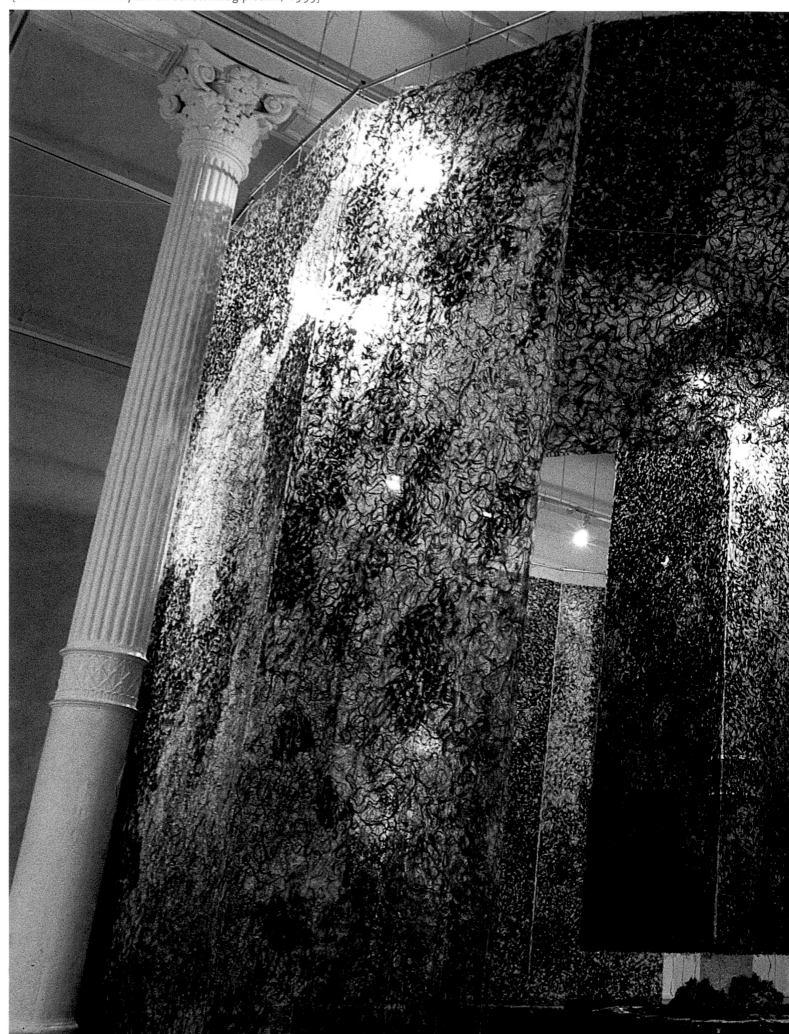

{usa monument #1: post-cmoellotniinaglpiostm, 1995}

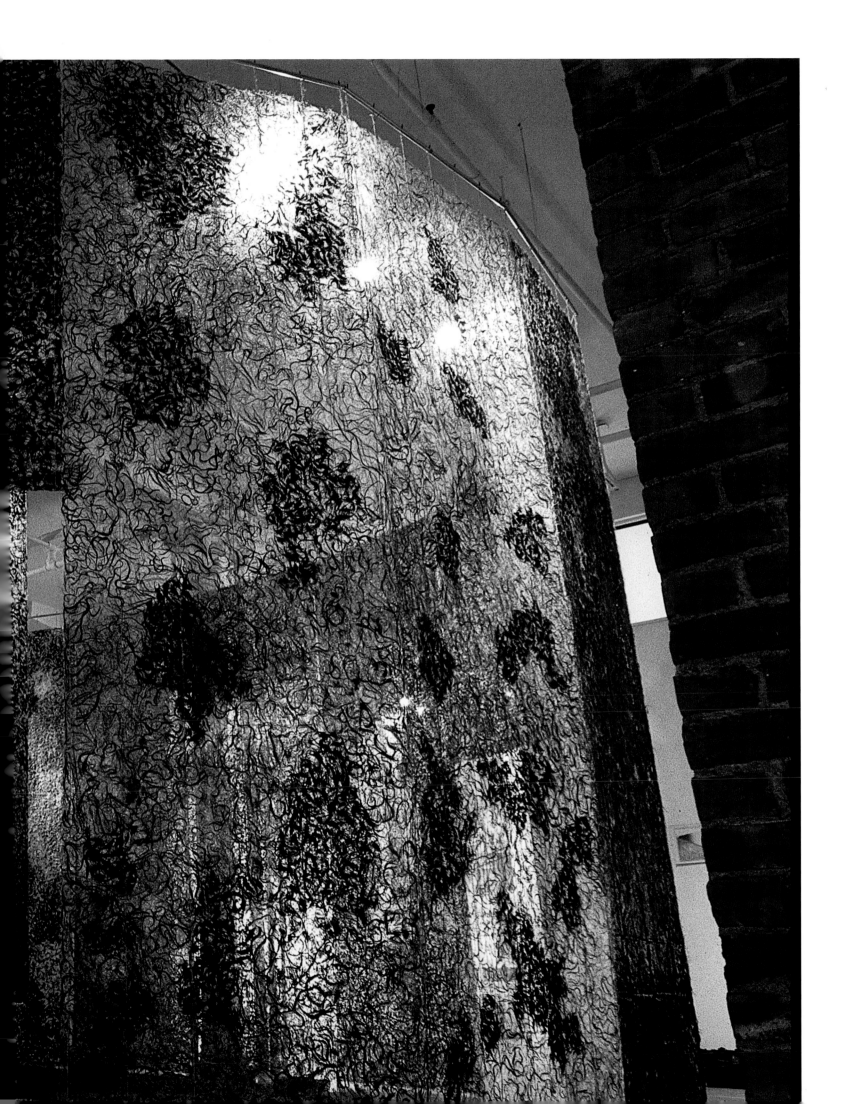

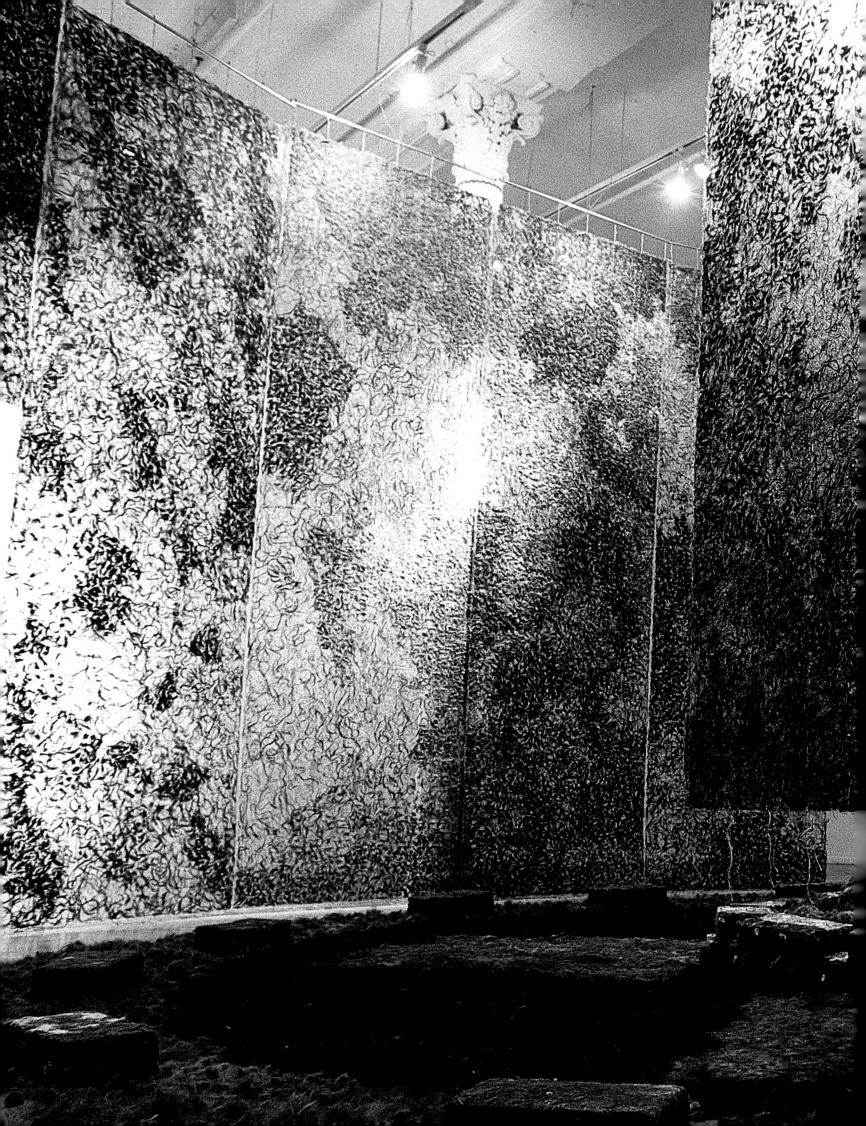

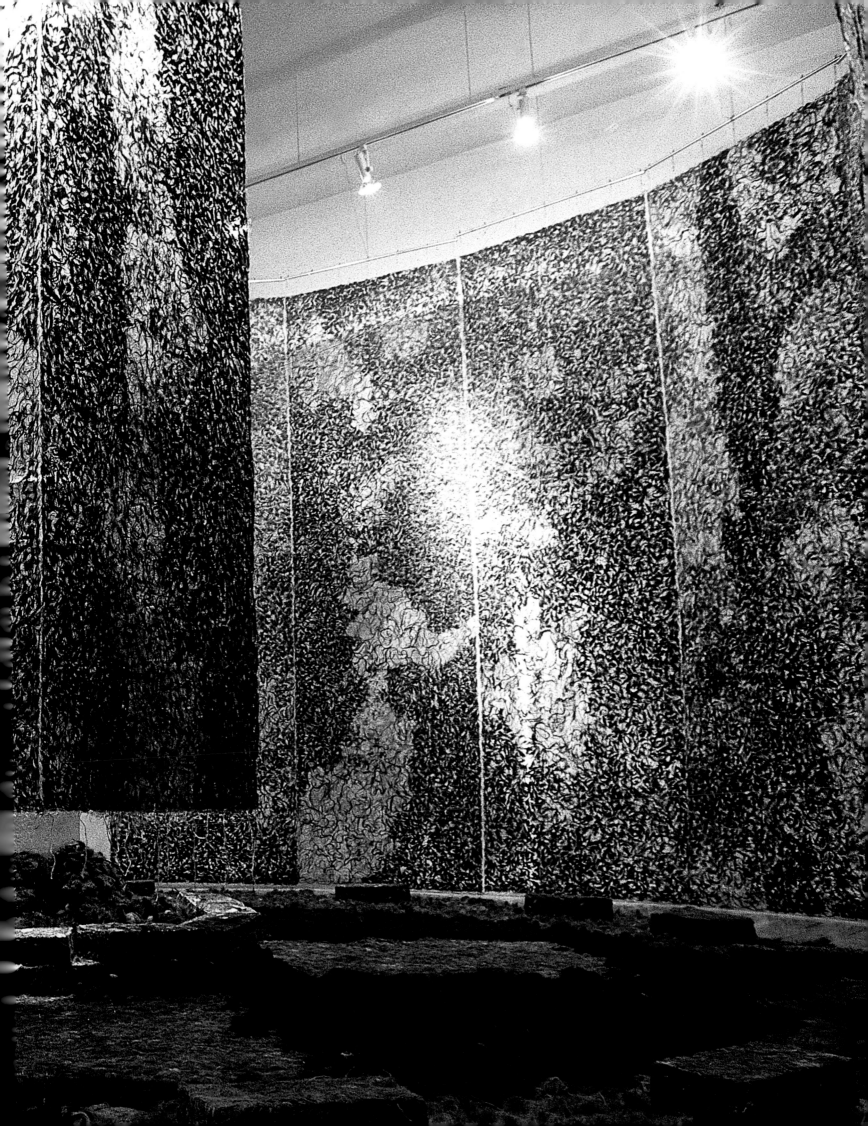

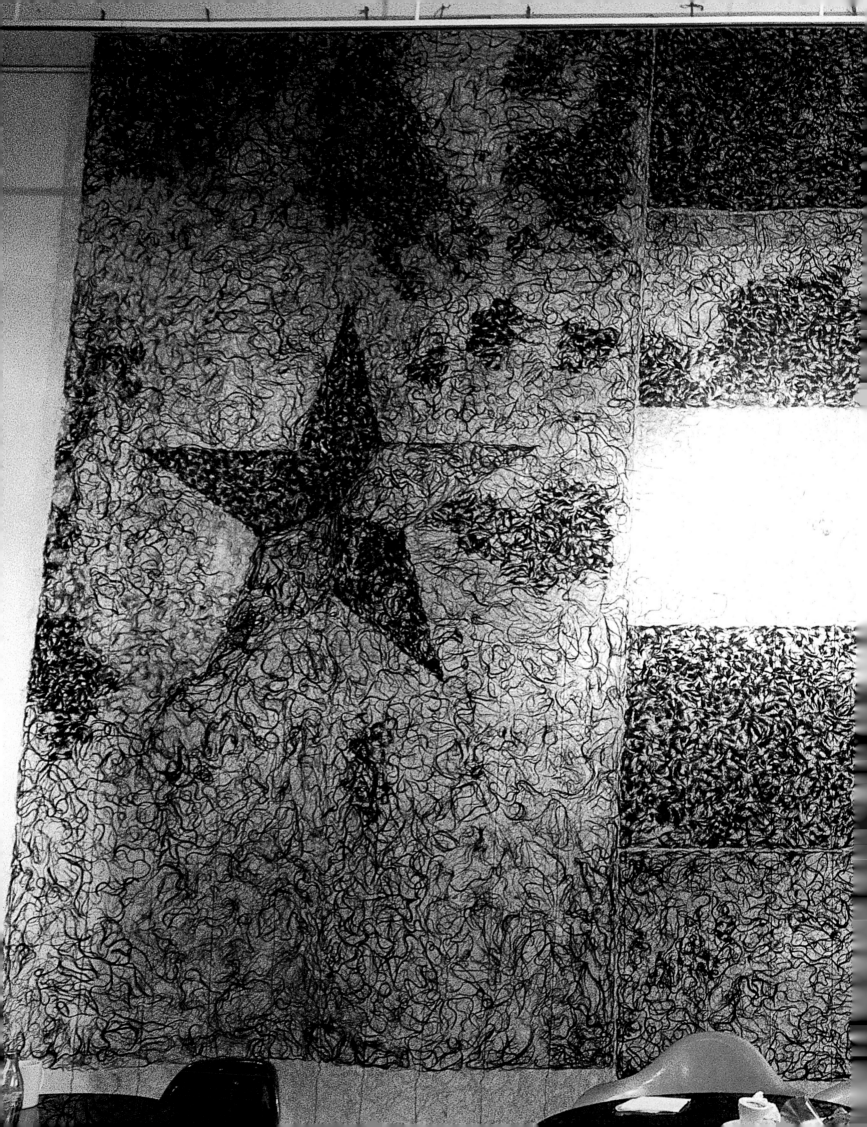

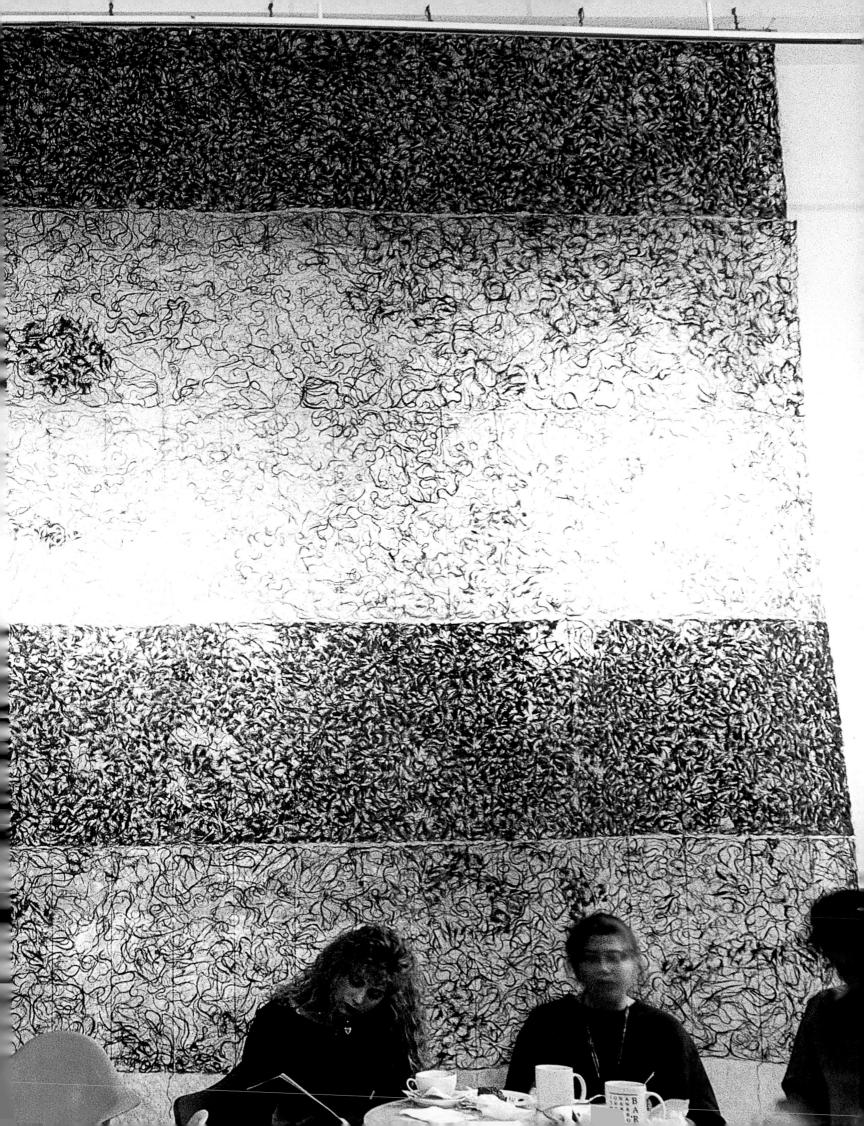

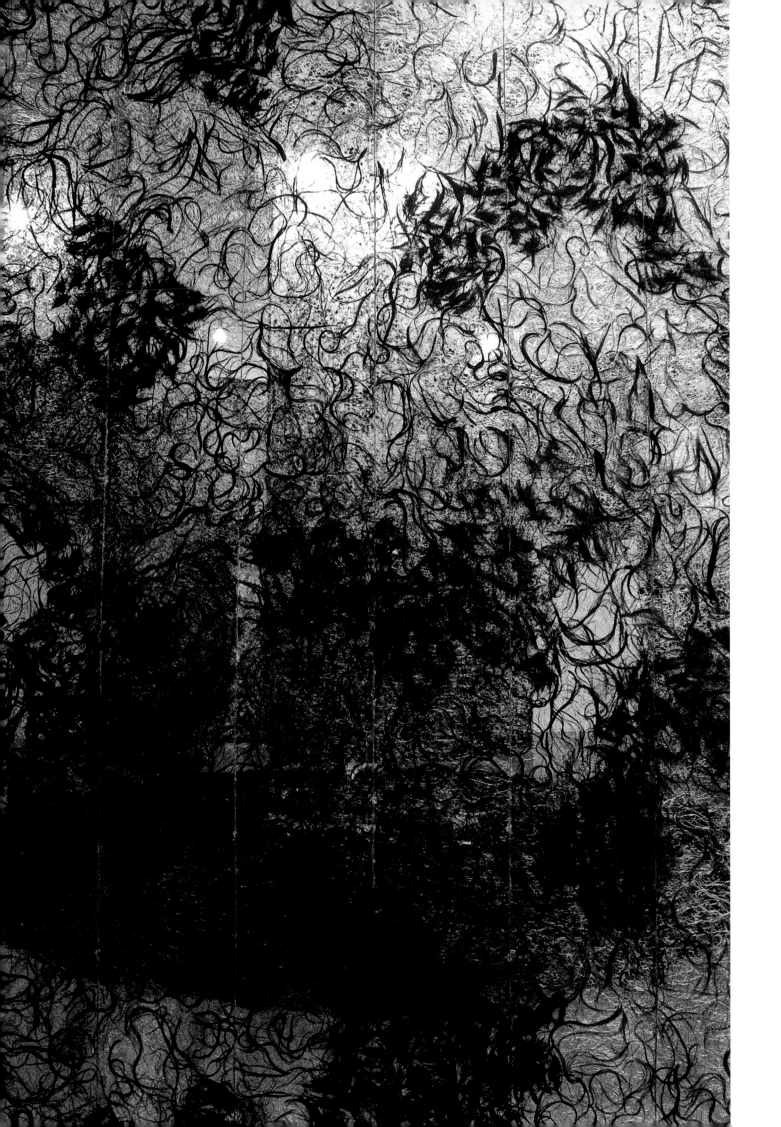

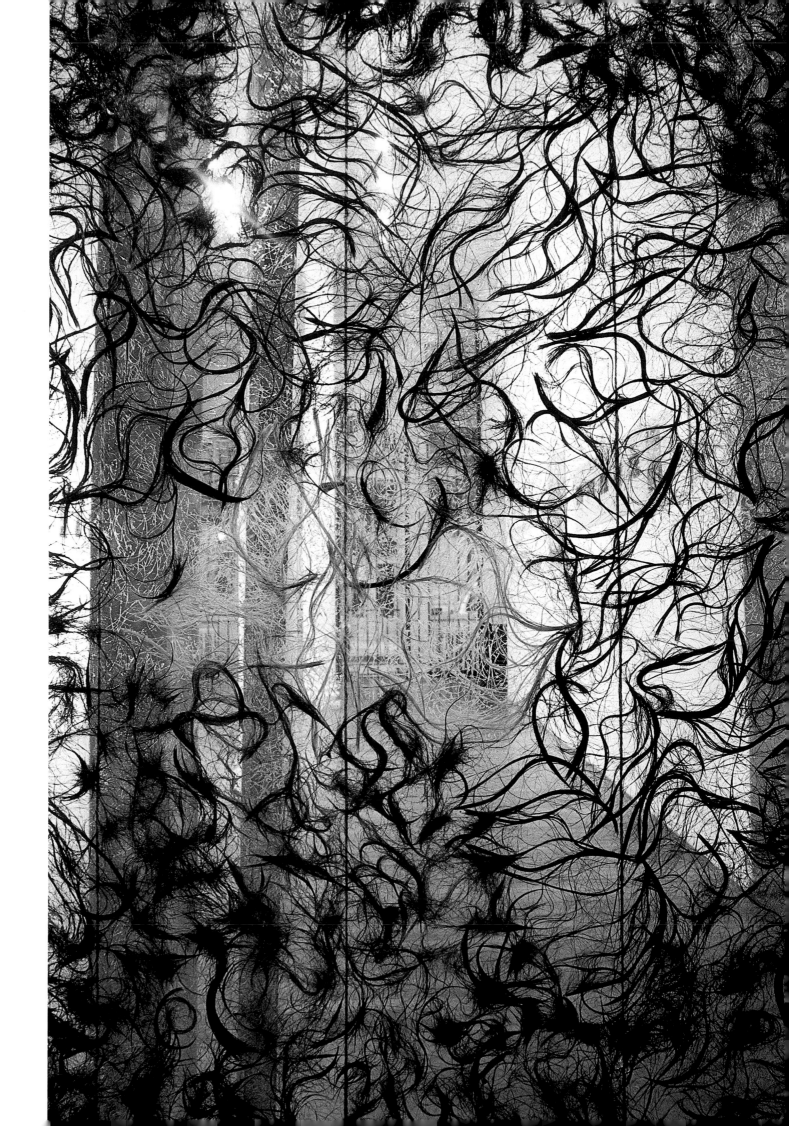

{israel monument: the holy land, 1995}

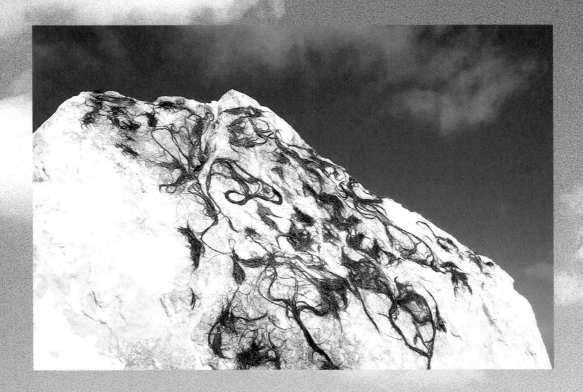

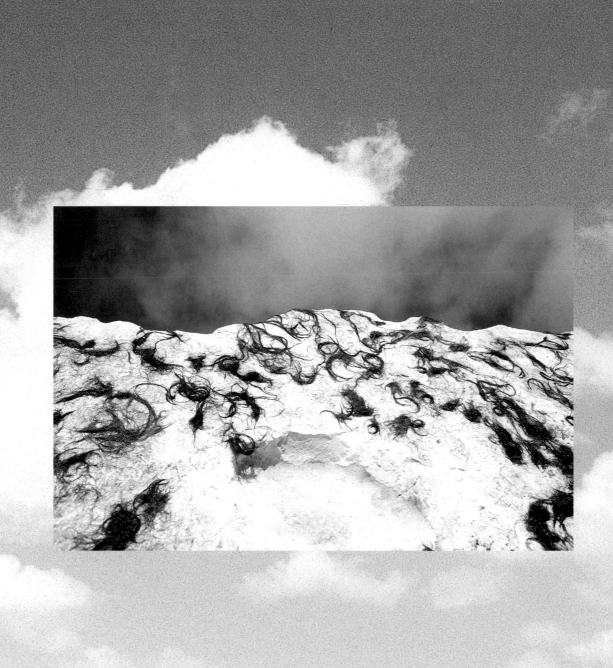

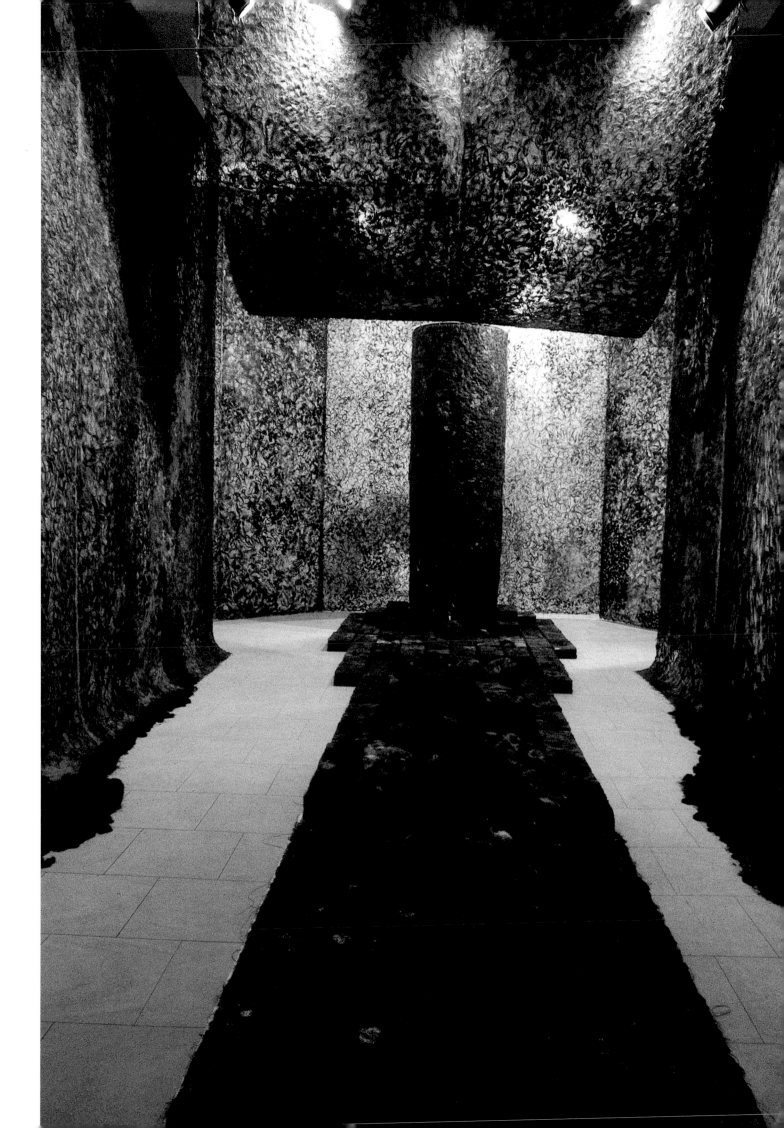

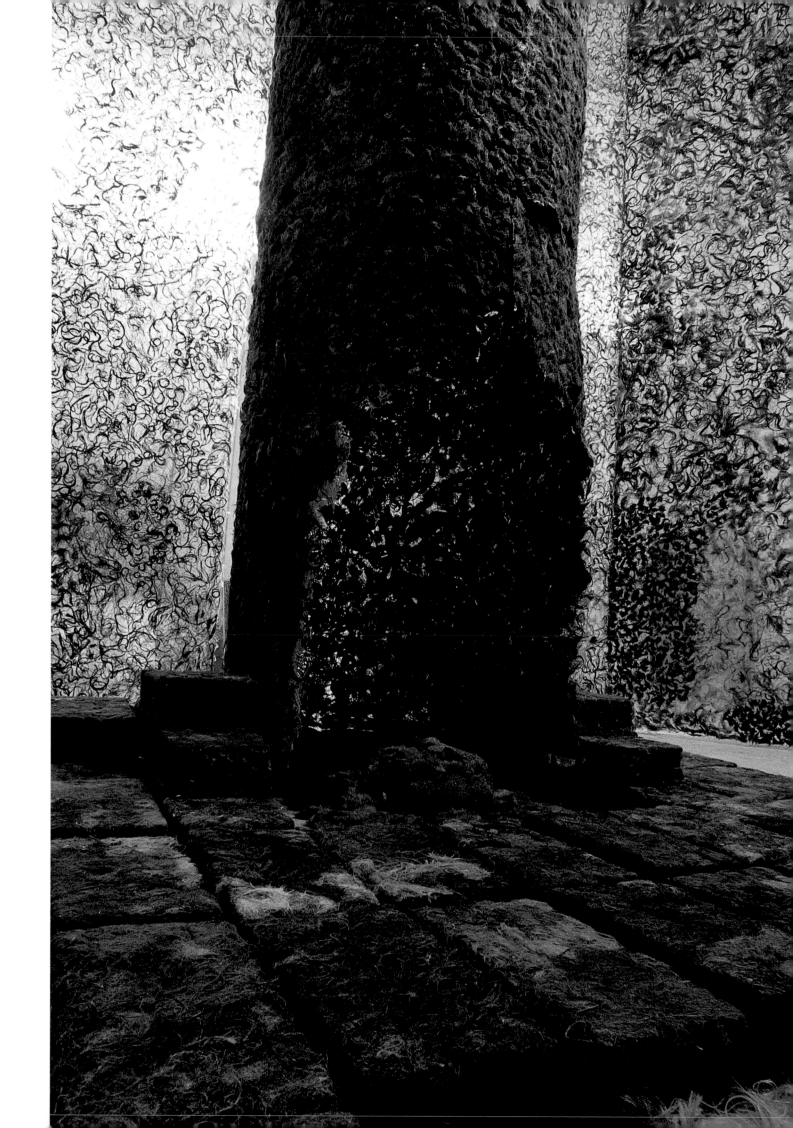

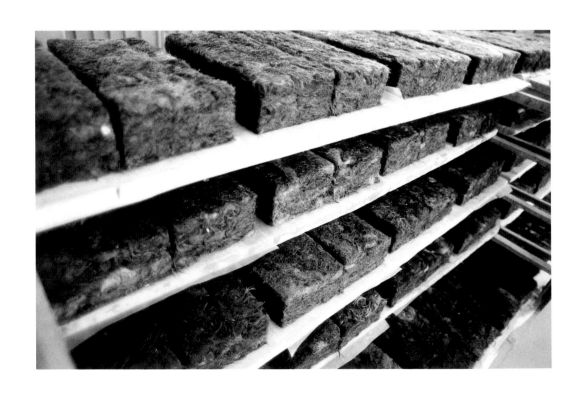

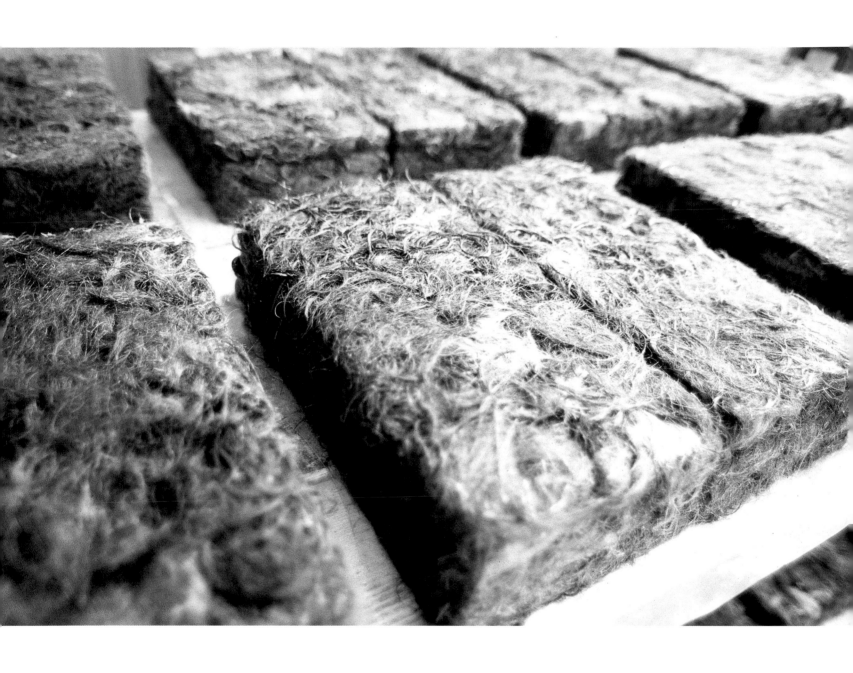

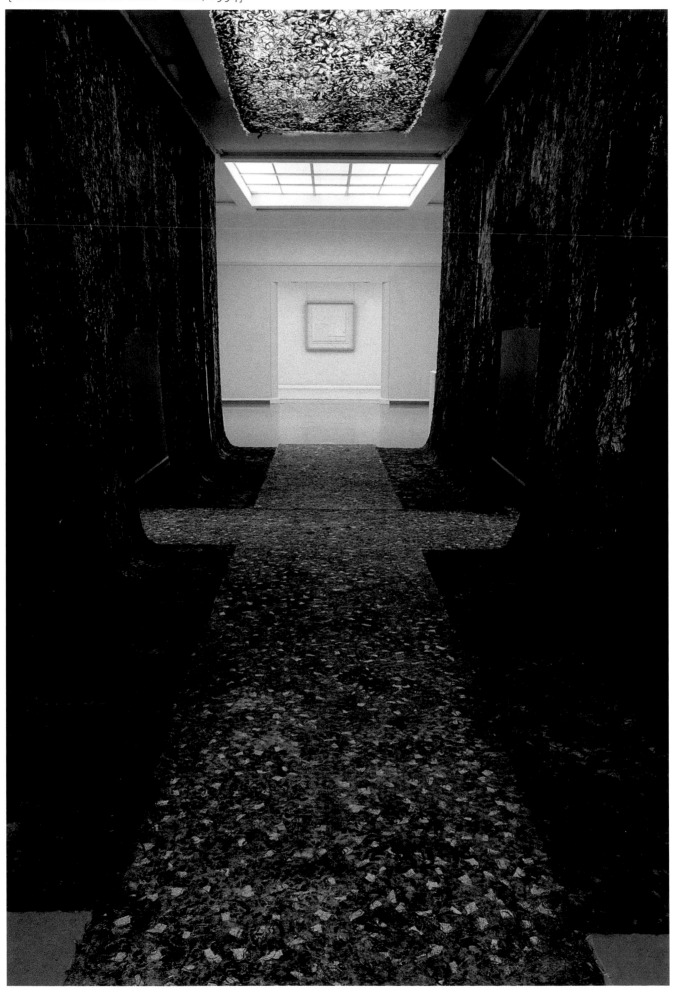

{holland monument: v.o.c. – w.i.c., 1994}

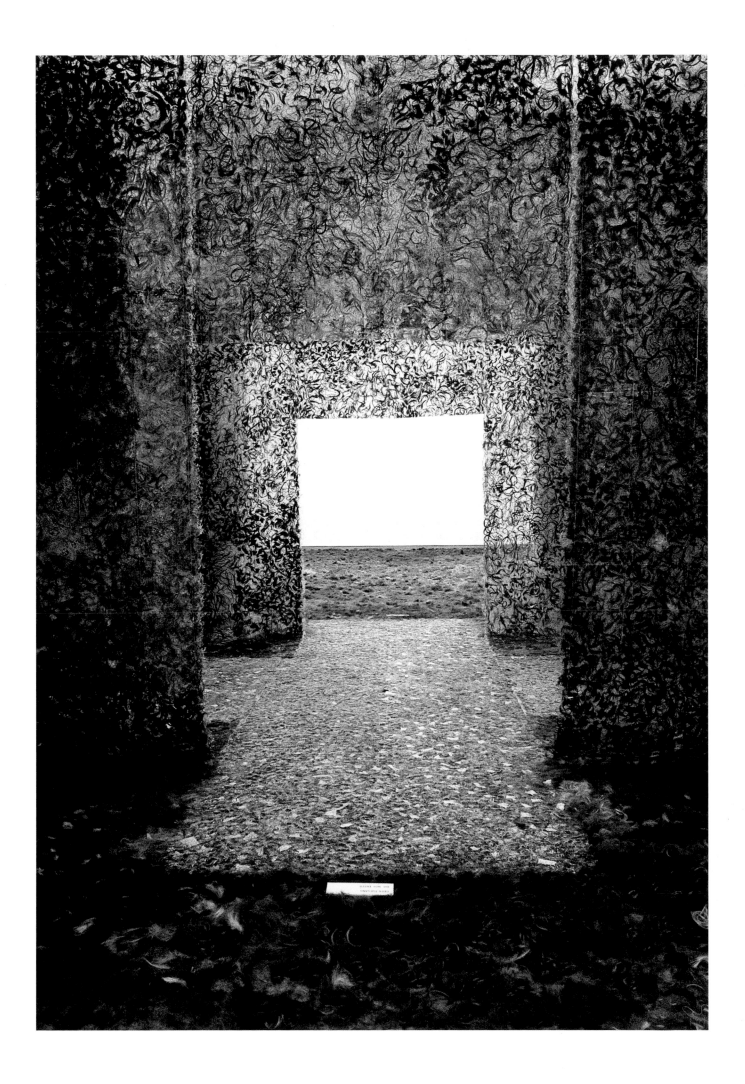

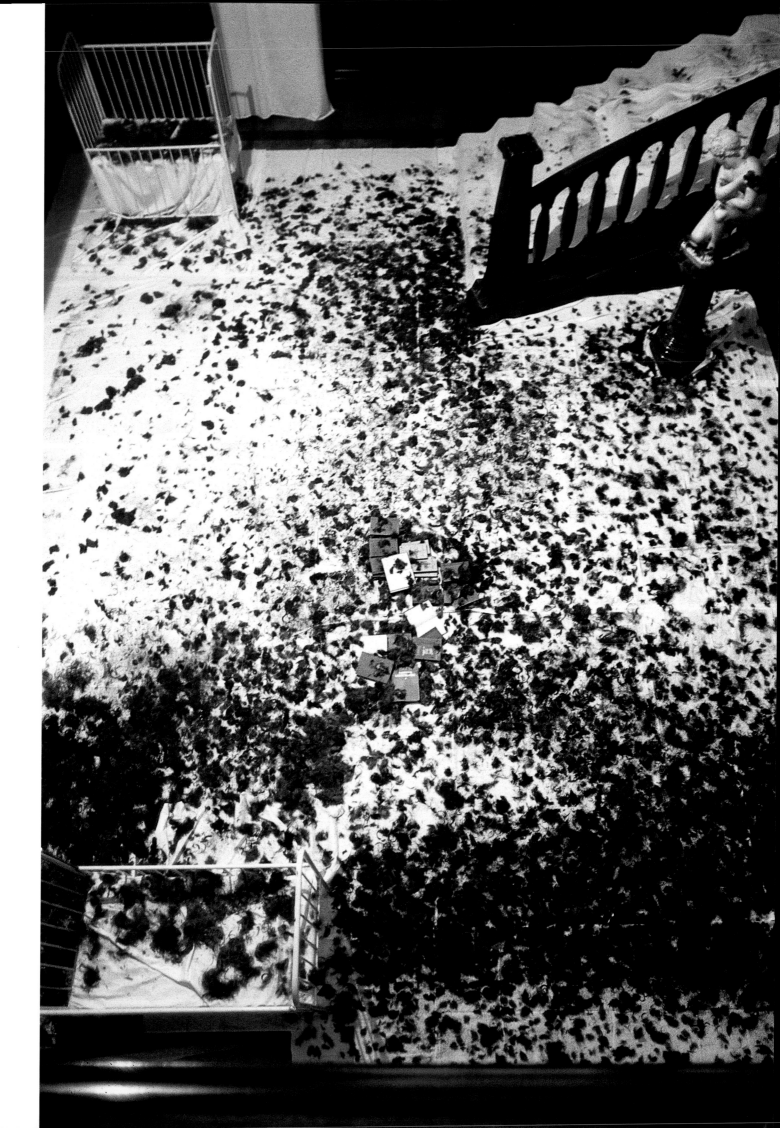

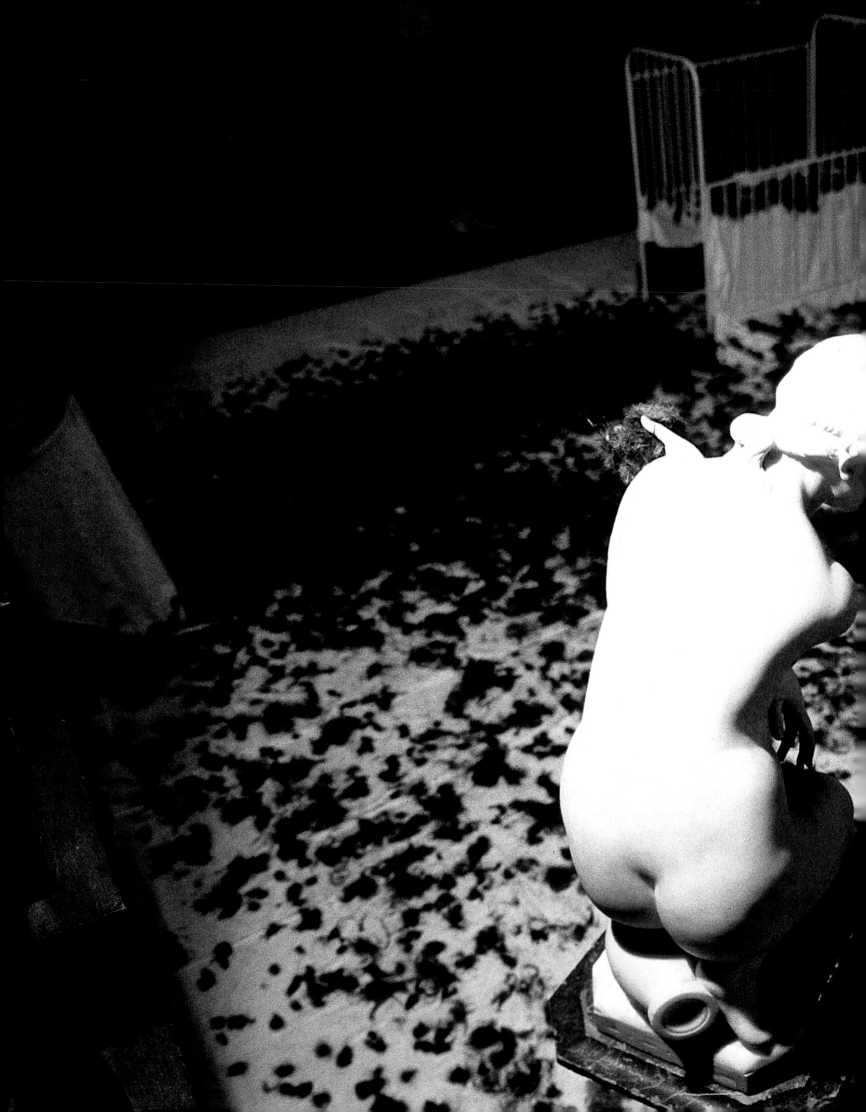

from middle kingdom to biological millennium

David Cateforis | **An Interview with Wenda Gu**

The following interview was conducted in the artist's Brooklyn home on August 16th, 2002.

David Cateforis Let's start by talking a bit about your background. Were there any particular factors in your upbringing that steered you in the direction of an artistic career?

Wenda Gu I think there were two factors. One was my sister's influence. She was in music school training to be a cellist. Usually during the Chinese New Year she would play the cello and her schoolmate would play the piano. My mother, who was an amateur soprano, would sing something. My sister also brought me a lot of artistic books and literature. The first literature book I read was one she brought home, and then my father took it away—he said "this is a dangerous book." That was during the Cultural Revolution. Further back, my grandfather was one of the earliest film people [in China] as well as a theater person, and his theater group actually had a record as the longest existing theater group before the Mao occupation.

DC This was your paternal grandfather?

WG My father's father, yes. And he established the theory of the director as the centerpiece of the movie industry in China. He did the first theater work involving dialogue. You know, in the Chinese traditional operas there's no dialogue, it's just singing. He created the first one [with dialogue]. He was another influence.

DC And was he also affected by the Cultural Revolution?

WG During the Cultural Revolution he was forced into the countryside, and stayed alone until he died. And my father didn't dare to go to his funeral, because my father was a Communist Party member, and at that moment during the Cultural Revolution you had to be very clear about the dividing line. My father didn't tell me any stories about my grandfather.

DC You grew up during the Cultural Revolution and you participated in the Red Guard. How did that experience affect you?

WG I have some memories of the Red Guards coming to my house to search for family gold or those sorts of things. And I remember they took my grandfather's manuscript of Chinese theater history and movie history—never published—they took it away and I've never found it. And every member of my family had to write criticism about my grandfather and paste it publicly on a wall. That was a vivid memory. And in particular one thing I remember, my brother did watercolor painting as a hobby, and he painted Mao's picture and put it on

the living room wall. It was a black and white watercolor. And I painted the Chinese national flag on both sides — that's the way they did it during the Cultural Revolution. Then the Red Guards came and they asked, "Why is Mao's picture in black and white? It's supposed to be colorful." So that was wrong. And with both flags they said the proportions were not correct, so they forced me to take them down.

All the children wanted to be trained to be in the Red Guard. I had a little bit of difficulty getting in to the Red Guard organization, but finally I got in because I had some skill in doing the big character posters. So I was always hired to do the propaganda posters.

DC You've spoken of the importance of those big character posters for your later interest in characters and writing.

WG Yes. I refer not to the political content. I refer to the creativity or true emotion. Because I thought about the history of Chinese calligraphy from the beginning until recently: the professional calligraphers, they are technically perfect, but not creative—they just copy from one dynasty to the other. So I thought that the big poster calligraphy, actually done by average people who had no knowledge of calligraphy (they even made a lot of mistakes in characters because of lack of education) was full of passion and belief. In artistic form I thought this work was more lively than that copied from tradition. Of course content is another thing. I refer to it from the artistic point of view.

DC After the Cultural Revolution you studied wood carving at the Shanghai School of Art and Craft, you worked in a wood carving factory, and then you went on to earn your Master of Fine Arts degree in traditional ink painting at the China National Academy of Fine Arts. How did you respond to this traditional training and this traditional craftwork, and how did these affect your subsequent development as an avant-garde artist?

WG That's a long story. Actually, I was fortunate, because right after I graduated from high school the art schools reopened, so I was in the first generation to get in after the Cultural Revolution. I had no choice regarding which category I wanted to apply to, but I was just excited to get in; if I hadn't gotten in, I would have been in the countryside cultivating land – that's the Maoist thing. They put me into wood carving which I hated. It's just like applied art—you carve furniture: trunks, tables, chairs, and lamps—I didn't really like it. And I was treated as a bad student sometimes because at that time I already had started to do ink painting. I thought "ink painting is fine art" (at that time I was naïve) and "wood carving is an applied art; I don't like it; I want to be a fine artist." So I always escaped from the wood carving class and just went to my bedroom to paint. The teacher would always come and pick me up and say "go to class."

After this, we didn't really have a choice, the whole class (about twenty-five students) all went to the Shanghai wood carving factory. I was lucky enough to be the only one out of twenty-five to be selected as a designer, so I went to the design studio of the factory. I then had a little more freedom to practice my art; there was enough time to practice my ink painting. From the beginning of my ink painting I wanted to do something new. I was influenced by my first teacher who was doing new landscape painting. I was influenced to do more modern style landscape painting. That was the beginning.

DC You studied landscape painting at the National Academy.

WG That was later. I first studied it with a private teacher before I went into the National Academy.

DC So you had a private teacher during the time you were at the factory?

WG Yes, I went to the teacher about once a week. It's a Chinese tradition—kind of feudal, you know. In the United States, you graduate from school; it's not like you're part of the tree. In Chinese painting you have a professor; you have a private teacher, and he becomes like your mentor. He's always there. It's just like a tree, from the root to the twigs, one generation to another generation. It's kind of a hierarchical system.

DC Master and student, and then the student becomes the master of the next generation.

WG Yes, so it's like a family, rather than just teaching art.

DC And you then studied with a prominent painter and calligrapher, Lu Yanshao, at the National Academy.

WG Yes, he just died three or four years ago. He was a master of landscape painting in the scholarly tradition. But at that time I shifted to the avant-garde. My school requirements were all traditional, but I was rebellious and always tried to do things I was passionate about. I look back to that time in the National Academy following a traditional master, and I think that was good, because I gained so much knowledge of the tradition from him, and this gave me more of a focus, a target. If you don't know the tradition, how can you go against tradition?

DC In the early 1980s you began inventing pseudo characters—fake, Chinese-looking ideograms that can't be read. You continue to use these in your work, along with invented scripts based on other major languages such as English, Arabic, and Hindi. What motivated you initially to create these pseudo characters, and what philosophical import do they hold for you?

WG At that time I was young and full of passion—I didn't really make a logical analysis. Today, I look back and find several sources. I started in, I think, 1983 to learn seal script, the characters only Chinese linguists can understand and modern people don't use. I think it was invented by the first emperor. When I first faced the seal script I couldn't read it, so it became a release, because I wasn't limited by what the words said. And at that time I was intensely reading Wittgenstein's philosophy of language and Russell and it coincided. Also I had my memory of the earlier big posters from the Cultural Revolution. These things came together, and the first chop I did was fake seal script. I felt such freedom, leaving behind the content of the words.

DC So only an expert would have known that the seal you carved had fake ideograms, since very few contemporary Chinese can read seal script anyway.

WG Right.

DC Any Chinese character is illegible to someone like me who doesn't read Chinese — it seems very exotic. But this seal script is exotic even to the Chinese. You go a step further and invent another ideogram that looks like seal script, but it's a fake one. Some critics have suggested that your pseudo-characters, which frustrate communication and drain language of its meaning, might be taken as rebellious gestures against the propagandistic use of language during the Maoist era. How do you respond to this political interpretation of your work?

WG I think that's right. I had my first solo show in my career right before I left China, in 1986 in Xi'an. In it I displayed a whole series of really huge ink paintings with all the miswriting. That show was closed before the opening, because the propaganda department people from Xi'an province went to inspect the show before the opening and were frustrated because they couldn't read the writing. Then they suspected some political undertone to the work. But at that time what I wanted to do was just differ from the tradition, and there wasn't much of a political implication. It was about language, about how to renew the tradition. So the show was closed, and afterward reopened, but only the professional artists were allowed to go in.

DC So you're saying that you didn't have a political intent, but the authorities suspected that you were somehow being subversive.

WG There was no direct political implication, but when you do something that goes against tradition, then people interpret it as a political statement.

DC Shortly after this show in Xi'an, you emigrated to the United States on a student visa. Why did you want to leave China, and what attracted you to America?

WG There were several reasons. First of all, for me, it was not for political reasons. I was rebellious, fearless, I didn't really care. If I really wanted to stay in China I would still do what I wanted to do. So it's not like a lot of people say that I was afraid of political pressure. For me there were two reasons. One is that I was established as one of the leaders in the contemporary art movement in China. I wanted to upgrade, to be more international. I wanted to see the world. And I didn't pick Europe, I picked America, because America was more interesting for its diverse culture, diverse races, and for its art center, New York.

DC Has living in New York made you feel more Chinese or less Chinese?

WG More Chinese, for sure. When I lived in China, everybody was Chinese, so nobody reminds you that you are Chinese. When I moved here, the environment and the people I met constantly reminded me of my Chineseness, of my cultural heritage. But on the other hand, I feel more international, because I come into contact with so many different people. So I use this cross form to explain the modification of my psychological being: one side is awareness of my Chineseness, the other side is more international. And the other line has two margins. One is where I come from: the Chinese tradition and the socialist experience. And at the other margin is high capitalism. At the time I left China, I had no experience with selling a painting — I was so

naïve—because there was not a single commercial gallery in China. So what I did there was purely art for art's sake. The self-marketing and how to survive by marketing art I learned over here. So Chineseness and internationalism, and socialist and capitalist, it's all coexisting in me.

DC I noticed that sometime in the 1990s you started calling yourself Wenda Gu instead of Gu Wenda, adopting the Western convention of putting the family name second instead of first. I was wondering if that was a kind of shift you made to feeling more Western and less Chinese, at least in your professional identity?

WG Actually, the first time I reversed the order was when I got my Social Security card. At that time I was still naïve, I didn't think about identity in the culture. At that time, fifteen years ago, this awareness was not as intense as it is today—there was no such issue. I just thought, "Oh, the American way is this, I'll change it." And then later on, people constantly reminded me, because Chinese scholars will still use Gu Wenda, and the Western people will call me Wenda Gu, like it says in my passport. So it became really chaotic and I gave up; whatever you call me, it's o.k. But there is some identity implication there; when people call you Wenda Gu or Gu Wenda, it reveals their mind as well.

DC In the late 1980s, you began to use human body wastes—first menstrual blood and placenta powder, then hair —in your art. What attracted you to these materials, and in particular to hair, which has become your signature medium?

WG During the period when I was in China, I was interested in language—conceptual language. Then after a certain period of doing ink paintings and installations, I came to distrust language. So I left language. Then I began making artworks involving materialism, which is the opposite of language—dealing with the essential world in which we are living. And I did several works relating to the metaphysics of materials. I did several outdoor pieces using marble and pigments—two land projects, one in southern France and one in Japan. These were burial land projects, meaning after they were completed, they disappeared. And I did some pieces for the P.S. 1 Museum. One piece presented three stages of grass: living, dried, and scorched—same material, different stages. Then after some research, I decided that the human is the center of the material world, so I switched to using human body materials. Also, I was really interested in contemporary genetic research. I thought this was an astounding field, involved in changing the original human being—it really intrigued me. So I moved to the human body period. The project I did with menstrual blood was really controversial and actually blocked my career for several years. No institution wanted to take my work, because it was too wild. And the piece I did was not as simple as a woman using her own blood, which has become very conventional today. What I did was to collect statements from these women—sixty women from sixteen countries—so each woman sent me the used tampons from a completed period, with her personal statement, story, or poetry attached. So the statement is more powerful than just using the material. But it became controversial because of the gender issue. A woman can use her own blood—she's free to use her own body. But, if instead of this, a man collects blood from women, it becomes more controversial. And a further controversy came from me being an immigrant, from another culture, which had further implications. The work actually started in 1989,

before the Mapplethorpe controversy. I was still naïve. I wasn't trying to make controversial work, I was just carrying on with the avant-garde experimentation I had started in China.

DC So you weren't trying to be provocative?

WG I was not knowledgeable about the American environment, about gender issues, about feminist issues, about religious attitudes towards the body. I was purely thinking about being rebellious and doing the work. But at the same moment, the Mapplethorpe controversy hit. I look back now and think about how daring I was and also how unknowledgeable I was about the American environment.

DC You also made a piece with placenta powder which was controversial.

WG That was exhibited at the Wexner Center for the Visual Arts in Ohio. This work was actually meant to challenge how we look at the same material from the unique perspectives of different cultures. Placenta powder has been used as a tonic or medicine in Chinese culture, and people there don't feel this is something controversial. But when you transport this to another culture, because of cultural perceptions, it dramatically changes the material's existence. So it's a kind of challenge. That's why I deliberately selected the placenta from normal, abnormal, aborted, and still born babies. This time, after learning from the controversy over my blood works, I had some knowledge about the American cultural environment. So this work purposely had some implications about abortion and those sorts of things. But it was still a kind of test of how different cultures can treat one material differently.

DC And what about hair, which you began to use around the same time?

WG The hair work is more involved with all the intensified issues around multiculturalism and internationalism, so I think this work is the greatest achievement of my career. When immigrants come to a new culture, they are faced with three possibilities. One is to remain in your own culture, the second is to totally give up your own culture and do whatever the new environment dictates, and the third is somewhere in between—like a combination of East and West, or whatever. But I felt I would not be satisfied with any of these, because I wanted to make work that was more inclusive, of all kinds of cultures, all human races. This is my motivation. And also I have to give credit to being in New York, because every day here you have dialogue with different cultures, different races—you always absorb from others. So the *united nations* project was the result of being here.

DC You conceived the *united nations* project in 1992, and so far you've presented it in installations in fourteen different countries. Could you talk more about the conceptual basis of the *united nations* project and how it's evolved over the decade that you've been working on it?

WG I think that the world is dramatically changing, so I've set up many of my projects as ongoing. Ongoing means the work is not finished; it still continues. Ongoing means open to the new environment, new situations, new times. So the work has been changing all the time, accordingly. At first I set up national monuments, using local hair, and relating to local culture and history. Later I shifted to a subproject, not referring to one particular nation, but more universal. For example, the work I did for the San Francisco Museum of Modern Art

(*united nations – babel of the millenium*): it's not about one particular nation, or one particular culture. But the one thing I set up from the very beginning is that the work will have a final ceremony. And I chose as the location New York, because the most diverse cultures and races reside here. But when and where still remain in question. I don't rush to the conclusion; I just keep going, going, going, because so many people and so many places require this work, because it's related to the local. It's also a very good strategy to take me around the world.

DC And you indeed have worked in numerous different countries on five different continents. Do you sometimes feel like an ambassador of art or something?

WG Yes, in a positive sense, people say I'm like a cultural ambassador, especially in the context of postmodern internationalism. On the other side, more ironically, they will say I'm like a cultural colonialist, because the work is done by a total stranger's hand, using totally local material. So it's kind of a strange dialogue. The only exception is the work I do for the China monument. There, it looks like I'm not a stranger.

DC Right. With the exception of when you're working in China, you told one reporter that you feel like a foreign intruder in any country that you're working in.

WG Yes, but when you talk about a cultural colonialist or cultural ambassador, they mean the same thing—just different interpretations.

DC I'd like to hear more about your use of hair as the principal medium of the *united nations* project.

WG I feel that the hair, for me, is almost religious. You could use a fingernail or something else as a bodily material, and it would become like a gimmick. But hair has so many cultural associations; there are so many meanings to it. For example, Victorian women made fabulous, beautiful jewelry out of hair. In the Hebrew tradition, in the story of Samson, hair was the source of his power. For Native Americans, Africans, and other cultures, hair has so many different cultural and historical implications. Hair is also associated with political tragedy in the Nazi period.

DC You're referring to when the prisoners in the concentration camps had their hair shaved off?

WG Yes. That was the source of the controversy surrounding the *united nations* work I did in Israel. I remember very clearly, when I arrived at the Tel Aviv airport, there was already a protest. The Jews all thought about the hair in relation to the concentration camps and questioned why a foreigner was coming there, so insensitive to the Jews' past experience. The national newspaper had a front-page inquiry. They interviewed political activists, and a writer, and curators about how this Chinese artist was using Jewish hair. And I had a half-hour dialogue with the chair of the Israeli parliament on a popular radio station. I said I was sensitive about the Jews' tragic experience. I was born in Shanghai. At one point when the Jews were escaping from Europe during

the Second World War, there was no other country that would open its doors to them, but they went to China. I know this history in Shanghai. So my purpose in making this work was not to try and refer to the Jews' tragic experience. *united nations* is a utopian idea; it's a great idea, but without Jewish hair, it would be incomplete. So finally I convinced them, and I did my project in the desert.

DC You mentioned the utopian vision of your *united nations* project—the vision of a unified humanity. Do you think that your art can actually help to bring about greater understanding, even harmony between different national, racial, ethnic, and cultural groups?

WG It's just my wish. But to be honest, artists don't have that much influence on the world. Only politicians have this power. So I think that it's just a dream.

DC But isn't it significant when public debates occur about your projects, as happened in Israel? Then they get on the front page of the newspaper instead of just being reviewed in an art magazine, and therefore they might have more impact on the political arena.

WG I think it can be noticed by more people if the work becomes controversial, but I don't think it will affect the political agenda. I'm not sure that any past artistic movement really changed the political world.

DC On the other hand, politicians sometimes use art to further their own agendas: witness Hitler's prescription of certain heroic styles, or Stalin's, or Mao's for that matter.

WG Yes, for propaganda.

DC For the present exhibition you're creating the twentieth installment in your *united nations* series. Can you describe your plans for it?

WG It will be composed of very thin hair braids, perhaps in the form of a tent—I still haven't decided. The hair braids are being made in my Shanghai studio. I have three women assistants who are constantly braiding, braiding, braiding—it's like meditation. And, interestingly, this new work will be related to the purpose of education, since the show will go to several art schools. The students of the art schools will have an assignment: every student has to make one piece and connect it to the continuing work, as a performance.

DC This relates to something you've spoken about before: people entering your installations have a more personal response to the work since it's made out of human hair.

WG That's the advantage to using human body material as the vehicle of the artwork. It's really closing the gap between the audience and the artwork, because people face it like they would face a mirror. On many occasions people come to my work and they ask, "Is my hair in it?" It's totally different from looking at a piece of stone or a piece of metal.

DC And by having the art students at the different venues of the show add their braids to the *united nations* monument, they very much will have a personal connection to it, and perhaps, as in your utopia, realize that we are all interconnected, interdependent.

WG Yes, whether they collect the hair to make it or use their own hair. This work will continue going on even after this traveling show ends. It will go on to other places until I feel that the *united nations* work should be concluded in the form of a solid globe made out of hair braids whose total length can run several times around the planet. For this work I'm thinking of the subtitle continuing kilometers. I thought of it in contrast to Walter De Maria's piece, *Broken Kilometer*. This is continuing kilometers. And instead of materialism, it's human, biological kilometers.

DC How does your own national origin and cultural background—Chinese—relate to the internationalism of the *united nations* project?

WG I want more to integrate into diverse cultures rather than just be a translator of my own Chinese culture. Often people in the West want to see you as a translator of your own culture and its exoticism. For me, this just serves as the first stage of cultural dialogue. Of course, in one sense I do translate my Chinese culture to the West, but my goal is also to integrate on a deeper level so that something new will come out of it, rather than just translating my own culture or absorbing from the West. So this can be related to the so-called third group.

DC Do you refer to Homi Bhabha's notion of a Third Space? That you're in-between? It's not East meets West, or East presents itself to the West, but you are in between the East and the West.

WG Yes. You know, if I go back to China today, people will say, "you're not Chinese anymore." But to the Western mainstream, I'm a Chinese representative. Cultural people in China will say to me, "you are colonized by other cultures."

DC Isn't part of the problem here thinking of cultures as pure and hermetically sealed, as opposed to impure and open to outside influences? If you think of Chinese culture as pure, then yes, you've been contaminated. The postmodern view would be to see cultural identity as something that is in process, something that is unstable—not something that is fixed and pure.

WG Yes, and today, I think if artists want to achieve something, to only have knowledge of a single culture is not enough. Because now we are in global communication. And of course, there will always exist a dominant culture, no matter what. But it's not isolated from the rest.

For a lot of people, globalism has come to signify Americanism—the idea of that dominant culture being the American one that is colonizing the rest of the world economically now, rather than politically. Economically and also through language. That's what is referred to in postcolonial terms not as an occupation of land or people, but the occupation of mind, because language is influential to the mind.

DC And you had to learn English to operate as you do. English has become the lingua franca of the international art world. Now, many artists would have been content to keep working on a single, successful series such as the *united nations* project that has brought you international recognition. But you've branched out, you've developed other series even as you've continued to work on the *united nations* project. Three of those series will be represented in this show: the *Forest of Stone Steles: Retranslation and Rewriting of Tang Poetry*, the *Ink Alchemy* series, and the *Tea Alchemy* series. So I'd like to turn our discussion to those. These series strike me as deeply rooted in Chinese culture, and you have produced all three of them actually in China. You've shown them outside of China, but it's in your studios in Xi'an and Shanghai that the works have originated.

WG That's dislocation. I think that as I went deeper into my own project, I discovered that showing human body materials was not enough. You have to change the human body material to make it into a cultural vehicle. A perfect example is the powdered hair ink. On one side, ink is one of the Chinese cultural treasures and has been for centuries. But at the same time this is totally non-traditional, because there's never before been ink made out of biological material. So it has two sides: one side is so traditional, the other side is nontraditional.

DC So, again, you're in-between. Now it's not in between East and West, but in between tradition and innovation.

WG Yes, and also I want to say this is like a bridge between ancient Chinese culture and contemporary biological developments, because when I use this ink for painting, I'm painting with a genetic sequence. This ink can be tested and traced back to those who donated the hair.

DC But of course since you are presumably using hair collected from different sources, you would end up with a genetic stew, wouldn't you?

WG Actually, this first project I did use purely Chinese hair, because I wanted to refer to the big debate in China over where ink painting should go. We have inherited ink painting from tradition and repeated it over and over again, but there has been nothing new. The current new trends in ink painting, besides being ink on paper, are no different from abstract expressionism—it's nothing new. I wanted to change ink painting, make it completely new. It's the same thing with the rice paper made from tea leaves. Traditionally, rice paper is made out of straw, not rice. So this time I produced 30,000 sheets of paper made up of eighty-five percent green tea leaf pulp.

DC Both of these projects, then, involve alchemy of a particular sort. Alchemy is normally defined as the transmutation of base metals into gold, more generally as a magical process of transmutation. So you are transforming tea leaves into paper; you're transforming hair into ink.

WG Yes, they become art materials. So just imagine, when you use the hair ink to draw a line on the tea paper, you're involved with genetics, with ecology, with all of these things. It's like the modern theory of architecture, which more and more requires the use of plant material to construct the building, instead of stone, cement, sand, or mud. They are using bricks made out of plants. In this way you use up fewer natural resources.

DC Plants are a renewable resource and so is hair.

WG Yes, hair is a human plant.

DC The installations of *Ink Alchemy* and *Tea Alchemy* that you've done recently and that you'll repeat in smaller versions in this exhibition, feature video monitors that document the process of producing ink from hair and paper from tea leaves. Now, these processes were accomplished, respectively, at an ink factory in Shanghai and at a paper factory in Anhui province. The inclusion of these videos seems designed to make visible and to honor the skilled labor of the Chinese workers who actually realize your alchemy.

WG Yes, and also it's the proof that this isn't just a joke—you actually see the process from the beginning to the end. So it's like scientific, hard proof.

DC Right. And you probably conceive of that whole process as integral to the work of art.

WG Yes, it's conceptually very important. For every new project that I do, I'm going to make a video document. So the process is part of the work—not only the final result.

DC Let's talk about your *Forest of Stone Steles* project, which you'll present in a smaller version in this show than you did in Australia.

WG Yes, I'll present just a few steles. These are massive—they weigh 1.3 tons. In the end there will be fifty; so far I have only produced thirty. It's a long process.

DC And these are being produced in Xi'an City, where the original forest of stone steles is located. Can you describe the historical references you're working with in this series and also the conceptual basis of the retranslation and rewriting of Tang poetry?

WG Traditionally, the stone steles actually functioned as tombstones for people of high position, whose accomplishments would be inscribed in sentences on the steles. And the most astonishing is the tombstone of the first Empress, which does not contain a single word. She thought that her accomplishments were beyond words. No description would fit her accomplishments, so the stele was left empty. It's really a gorgeous piece.

DC That's an example of conceptual art from ancient China. But your steles bear inscriptions. You're taking the Tang poem written in Chinese characters, the standard English translation, and then you retranslate the English sounds back into Chinese.

WG The first translation, from Chinese into English, is what I call a meaning translation. But poetry is a form of art —you really can't translate it. You can translate the meaning but you lose the beauty of the sound. So I did a

sound translation. Basically, I use the English pronunciation and choose similar sounds in Chinese characters to match the English pronunciation. One English sound can result in any one of many different Chinese characters, which all have the same sound. So I choose particular Chinese characters and make a new poem. My translation mimics the sounds of the English but at the same time has a new meaning.

DC And then, when you take your new Chinese poem and translate its meaning back into English, you end up with a kind of Surrealist poem.

WG Yes, it's totally different. And that's the reality of cultural translation—that's the symbolic meaning.

DC So you're dealing here with the difficulty of cross-cultural communication.

WG And also it's a kind of intellectualized pop culture. You see names like Motorola, McDonalds—they all have Chinese versions that mimic their English sounds.

DC So there are Chinese characters that would be pronounced in a way that would produce the same sounds?

WG Similar sounds, but the meaning would be different. So this is the culture we are living in. Bonsai means "landscape on a plate," or "plant on a plate." Bonsai is the sound translation in English, but there's no such word in the English vocabulary for this thing, just like there's no Chinese word for McDonald's. This is a popular cultural phenomenon. So the *Stone Steles* are intellectual on one side and popular on the other side – inclusive of both.

DC You also will display ink rubbings taken from the steles.

WG It's like a special way of making prints. The amazing thing is the way the steles are produced. They are all handmade, hand carved, even hand quarried, because it's absolutely forbidden to use explosives to get the stones, because that will create hidden cracks. And this is exactly the same stone that was used to make the ancient forest of stone steles. So it retains originality. This is also a way of dealing with cultural identity. You know, if you make an ink painting here, it's not the same as making an ink painting in China, because the material is dislocated.

DC So you really had to go back to China and use this quarry.

WG And entirely the same process to produce them. I could have used a computer to do the carving, and finish it very quickly—easy and perfect, but there's no human touch. I wanted the handmade quality. The thing I always want to do is to make one side completely new, the other side completely traditional and authentic—they coexist.

DC So, what's the new part of the *Forest of Stone Steles*?

WG The characters I designed myself—that's my calligraphy. And the translation, that's entirely new. And the way I install the steles—horizontally. Originally they stood upright, like a forest. I'm making them flat.

DC And traditionally they functioned as tombstones. Do you intend your forest to have any connotations of death or burial?

WG I have no such intention. Maybe somebody will come up with that idea and suggest that this work hints at the death of an existing culture. Translation back and forth produces something new—it is really symbolic of the reality we are living in. One side is ironic or humorous. On the other side, new things come from this. I really want to approach things in the culture that are iconic.

DC Like the tea ceremony or ink painting—things that are loaded with meaning.

WG Yes, icons of the culture.

DC These projects seem rather different from your *united nations* series. First of all, they are more deeply involved with Chinese culture. And here you are really in the position of interpreting or reinterpreting Chinese culture for Western or other audiences. These works don't seem to be so much involved with the utopian project of uniting humanity, but rather with rethinking Chinese tradition and seeking to innovate within it.

WG It's kind of a constant movement, because I have two sides, Oriental and Occidental. So this gives me a space to move around all the time. You can see very clearly my intention. In my earlier work I tried to find an opening into the West. Now I'm looking for a way to recolonize, find some way to influence existing Chinese culture today. The focus is shifting, towards the West, towards the East, back and forth. That's the position I'm in: in-between.

Wenda Gu's united 7561 kilometers

David Cateforis

united 7561 kilometers *is the twentieth installment in Wenda Gu's ongoing global art project,* united nations, *which he began in 1993. Measuring approximately forty feet high and twenty-five feet in both width and depth, this work was first installed in the foyer of the University of North Texas (*UNT*) Art Gallery. It will be installed in different spaces at the other venues of the traveling exhibition "from middle kingdom to biological millennium," taking on a different appearance in each instance due to the character of the physical space it occupies.*

Like all of Gu's united nations *installations,* united 7561 kilometers *is made largely of human hair. In this case, the hair has been used in two ways. First, it has been pressed into glue to form twelve translucent, rectangular panels suspended in the shape of a square column at the center of the work, illuminated from within by three suspended light bulbs. The hair in ten of these panels takes on the form of synthesized, nonsensical characters based on elements of Arabic, Chinese, English, Hebrew, and Hindi. Two contiguous panels on the base of one side of the column feature continuous text in nonsensical Arabic and English, respectively.*

Human hair has been formed into a continuous braid 5000 meters in total length which is suspended above and on either side of the central column to form a tent or temple-like structure that the viewer is invited to enter. According to Gu's calculations, the individual strands of hair comprising this continuous braid would extend 7561 kilometers in length, the distance of the piece's title. Created over the course of about two years by three female assistants in Gu's Shanghai studio, this long rope of human hair symbolizes the immensity of the global population and the essential interconnectedness of human beings which are central concerns of the united nations *series as a whole. At the same time, the persistence of racial and ethnic differences among humans is suggested by a few braided lengths of pure blond hair that appear on both sides of the canopy, contrasting the otherwise uniformly dark color of the braid.*

The braid is hung in 191 divisions of equal length. At the base of each of the two side "walls" of the "temple," the hair braid is threaded through 191 rubber stamps bearing the names of the 191 nations of the world (as of the year 2003), spelled backwards in lower case letters (e.g. dnalaezwen, lapen, namo). At the end of one side, the braid continues in a pile on the floor and is threaded through several additional rubber stamps with blank areas to accommodate the names of new countries. This element of Gu's work suggests that rather than unifying, humanity will in the future divide itself even further politically.

The following is an edited transcript of the author's email interviews with Wenda Gu (from the 22nd to the 24th of January, 2003) concerning the piece *united 7561 kilometers*.

David Cateforis What is the origin of the hair used to make this work?

Wenda Gu Among all the national monuments and sub-projects of the *united nations* series, this one was the most difficult in terms of hair collection. As you know, this particular work needed long hair to create the continuing, thin braid. The human hair in this work is mostly Chinese. The rest was collected from different countries whenever I had a chance to get long hair during the past ten years of creating the *united nations* project. However, I was fortunate to find a source in Shanghai: a company that recycles hair for chemical use. From that company I have been able to get a large amount of long hair. The long hair is not easy to collect from the hair salons and barbershops around the world due to its value to the wig market.

DC How long did it take your assistants to make the 5000 meters of braid?

WG It took three assistants about two years to get the job done.

DC Are they continuing to work on the braid now? How long do you think it will be eventually?

WG They are not working on it at the moment. I've been thinking about extending the cumulative single hair length in this continuing hair braid to match the circumference of the globe.

DC In using braids do you intend any reference to the fact that Chinese men wore their hair in braided queues during the Ching period? Or that women wore braids during the Cultural Revolution?[1]

WG I didn't have any intention of making reference to people's hairstyles in different periods in China. I didn't intend for this reference to enrich the conceptual content of the work.

DC Why are you emphasizing the overall length of the hair braid (5000 m) and the individual hairs that comprise it (7561 km)? What metaphorical significance do you find in the notion of length or distance?

WG There is no conceptual significance to the current figures of 5000 m and 7561 km besides these two factors. First, these are impressive lengths and difficult to make. Second, these figures indicate the precise current situation of the work. The title of this particular work may change to 7584 or any larger number when the hair braid length is increased in the future. Somehow this work's title invokes a kind of metaphysics and metamorphosis and abstraction in terms of infinity and eternity. It is just a continuation of the life cycle—as Oriental philosophy believes that there is no beginning and there is no end. I do feel in the same way that the title of this work is endlessly meaningful and at the same time is meaningless.

DC Why have you left a few sections of purely blond hair at different points in the work? Is this to suggest the persistence of racial differences in the human population? Or that a synthesized racial identity has not yet been achieved?

WG Not at all. It is all randomly arranged. Consider the fact that those three women assistants who made it are young and know absolutely nothing about all the current issues in this world. And I was not in Shanghai directing them. I saw this work for the first time just a few days earlier than you, during the process of installation. But it does reveal certain problems in our society—that we live in a very difficult, issue-oriented world. It means that people do have all kinds of preconceptions in looking at a thing like this. That is why I always believe that the content of an artistic creation is constantly changing and being enriched when it is displayed in public.

DC What is the significance of the rubber stamps bearing the names of the 191 countries?

WG From the beginning of the conceptual design of this ongoing global project *united nations* in 1993, I have firmly believed that "all human beings united" is a purely utopian idea that humanity imposes on itself, while the reality that humanity has lived throughout its existence is in fact the opposite. I believe that such a utopian idea can only stay in ideology, not in reality, and that it exists as a wish or hope in human life. However, as I stated in my thesis, "The Divine Comedy of Our Times," at least on one level, art is about ideology. Therefore, this age-old idea can be fully realized in the art world. As a matter of fact, I've incorporated the hair of more than one million people in this project. In this particular project, the 5000 m-long human hair braid was divided into 191 pieces of the same length (equal to the number of countries in the world today). The pieces of braid were then reunited by 191 rubber stamps carved with the 191 nations' names. This tells us that the world is divided into 191 parts but at the same time these parts are united. It is an absolute paradox. Because of the very nature of this project, from the very beginning it has been an ironical comedy when it faces the reality we live in. It is even more so now.

DC Why have you spelled the names of the countries backwards, in lower case letters?

WG When you carve the countries' names backwards on the stamps, it means that if you use the stamp on paper the letters will come out in the right order but the letters will be backwards. It will never be right either way. Does that mean that the stamps recreate the 191 existing names, or 191 plus 191 new country names, or that the stamps eliminate all the countries in the world? Do the stamps answer all the questions of human existence? It is interesting! It is fun, isn't it? Oh! Lower case is only my style in English writing.[2] I guess that artists are traditionally not capitalists. Perhaps it conveys the idea of equality if I write all country names in lower case letters.

DC Why have you left a pile of braids on the floor at one end with several blank rubber stamps?

WG My *united nations* art project has experienced the changing reality of ten years. In 1999, I created the *united nations – man and space* project for the 2000 Kwangju Biennale, featuring all 188 national flags of the world according to the world map at that time. Now we are in 2003 and I have to make 191 country names on the stamps. Are we more divided than united? The blank rubber stamps on one end of this 5000 m-long human hair braid symbolize that we are in a process that will fill in those blank stamps in the future.

DC What, for you, is the significance of the synthesized characters on the central hair column?

WG Those are the words synthesized from parts of five languages: English, Chinese, Hindi, Hebrew, and Arabic. This is a process of deconstructing individual languages and reconstructing a new one. A culture can't be precisely translated by others and can't be comprehended correctly by others. There is no doubt that through the translation we create something different. This is also a central concept of my other ten-year project, *Forest of Stone Steles – Retranslation and Rewriting of Tang Poetry*. The plan of the large "temple" formed by *united 7561 kilometers* is conceptually based on two elements: the entire roof and the walls are shaped by just one long hair braid, while the column is about language. It is a composition combining human nature and artificial nature. Artistically, my works are usually monumental in scale but intricate in their details and symmetrical in structure, with a center and surrounding elements.

DC Why do two of the panels in the central column feature nonsensical Arabic and English, respectively, while the others all bear a single, large character?

WG Those two panels are there by mistake. I thought they were like all the other hair panels in the stack in my studio when the transportation company came to pick them up. I found out they were different when I was actually doing the installation. The panels were supposed to be uniform.

DC Why, other than for aesthetic reasons, have you suspended lights inside the central hair column?

WG It is purely for aesthetic reasons. The human hair panels will sparkle continuously with the lights behind them. It is gorgeous—it is like the body waste transcends into a rising spirit.

DC At the opening of your exhibition in Denton, you engaged a local hairdresser to cut the hair of volunteers to be pressed into a hair brick, and you arranged for a performance to be staged in the foyer occupied by *united 7561 kilometers*. To the music of Chicago-based electro-acoustic composer Olivia Block, which combined taped sound and live music by five wind players from the UNT College of Music, Mary Lynn Smith of the UNT Dance and Theater Arts Department performed a striking, improvised dance in and around your piece, beginning inside the hair column and later moving through both of the walls of hair braids. This is not the first time you've arranged for music and dance performances to be staged in conjunction with your *united nations* works. Can you describe how these collaborations come about and the significance you attach to them? And can you address in particular the importance of physical interaction between the dancers and your hair installations?

WG Olivia Block's music and Mary Lynn Smith's dance under my temple-like installation were, just as you pointed out, striking. The music and the dance are cohesive themselves as well as cohesive with the installation. I think that Olivia and Mary Lynn worked precisely in a way to interpret my art installation and enriched and extended its meaning. As I suggested earlier in our interview when discussing my use of large scale balanced with intricate details, center balances against surrounding elements. I am always interested in creating balance in my artistic creations. In this instance, it is a question of balance between the serious and silent nature of the work and the moment of celebration and spectacle embodied in the performance. The performance brings out the spirit of the installation, if it is the right performance and presented under the right circumstances.

I've thought of several points concerning the performances staged during the openings of my exhibitions. First, by its very nature an "opening" (whether of an exhibition or anything else) is about celebrating something—it is about the "spectacle" of an event. Designing a performance to incorporate within a large installation at the opening event is conceptually profound and strategic. Second, there is the significance of my use of human body materials, which I have characterized as a "ready made subject," as "silent-selves," and as "post-life" (see my thesis, "the divine comedy of our times"); the body materials used in my art works are permanently "silent" and "post" life while the performing bodies are temporary and "alive." Thus in the juxtaposition of the installation and performance you can see clearly the wonderful balance between "silent" and "alive," between the permanent and temporary "subject."

The last point related to performances with the installations is that instead of the viewing audience remaining silent in front of an art object, as it does traditionally, the art made from human body materials provides a way to close the gap between the audience and the "subjective art work"—both are the same but in different life stages. As a result, the audience is drawn into the work. You look at the work as you look at yourself. Conceptually, the performance incorporated with the installation has the same function: its function is to get more people involved with the work.

1 Melissa Chiu, conversation with the author, Januray 2003.
2 Wenda Gu's original email responses were all written in lower case letters.

Works in the exhibition "Wenda Gu: from middle kingdom to biological millennium"

Forest of Stone Steles – Retranslation and Rewriting of Tang Poetry, 1993 – 2003
 Six stone steles (#10 – # 15)
 Six ink rubbings (#10 – # 15)

 Stone stele dimensions:
 190 cm (length) x 110 cm (depth) x 20 cm (height)
 (75 in x 43.5 in x 8 in)
 Each stone stele weight: 1.3 tons
 Each ink rubbing dimensions:
 97 cm x 180 cm
 (38 in x 71 in)

Each stele contains a poem from the Tang dynasty (618 – 906 A.D.) by Chinese scholars such as Li Bai, Du Fu, and Wang Wei; a translation into English by Witter Bynner; a phonetic retranslation back into Chinese characters; and a poem by Wenda Gu. The poems and translations are inscribed on the steles by hand. The original poems are in Chinese and translated into English by Witter Bynner (Witter Bynner, *The Jade Mountain* (New York: F.S.G., 1952)). The phonetic sounds of Bynner's translation are then transformed back into Chinese so that when it is spoken in Chinese it sounds like the English of Bynner's translation. Wenda Gu then creates new poems from selected sound-words which are also inscribed on the steles. The complete *Forest of Stone Steles* consists of fifty stone steles. All steles were carved in Xi'an, China.

Tea Alchemy, 2002
 30,000 sheets of tea (rice) paper made out of 4000 pounds of green tea with metal tea powder spreader and 100 pounds of green tea powder, Chinese classic accordion painting book made of green tea paper.

Created at Hong Ye Rice Paper Factory, Jing County, Anhui Province, China, 2001 – 2002.

Commissioned by Chado International Cultural Foundation, Japan, Etoen Company and Asia Society and Museum, New York, New York, U.S.A.

Ink Alchemy, 2000 – 2001
 Three boxes of liquid ink
 Three boxes of ink sticks made of powdered hair (Chinese)
 Ink stick, glass jar of human hair, glass jar of semi-charred human hair, glass jar of powdered human hair.

 Manufactured at Cao Su Gong Ink factory, Shanghai, China.

Hair Bricks, 1994
 Six human hair bricks

Enigma of Birth, 1993
 Powdered human placenta (normal, abnormal, aborted, still born) in four glass jars sealed with beeswax.

united nations – united 7561 kilometers
 Hair, glue, and rope.
 5000 meters of human braids from
 7561 kilometers of human hair with rubber stamps of 191 nations of the world.

The exhibition is accompanied by the following video documents:
"Making *Forest of Stone Steles*"
"Making Genetic Ink"

{Forest of Stone Steles – Retranslation and Rewriting of Tang Poetry, 1993–2003}

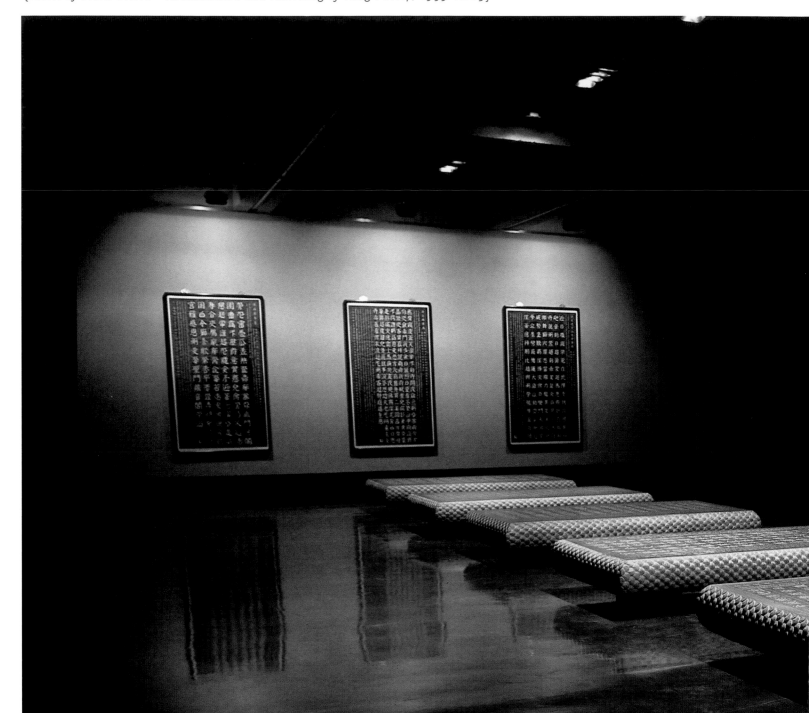

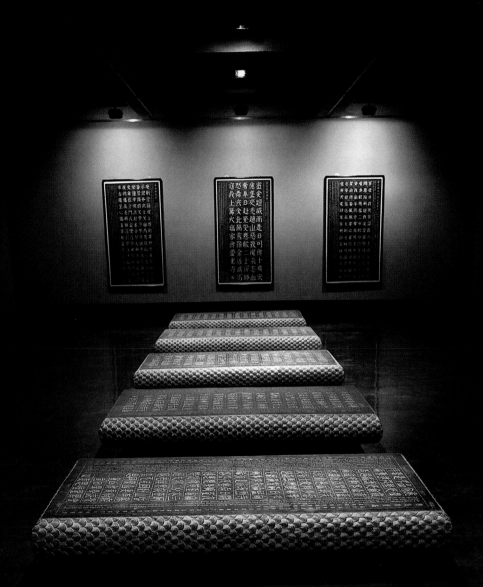

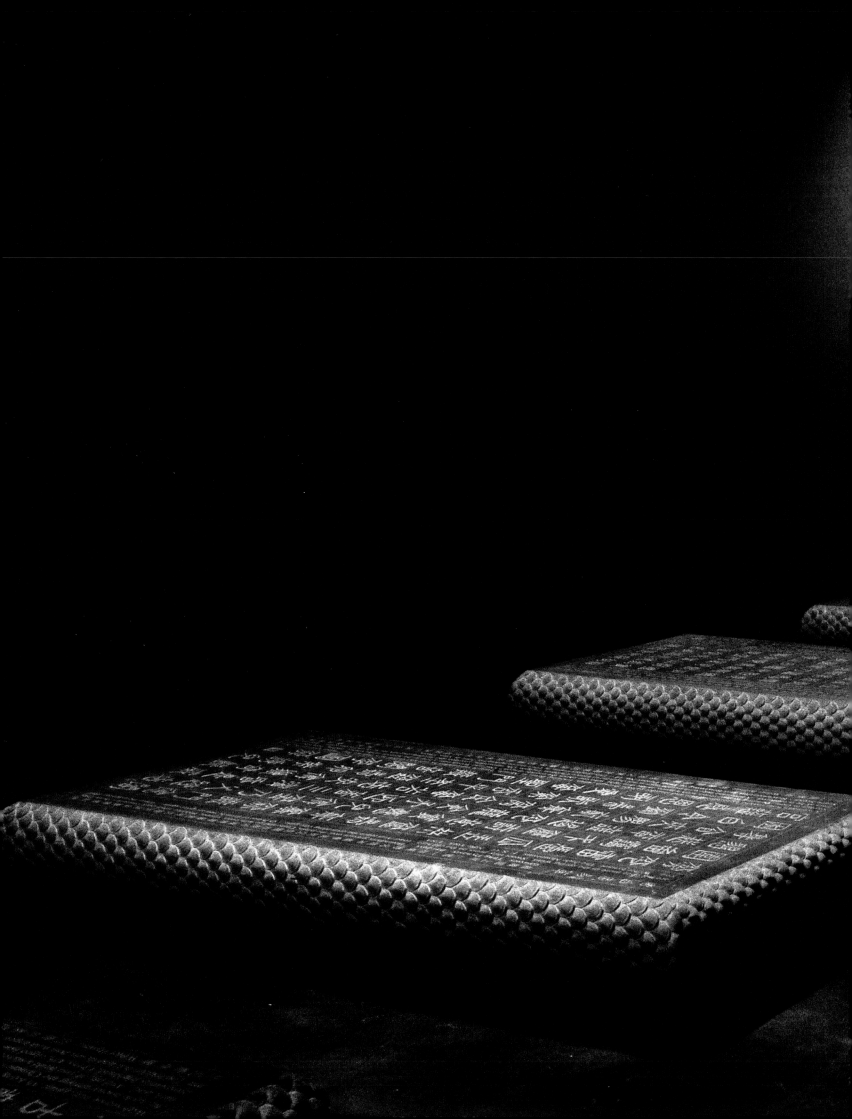

{*Hair Bricks*, 1994}

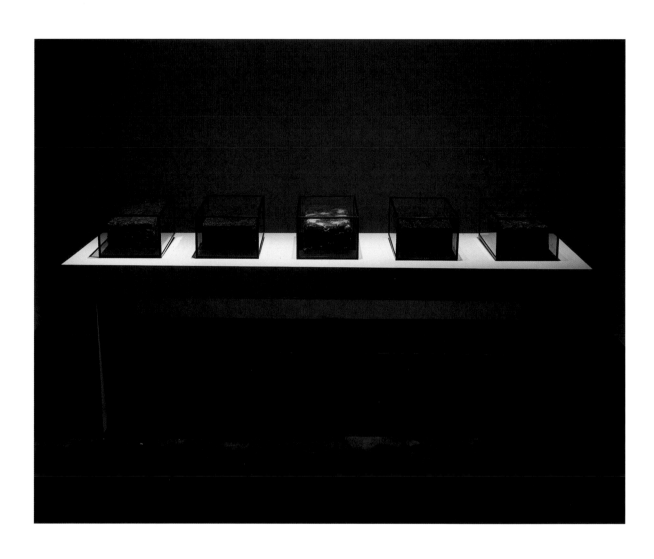

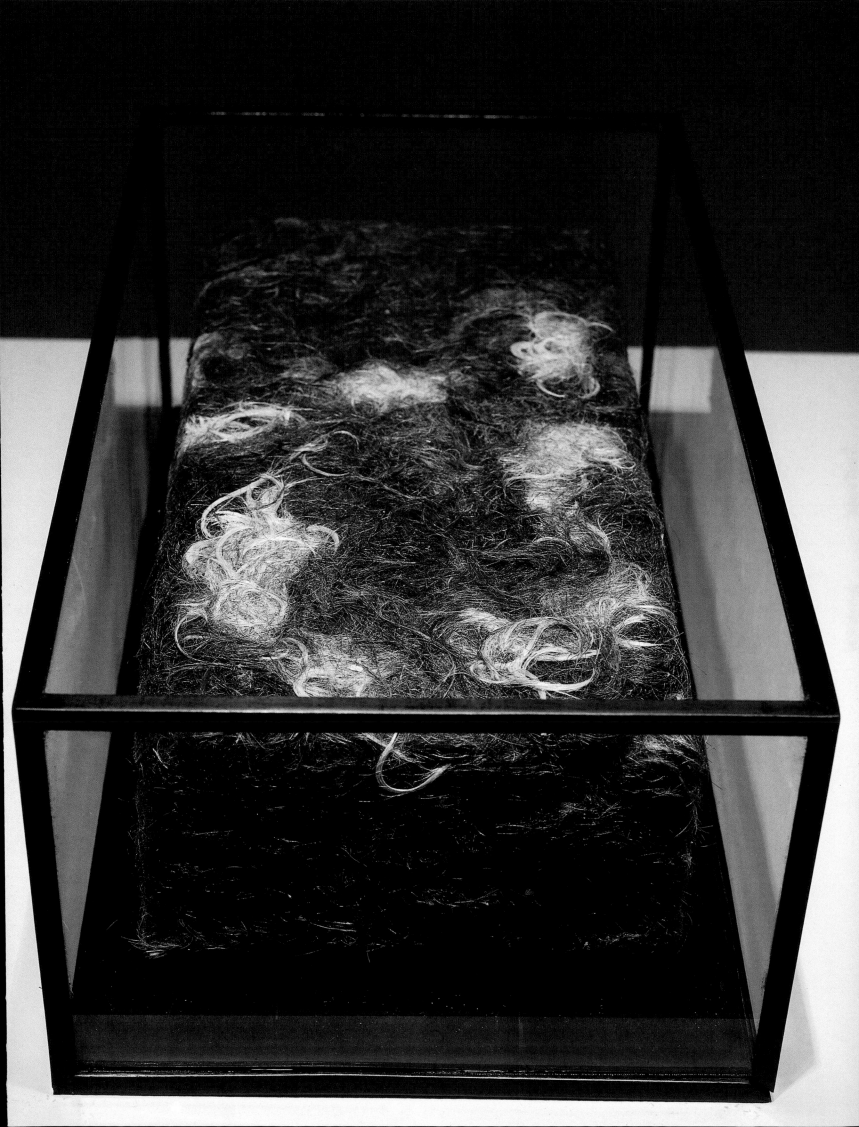

{*Enigma of Birth*, 1993}

{*Enigma of Birth*, 1993}

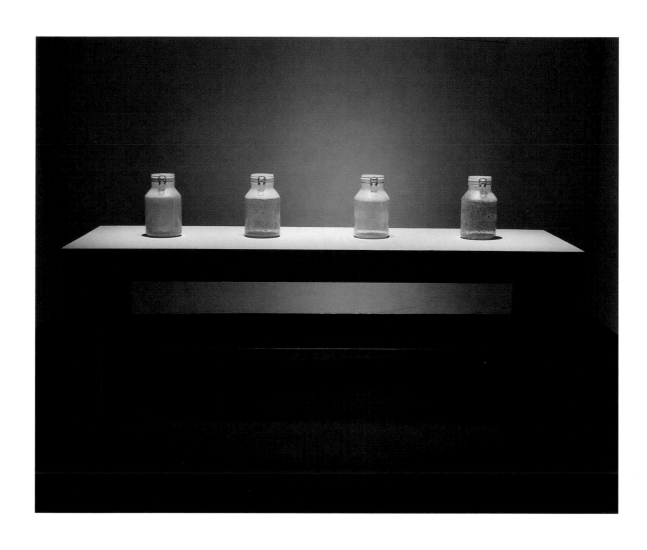

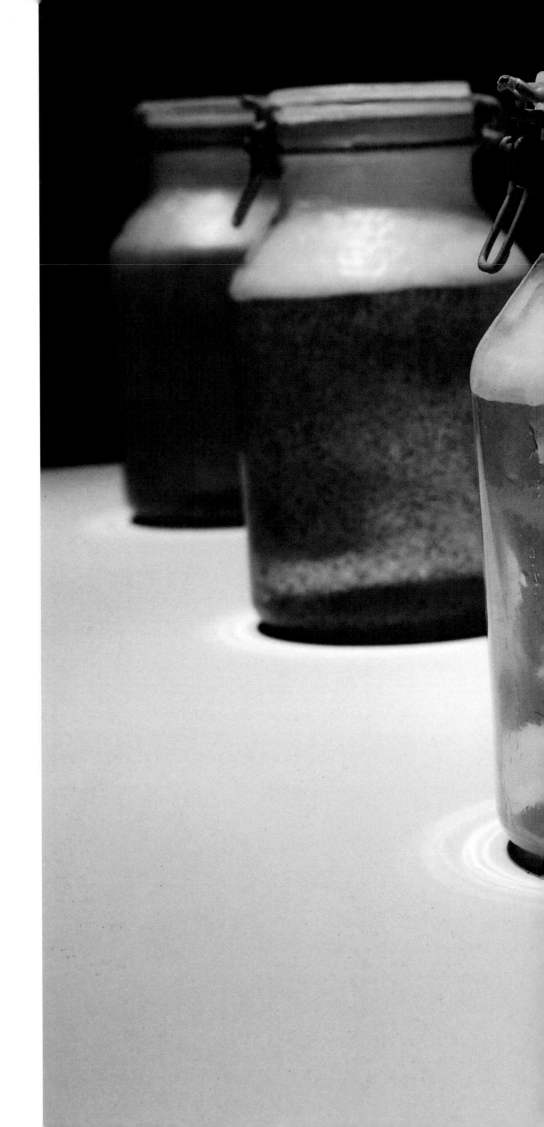

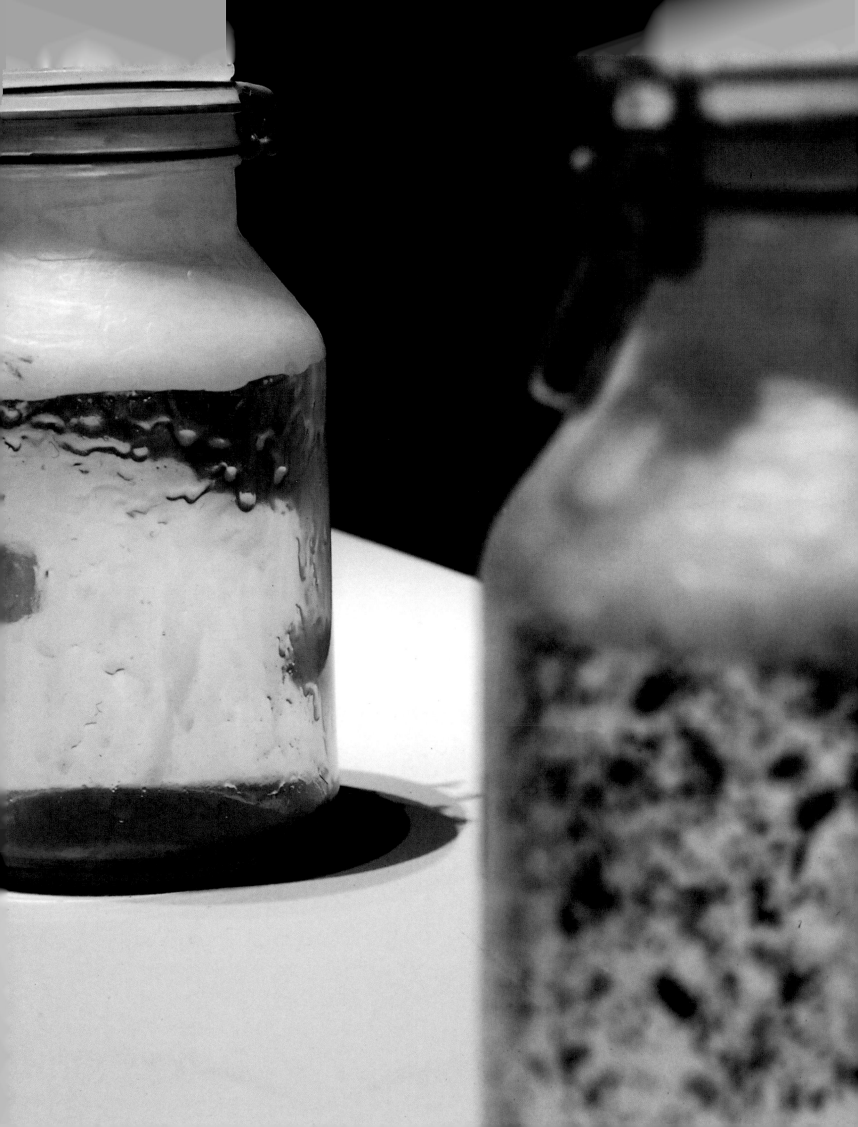

{*united 7561 kilometers, 2003*}

Tradition and Confrontation

Neo-Hexagram: Early Work

Gan Xu

In 1985 Wenda Gu became a national figure in *Guohua* (Chinese ink painting) due to his conceptualization of traditional Chinese character-painting.[1] Some Chinese ink painters even stated that 1985 was the year of Wenda Gu in Chinese ink painting.[2] This critical acclaim however, meant little when Gu's first solo show opened at the Gallery of the Artist's Association of Shangxi Province in Xi'an in 1986. The officer from the Department of Propaganda of Shangxi Province deemed Gu's work unacceptable for public viewing and locked up the exhibition allowing only those with written permission from the President of the Association to view the show. As an art history graduate student at the Xi'an Academy of Fine Art, the little bit of the show that I saw was through a small hole in the door. I did not have written permission to see the exhibition. Xiao Fen, the Communist Party Secretary of the Zhejiang Academy where Gu taught, summed up the Association's beliefs regarding Gu's work when he referred to them as "pornographic, vulgar, obscene, and superstitious."[3] Ultimately, Wenda Gu was removed from the Department of Chinese Ink Painting and left China in 1987.

Fig. 4.1
Three Goddesses, 1982.

Almost from the start of his career, Gu's paintings were controversial. His works challenged Party orthodoxy regarding art as promoted in Mao's era and again during the chilling Anti-Spiritual Pollution Movement of 1982–84, a political movement that some Chinese intellectuals called "The Second Cultural Revolution." These conservative views regarding art remained in effect in China until December of 1986 when a new Anti-Bourgeois Liberal Campaign began. An example of Gu's work that was attacked during this period is his *Three Goddesses* (1982) (fig 4.1). In this work, Gu explicitly depicted a woman's vagina, a subject virtually unseen in art after Mao took power in 1949. Gu's work continued to be criticized throughout the mid 1980s, especially after January 1983, when the official art magazine *Meishu* (*Art*) promoted "Revolutionary Realism," and the Sixth National Art Exhibition in 1984. Unmistakably, this exhibition demonstrated the official orthodox, it was dominated by works promoting Revolutionary Social Realism.

It was during this period that Gu began using large red "Xs" in his work. "Xs" and "Os" had been used by Chinese teachers for centuries as a way of disapproving or approving of a student's calligraphy. In addition, "Xs" were also used by officials of the dynastic Chinese government to cross off the names of criminals who were to be beheaded. In his work, Gu expands the negative connotations of the "X" already held by the Chinese—the "X" becomes the means by which he literally crosses out all forms of repression and tyranny. In *Totem and the Society of Taboo* (1986) (fig 4.2), Gu paints a large, red "X" over a mouth. The image can be read both literally and metaphorically. The literal meaning is "no spitting." The metaphorical meaning is Gu's way of indicating the lack of free speech in China. In *Sounds of Exclamations When Tied Up— Gu!Gu!Gu!* (1986) (fig 4.3), Gu paints huge Chinese characters that spell out his family name. The large format of the characters references the official posters produced during the Cultural Revolution. The meaning of this work, however, is more personal. It is Gu's denouncement of the government's cruelty against his family and the Chinese people as a whole during the ten terrifying years of the Cultural Revolution. Gu's

Fig. 4.2
Modern Meaning of Totem and Taboo, 1986

Fig. 4.3
*Sounds of Exclamations When Tied
Up – Gu! Gu! Gu!*, 1986

Fig. 4.4
Wisdom of the Blind, 1985

grandfather was an important figure in the "Chinese New Drama Movement" of the early twentieth century. In addition to being a professor at the Shanghai Drama Institute, he was also the author of the first modern Chinese drama, *Isolated Army*. During the Cultural Revolution, Gu's grandfather was accused of being a counter-revolutionary and sent to live in a farmer's kitchen in the countryside. He died alone without any of his children beside him. As a teenager, Gu must have seen his grandfather's name written on posters in huge characters, brushed over with red "Xs" by the Red Guards. These same crossed-out characters also appear years later in Gu's work. The images are transformed, however, from political propaganda to personal anger. The red of the image is no longer the bright, powerful red symbol of Communist China, but the swirling, agitated red of violently spilled blood. Gu's work represents a loud scream that echoes throughout the Chinese art world.

In searching for his own style, Gu states that he is "negating the [Chinese] tradition by utilizing Western art." He began using oil paints which allowed him ease of handling and an enormous range of possible techniques for laying down the pigment. He also began looking at Western art, adapting themes, subjects, and styles into his own work. In his self-portrait *The Wisdom of the Blind* (1985) (fig. 4.4), Gu used oil paint and a specifically Western subject. In the painting, he shows himself with his back to the viewer facing a painted bust of the Greek poet, Homer. In Western art, a painted or sculpted bust of Homer might be incorporated into a larger composition as a metaphor for the search for inner truth as opposed to outward reality. In his self-portrait, Gu uses the reference to Homer as a metaphor for his search for his own style—one distinct from traditional Chinese ink painting and landscape imagery. In *The History of Civilization* (1985) (fig. 4.5) we see once again, the influence of Western art on Gu's painting. In this work, it is clear that he was influenced by the works of the twentieth century Surrealist painter Salvador Dali. Like Dali, Gu explores the recreation of both visible reality and the invisible world of the subconscious mind. He expresses worldly negation with unworldly figures. He said that the painting presented "the world of my dreams and presence, it is the horror of my uncertain future."[4] Like so many of his paintings during this period, *The History of Civilization* was heavily criticized. The official Chinese criticism aimed at rebelling artists like Gu resounded of Mao's intimidating statements, which accused the artists of "blindly imitating Western modern art, some works of which are preposterous, some express the mood of aloofness, void, depression, hesitancy, dispiritedness, craziness.... We must not replace our proletarian ideas with bourgeois ideas...."[5] Gu's obvious reliance on Western modernism was both culturally and politically offensive to conservative Chinese critics.

Eventually Gu abandoned his Dali inspired painting not because he feared being persecuted, but because he had begun pursuing a new interest. In his studies of Western art, Gu noticed similarities between Van Gogh's violent, swirling, mark making and the compact, drooping strokes made by the great Song Dynasty master, Fan Kuan. This discovery inspired his return to ink painting. Gu's already excellent command of traditional Chinese ink painting techniques can be seen in *The Smoky Mountains in a Silent*

Fig. 4.5
The History of Civilization, 1985

Fig. 4.6
*The Smoky Mountains in a Silent
Night*, 1980

Fig. 4.7
Remote Antiquity, 1983

Night (1980) (fig. 4.6). His command of these techniques provided him with a foundation for his later experiments with ink painting—experiments that allowed Wenda Gu to challenge tradition from within. His early avant-garde ink paintings reveal vestiges of Western art, particularly in his handling of the landscape. By 1983, however, Gu began incorporating carefully brushed Chinese characters into these landscapes, such as those seen in *Remote Antiquity* (1983) (fig. 4.7). His painterly handling of form reveals his interest in the characters themselves. Gradually the characters take on a dominant role in his works and Gu's interest in them shifts from the expressiveness of the forms themselves to their ability to convey conceptual meaning.

Chinese is the only language in the modern world that is both ideographic and pictographic. Unlike Western languages, the Chinese written language is formed by various combinations of standardized lines. These lines are the result of thousands of years of transformation from simple, stylized pictures representing objects in the visible world, to abstracted forms that can represent either a single word or a complete idea. Chinese is also the only language in which the characters can be arranged and read from left to right, right to left, and top to bottom. For centuries, Chinese characters have been encoded to express hidden ideas. Chinese emperors brutally persecuted people for their "word crimes," crimes based solely on the official

Fig. 4.8
Pseudo-Characters Series:
Contemplation of the World, 1984

interpretation of the meaning of the words written by the accused. This persecution continued under Mao. Gu's interest in incorporating characters into his paintings stems not from a desire to play word games like the dynastic scholars did; he was struggling to find his "*tushi*," or artistic schema. In Gu's case his "*tushi*" was to find a means to give visual realization to the unknown and to provide the viewer with a bridge to this unknown world. For Gu, painting is a matter of transforming the mystical experience of the inner self into the actual act of painting. It is through this act that he realizes his "*tushi*," specifically, the act of painting large Chinese pseudo-characters. Gu believes that the concise description of the complex ideas of the artistic schema is the unknown, infinite world; the simplicity of the artistic schema is the simplicity of human knowledge as compared with the infinite, unknown world.

Gu's *Pseudo-Characters Series: Contemplation of the World* (fig. 4.8), painted in 1984, marks the beginning of his new interest in both the act of painting and the painting of large, fragmented characters. In this work and others like it, Gu's "*tushi*" is a contemporary interpretation of the ancient idea of "*tu*" as defined by the ninth century art historian Zhang Yuanyuan in his "On the Origins of Painting." In this work, Zhang Yuanyuan states that

> the word for depiction, '*tu*' contains three concepts. The first concept is the representation of principles, and hexagrams are examples of this concept. The second concept is the representation of knowledge. This concept is best realized in the writing and studying of Chinese characters. The third concept is the representation of forms, and this is achieved through painting.[6]

In the pseudo-character paintings, Gu reinterprets these concepts as: unknown principle, fragmented knowledge, and abstract form. The most recognizable of these concepts is Gu's abstraction of nature and natural forms in his paintings. The landscape is transformed into large washes of ink across the page. The unknown principle is seen in the many variations of unknown characters included in his paintings. Although made up of fragments, Gu's neo-hexagram itself is read as a unified, single element. It becomes for Wenda Gu a means of representing the principles of the universe through combinations of abstract lines of the unreadable Chinese characters. Finally, fragmented knowledge is seen in the misplaced characters, erroneous characters, negative characters, upside-down characters, printed characters, and scrambled characters. Each of these fragmented characters, however, still carries some of their original meanings, cultural messages, and historical information. It is through the fragments that Wenda Gu achieves his "*tushi*." It is the pseudo-characters that allow him to convey additional messages and help him to represent the unknown world, the world Gu himself acknowledges he is unable to penetrate.

When looking at Gu's paintings, the deconstructed Chinese characters inhibit the viewer's attempt to interpret the character's exact meaning. Rather, the viewers are forced to face the "*tushi*" and to challenge preconceived notions of significance through word image. In many cases, Gu's paintings are pure imagery of Chinese written characters. These characters have been taken away from their original function to play a syntactical part in a sentence. They are detached, synthesized, misplaced, overlapped, miswritten, negated, and inverted to create an uncertain world. By rendering the uncertainty of the world, Gu wants viewers to feel dissatisfied with what they already know and to continue exploring the unknown world which, according to his words, includes "the nonobjective, uncertain, even the unspeakable feeling of human existence."[7] Gu's pseudo-characters allow the viewer to be stimulated by their vague and variegated elements. The viewer is able to create their own meanings and establish their own aesthetic interpretation of the paintings.

Gu's treatment of the Chinese characters reflects his own philosophy as influenced by the writings of Ludwig Wittgenstein. Using Wittgenstein's philosophy as a starting point, Wenda Gu believes that the written character is the visible manifestation of man's ability to reason. For Gu, intuition can penetrate into

those realms where reason cannot. Reason is limited because of the restrictive nature of the written character. Wenda Gu believes that reason reveals only a small part of the world and that preposterousness, weirdness, and fantasy hide in the dim area of the world's periphery. Our lives are confined within the demarcations of knowledge and reality, but the desire to go beyond the known is insatiable. The human desire to transcend the known universe will always drive us to explore and conquer. It will always encourage us to transform the ideal and deified world into reality.[8] Wenda Gu also believes that art is based first on our visual experience, and then on our ability to move beyond the visual and "see" the spiritual figure contained within the image. In order to visualize the spiritual figure, Gu created a new kind of Chinese ink painting, one in which new concepts and unique forms are perfectly balanced. Historically, Chinese landscape painting is an expression of ideas and spirituality. Zhon Bin, a fifth century Chinese landscape painter, pointed out that, "As for the landscape, it has physical existence, yet tends toward the spiritual."[9] Gu's words echo those of Zhon Bin. He said, "The objects in a landscape appear in the form of symbolic signs... [they] are embodied as concept... the objects are described as the spirituality of the subject."[10] In Gu's work, however, the embodiment of these ideas are no longer the mountains, clouds, trees, and streams seen in traditional Chinese ink painting, but abstract and semi-abstract ink marks that float across the page along with similarly abstract, pseudo-Chinese characters. Gu's ink paintings are not the expression of his personal emotions and ideas. Rather, they are a conglomerate expression intended to convey contemporary ponderings about the universe and the unpredictability of the world. Like many young artists in the early 1980s, Gu felt strongly that he had a responsibility to awaken the sleeping souls of the Chinese nation after the seemingly endless political unrest of the twentieth century. Gu's ink paintings are not ornaments to decorate an interior, nor are they the self-amusement of the modern literati. In order to intensify the expressiveness of his ink paintings, Gu abandoned the traditional ink painting format including traditional compositions, mark making, and methods of mounting and hanging his works. His ink paintings are monumental in size and have an extremely strong visual impact. Gu once declared that, "I paint not to provide visual pleasure, but to tremble the soul."[11]

Gu's audacious explorations, his new techniques, his elimination of individual brush stroke, and unreadable Chinese characters have allowed him to create a new kind of Chinese ink painting: conceptualized abstract ink painting. Gu's new ideas have released Chinese landscape painting from its ivory tower and brought it into the realm of contemporary expression. Although Gu is not the first Chinese artist to create abstract paintings, he is the first Chinese artist in mainland China to receive international recognition due to his conceptualized abstraction in ink. By creating an artistic schema, Gu's silent presentation always aims at the innermost realm of the individual's incomprehensible mind. His goal is to provide the viewer with a mystical inner-experience beyond clear comprehension. Meanwhile by using conceptualized languages that can be understood by viewers from both the East and the West, Gu has created images that reveal the psychological tension of the Chinese who face unprecedented social change from the new global economy.

For Wenda Gu, the act of painting is often a theatrical performance (fig. 4.9). His movements around and above the rice paper is not unlike that of a Shang dynasty priest. Four thousand years ago, the Shang priest performed the ritual of making and reading the cracks of burnt oracle bones. Through his reading of the cracks, the priest was able to predict the future, and interpret the unknown. Gu's goal is not much different from that of the Shang priest; he wishes to create images that allow the viewer to see into the unknown. Gu's explorations into ink painting have made him "the most original and authentic artist to emerge in China since the revolution."[12] He is a visual philosopher who records his thoughts in images, not words. His interest in the cultural heritage of both the East and the West has provided him with enormous visual vocabularies from which to draw. His unique perspective can be seen in both his pseudo-Chinese character ink paintings and in his later human hair installation piece *united nations*, a series of about twenty cultural commentaries created around the world. Like the Shang priest, Wenda Gu shows us his oracle, it is our turn to read it.

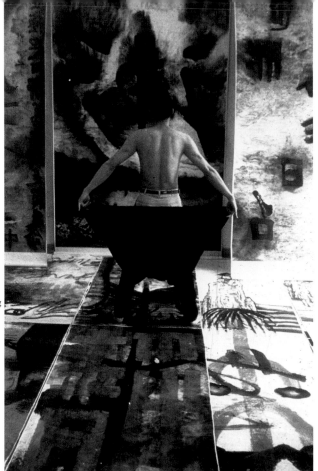

Fig. 4.9
Wenda Gu in his studio at Zhejiang
Academy of Fine Art, 1984.

1 For the purposes of consistency with the rest of the book, the editors have changed the author's original references to "Gu Wenda" to "Wenda Gu." See David Cateforis's interview with Wenda Gu for a detailed discussion of the cultural implications and complexities of the artist's name.

2 Chen Guoyong, Professor of Chinese Ink Painting at Xi'an Academy of Fine Art, personal conversation with the author, Xi'an, November 1985.

3 Michael Sullivan, *Art and Artists of Twentieth Century China* (Berkeley: University of California Press, 1986), 265.

4 Gu Wenda, letter to the author, 20 February 1988.

5 "45th Anniversary of Chairman Mao's *Speech on Literature and Art in Yian*," *Meishu*, (June 1987): 4.

6 Zhang Yuanyuan, "On the Origins of Painting," in *Li Dai Ming Hua Ji*, reprinted in Susan Bush, *Early Chinese Texts on Painting* (Cambridge: Harvard University Press, 1985), 51.

7 Gu Wenda, "On the Music of Painting" (master's thesis, Zhejiang Academy of Fine Arts, 1984), 5 (translated by the author).

8 Gu Wenda, "The State of Art," in *The Trend of Art Thought*, Wuhan, (August and September 1985), 21.

9 Zhon Bin, *Introduction to Painting Landscape*, in Susan Bush and Hsio-yen Shih, *Early Chinese Texts on Painting* (Cambridge: Harvard University Press, 1985), 38.

10 Gu Wenda, "Notes on Art," *The Artist*, Beijing, Jan., 1985, 6.

11 Wenda Gu, quoted in "Notes on Gu's Show," *Fine Arts in China*, Vol.33 (1986): 2.

12 Peter Selz, *Gu Wenda – 2000 Natural Deaths* (San Francisco: Hatley Martin Gallery), 1990.

The Cultural War: A Report From an International Exhibition – "Interpol"[1]
The Incident

Wenda Gu The international exhibition, "Interpol," which was co-organized by the Färgfabriken Center for
Contemporary Art and Architecture, Stockholm, Sweden and the Contemporary Art Center, Moscow, Russia,
focused on the dialogue and collaboration between eastern and western Europe after the Cold War.

At the opening on February 2, 1996 at the Center for Contemporary Art and Architecture, one of the
Russian artists, Alexander Brener, executed a drum performance accompanied by wild screaming. After sev-
eral minutes he turned his attention to my adjacent installation, *united nations: swedish-russian monument:
interpol* (see *united nations* plates), an eighty-four foot hair tunnel installation, as a target to attack. After
destroying my work, he immediately fled from the scene. In a matter of minutes, the entire collaborative
exhibition turned into the "headquarters" of a "cultural war."

Background on the "Interpol" Exhibition
About two and a half years ago, Viktor Misiano, director of the Contemporary Art Center in Moscow, and Mr.
Jan Åman, director of the Färgfabriken Center for Contemporary Art and Architecture in Stockholm, began a
dialogue about the psychological and mental separation and resulting conflicts after the collapse of the
Berlin Wall. The Wall's demise has not eliminated the differences between the larger political, social, and
ideological structures between East and West. In contrast, the collapse of the wall intensifies direct con-
frontation and reveals a psychological "Berlin Wall" which is more difficult to surpass. Both curators attempt-
ed to organize an international exhibition to address this historical phenomenon in art.

Both curators chose artists from Sweden and Russia as well as international artists. In October of 1994,
the curators and all of the artists had an initial meeting in Stockholm to discuss the subject matter of the
show and a series of collaborative project proposals between the Russian, Swedish, and international artists.
(Many of these collaborative proposals later collapsed.) The Russian artist Dimitry Gutov, known as a true
believer of Marxism in Russian avant-garde art circles, invited me to collaborate as a Chinese/American
artist. He repeatedly told me of his distaste for capitalism and the Russian reality today. At the same time, he
told me of his hatred for contemporary art. As a Chinese man who has been living in New York for eight
years, my role was as a "third party" somewhere in between these two groups of artists. I have a special sen-
sibility for the conflicts between these two groups because of my past and present experiences with both
socialist and capitalist societies. From the three days of discussion in Sweden, I could already feel the rising
tensions of a potential "cultural war." Instinctively, I predicted the potential for "danger." The Russian artists,
under the direction of their curator, Mr. Misiano, frequently attempted to conceptually command and occupy
the whole exhibition plan, even trying to control the show's catalogue. Evidently, this behavior reflected the
ambition of the Russian artists, who, from this collapsed superpower nation (the former Soviet Union),
exhibit a somewhat twisted notion of their former strength. Comparatively, the Swedish artists, who live in a
privileged Social Democracy, have never really experienced hardship and tragedy, not even during the Second

World War. Because of these disparate experiences, these two groups appear in theoretical dialogue from completely different natures. The Swedish are romantic, gentlemanly, even scholarly, while the Russians, having a great hunger and desire for better recognition, operate from a more aggressive and controlling point of view. At that time, I was thinking about how to represent the spoken and unspoken conflicts behind these two groups. I remembered making a joke during the break in the meeting saying that when artists play in center court, they need a referee, and I felt like I was the referee. The Moscow meeting let the Swedish artists understand how they are in the shadow of the Russian aggression and perhaps see that the artistic dialogue and the theoretical collaboration was just a pretense and a reflection of a political, cultural, and economic power game.

The Conceptual and Strategic Basis of My Participation

As an Asian artist living in New York, belonging neither to eastern or western Europe, my proposal was to continue my global *united nations* project and create the *swedish-russian monument: interpol.* The concept of the larger project takes into account all the regional dialogues and confrontations based on many differences. And because of the project's concept and scale, the work brings me into the unique position of being a "third party insider." My strategy was to try to symbolize the significant collaboration between eastern and western Europe. I decided to construct a pure hair tunnel made of Russian and Swedish hair. In the middle of the tunnel, I suspended a genuine rocket, loaned to me by the Royal Swedish army. The Färgfabriken Center for Contemporary Art and Architecture started to collect hair from about twenty barbershops beginning in July of 1995. In November of 1995, I went to Stockholm for a second time, to arrange for the production of hair bricks in a mineral fiber factory and to negotiate the loan of the rocket from the Swedish Defense Office. (Actually, it was not until the last moment that they agreed to the loan.) According to the political and cultural environment and the exhibition topic, this project was very effective in terms of its concept and material and artistic strategy. At the same time I gave a lot of thought to how this work could be visually powerful and stimulating. I wanted it to become a trap to take this dialogue to a new level. Before I left Stockholm, Mr. Jan Åman told me my work would occupy the central space as the main installation for the exhibition. With this knowledge, I intuitively felt the work could be a target for aggressive Russian artists to attack. In fact, my intuition was very correct.

The exhibition's psychological and realistic environment provided a very unique situation to consider how the installation work could hold all possible challenges. These external challenges became a device for the work itself to become more challenging. At this point, I decided to lengthen the hair tunnel to eighty-four feet and suspend the rocket at the entrance of the tunnel at the audience's eye level. The visual impression is that of running through the long, narrow hair tunnel as a hint of using "military action" to control the "cultural battle." I wanted the work to stand as a "referee" of cultural confrontation.

The third trip to Stockholm was one month before the show. Twenty days before the opening I began intensive work with assistants provided by the Royal Swedish Art Academy and the School of Arts and Crafts. Two days before the opening, I hung the rocket. Several times during the installation I found that different things, such as tape and wood sticks, had been placed on the rocket; I took this as a clear "warning." The evening before the opening, the Russian artist, Dimitry Gutov, executed his performance piece, "The Last Supper," and all curators and artists participated in his seafood dinner. After this dinner started, another Russian artist, Alexander Brener, said, "This collaboration between the East and West is a failure." I later replied to his statement saying, "You said that this collaboration failed. Actually it is your romantic ideology about a collaboration that failed." At that moment I could see clearly that it was just theoretical dialogue and I mentioned the dialogue between Beuys, Keifer, Baselitz, and Kounellis, in which Beuys predicted that a battle among races and cultures would ensue in the next generation of artists. Gutov's "Last Supper" fully predicted the danger veiled by the peaceful dinner. After the dinner one of the Slovenian artists said to me, "You're in danger." I responded with a smile of understanding and apprehension; at the same time I half believed he was kidding. Upon returning to my flat later that night, I deliberated upon the possible implications of that evening's performance dinner. Now as I suspected some type of foul play and prepared for a possible attack from the Russian side, even physical aggression, I returned to my previous idea which was to hang a large European Community flag above the rocket to deepen the significance of the symbols that were now coming under attack. But I did not imagine that the work would be destroyed, not even when another Russian artist mentioned to me that Alexander Brener and Oleg Kulik were the most dangerous artists in the Russian group.

The Opening Reception of "Interpol"– Cultural Battle
During the opening, the Russian performance artist, Alexander Brener, loudly screamed while he played a set of drums at the front of my installation. I was paying special attention to him at that time as I was videotaping his performance. Observing him through the video camera lens, I realized that he was not emotionally engaged with his playing. Rather, he was carefully watching the audience's behavior and paying close attention to my every move. I left the exhibition space momentarily to receive friends in an adjacent part of the building. One minute later, a German artist came running up to me shouting that Brener had destroyed my work. I immediately followed him back to the show to find the audience of about one thousand in absolute silence, staring at my piece in shock. At that moment, I was very emotional; I had never experienced a situation like that before. The work looked like the aftermath of a terrorist bombing. Because of the materials and nature of the work, with its hair, flag, and rocket, the installation now resembled a battleground. About ten minutes later, the audience regained their composure; some of them called newspaper reporters, the local radio and TV stations, while the Center notified the police. The French art critic, Olivier

Zahm screamed, "This is absolutely a neo-fascist action!" Another French writer, Elein Fleiss, came to me and suggested that if I intended to have a lawsuit, she would like to be a witness. When the police arrived, they arrested the other Russian artist who performed as a chained, naked dog as he attempted to attack and bite a two year old baby. Some audience members actually kicked him in the face. Meanwhile Brener escaped from the premises immediately after his actions.

The media arrived and reporters interviewed me as well as Jan Åman and the Russian curator, Viktor Misiano. Misiano explained that the exhibition created the perfect stage for a dialogue and collaboration between eastern and western Europe. At that moment, I requested that the director of the Center hold a formal press conference the next day. The French critic, Mr. Zahm, asked me to remove the work by saying, "It's not your work anymore. It's been damaged by the fascists." Now having had time to regain my rationale, I responded to him by saying, "Whatever happens to my work, it is still my work. Whatever transpires from it becomes a symbol and testament of its existence."

This incident evoked a deeper, symbolic significance in my global art project *united nations*. The combination of my position as creator of the work, born in China but now residing in the United States, together with the Russian artist's "participation" in the piece, symbolizes the power structure of the world: China-America-Russia. It perfectly represents our present day cultural reality as we transgress into a global community.

Several years ago, I recall reading an article by Samuel Huntington of Harvard who predicted that the essence and focus of the twenty-first century would be the cultural conflicts among nations, races, and differing cultures. The destruction of my installation serves as a testament to the cultural conflicts that have already begun. But cultural conflicts have always been a part of human civilization; bloody religious wars are an obvious example. Historically, cultural "battles" were hidden behind gentlemanly intellectual discussion and further restricted from physical action by geographical separation. Paraphrasing two Chinese idioms, we once "lamented our littleness before the vast ocean"; yet, now we have transgressed our physical boundaries so that we can "fight at close quarters and engage in hand to hand combat; we can speak frankly, not mincing words." This is our migratory cultural reality.

The following day, the Färgfabriken Center for Contemporary Art and Architecture held my requested press conference. In the beginning I pointed out that this incident was not personal and my speech was neither defensive nor offensive. I stated that I saw this "performance" as a mirror reflecting a political and economic power game. I did not see the use in simply labeling the actions of the artists as neo-fascist or neo-nationalistic and suggested that we needed to analyze them on different levels. First of all, on the level of their actual action, it was a "crime." On an artistic level, it was a repetition of old Dadaist ideology. On a purely ideological level, the action relates to a deep historical, cultural, social, and political background. The artists and the curator are not neo-fascists; they are Russian Jews who are not embraced by Russian

nationalists in their own country. But their ideology and action abroad has many links to a brand of nationalism and Communism, which has many tendencies similar to Nazism, with its inherent dictatorial formats. In the Western art scene, Mr. Misiano is well respected as a scholar and curator. Yet within his own country, he encourages artists to act with aggression reflecting a nationalistic attitude.

Alexander Brener's potential impetus for destroying the installation reflects the reality of Russia today—a politically, economically, and socially degenerated, chaotic, and frustrated society. Historically Russia has existed as a superpower in this world; yet, the country's great confidence and aggression have been undermined in the current environment. The incident of destroying art may have been inconceivable for Swedish people, but as a U.S. resident coming from Socialist China, I can understand it from both capitalist and socialist perspectives. These well-known Russian avant-garde artists are known to stand against Communism with pride. With the downfall of Communism, these heroes lost the target of their attack. They shifted their attentions to power structures in the West—the killer of Communism. On the one hand, they eagerly chase Western material civilization and recognition; on the other hand, they hate being subservient. This kind of unsolvable predicament is their ideological base. Gutov repeatedly said to me, "I hate Russia today and I hate contemporary art." But these artists are the representatives of Russian contemporary art and it is not difficult to imagine this paradox. Interestingly, the criticism of this incident from the European artistic community was more theoretical in nature. But from an American point of view, there was simply one answer: process a lawsuit against the artist and put him in jail. You must prevent this type of action from happening again in the art world.

On an artistic level Brener's action has no significance at all. The Dadaists threatened to destroy art museums but ironically, after forty or fifty years, the museum system has not only *not* disappeared, but it is still a dream-like goal for artists. One could draw the conclusion that subversion and invention has its value to civilization's history only when it follows indisputable and universal objective law. Strictly speaking, as ideology, Dada has its ultimate significance in art; but some aspects of Dadaism, when brought into physical practice become false according to universal law. It is possible that Brener did not fully acknowledged his performance according to this separation of ideology versus fruition as he acted out Dadaist concepts in a frustrated act of aggression. Was Brener's intent to mimic historical acts of such Dadaist predecessors as Marcel Duchamp, or Manzoni, or the more contemporary Jeff Koons? If so where is the sophisticated subversion and strategy evident in the "silent violence" of Duchamp's urinal? In the past, many destructive happenings have occurred which now appear as insignificant and only for the sake of temporary publicity. Mr. Brener may not have deeply considered the sophistication of today's contemporary media; his old-fashioned shock-value might be easily dismissed. Instead of addressing his actions, Mr. Brener immediately fled the scene. He said in the press conference that the show had no reason to exist, that the collaboration was a failure, and that Wenda Gu's work should not exist in the exhibition. In our reality, art stands for freedom and is

regulated by democracy. This pair of counterparts directs human development.

Mr. Misiano said that this incident brought up an essential stage for the dialogue between eastern and western Europe. I believe this has some validity, but one cannot admit that a crime is reasonable. As humans, we still have the responsibility of knowledge, basic humanity, and common destiny. With his words, Mr. Misiano misses this basic human position; as an intellectual, he loses his authority.

Postscript

At the opening many people from the audience came to me in tears expressing their sorrow. I repeatedly replied to them that I interpreted Mr. Brener's "destruction" as a "special participation" in my global art project *united nations*. I feel sorry for him. This work contains thousands and thousands of Swedish people's contribution. His "attack" put him in direct opposition with the Swedish people.

On the day after the attack, one Russian artist came to me inquiring if the Center had any insurance. A Slovenian artist suggested, "If you could get money from the insurance company, you could use it to sponsor Mr. Misiano's wife's art magazine and the Russian artists." While still deliberating over the incident itself, and recognizing a blind lust for gain, I could only respond with a laugh.

For the sake of my *united nations* global project, I said to Mr. Brener, "Thank you for your 'collaboration' and have a good trip back to Moscow." Mr. Misiano came to me and said: "I remember there was a postage stamp with a picture: Stalin and Mao are shaking hands — the Russian and Chinese are great friends...." The "Interpol" exhibition incident has left ice cold relations between the Swedish, Russian, and international artists. My installation bears witness to "The Cultural War."

1 This is an edited version of Wenda Gu's original essay "The Cultural War" which was written in February 1996 in New York following the incident at the opening of "Interpol." Two other versions, which were edited and published without the permission of Wenda Gu, appeared in: *Flash Art* (Summer 1996):102–103; and Eda Cufer and Viktor Misiano, eds. *Interpol: The Art Exhibition which Divided East and West* (Ljubljana, Slovenia: Irwin; and Moscow, Russia: *Moscow Art Magazine*, 2000), 39–41.

The symposium "Transnation: Contemporary Art and China" was held at the University of North Texas on the occasion of the opening of the national traveling exhibition "Wenda Gu: from middle kingdom to biological millennium." The symposium was moderated by Dr. Jennifer Way, Assistant Professor, University of North Texas and the participants included Melissa Chiu, Curator of Contemporary Asian and Asian American Art, The Asia Society and Museum, New York; Dr. David Cateforis, Associate Professor, University of Kansas; Rob Erdle, Regents Professor, University of North Texas; Wenda Gu, Artist; Dr. Jennifer Purtle, Assistant Professor, University of Chicago; Dr. Harold Tanner, Professor, University of North Texas; and Dr. Gan Xu, Associate Professor, Maine College of Art.

"Transnation: Contemporary Art and China"

Jennifer Way

Symposium Postscript

In describing one of the pieces in the exhibition, *Forest of Stone Steles*, Wenda Gu suggests that "whether a language is translated literally or through sound similarities, the translation itself generally becomes a reflection of the linguistic, political, [and] cultural environment of its time."[1] Works of culture signify an environment and vice versa, and viewers decode artwork and environment or, if you will, text and context. In myriad ways, the stone steles, together with the other works in the exhibition, navigate between middle kingdom and biological millennium. At the same time, they foreground location and the position of viewers in the physical spaces of the work, referring also to environments consisting of nationalities, ideologies, ethnicities, and spoken, oral, and visual cultures.

The title "from middle kingdom to biological millennium" is an important clue to comprehending how the exhibition reflects "the linguistic, political, [and] cultural environment of its time." After all, the title proposes transition between one era ("Middle Kingdom") qualified by place and time and another, a biological millennium that is not as easy to define. "middle kingdom" refers to China in general but also to the Chou empire of ca. 1000 B.C., whose members considered themselves the geographical and cultural center of the earth. This notion resonates in the official name for post 1949 China, *Zhonghua renmin gongheguo*, or "middle glorious people's republican country." In the exhibition, the title "middle kingdom," shifts to an era somehow embodied not necessarily politically, socially, or subjectively, but rather, organically ("biologically") and spiritually.

If it astounds while confounding, "from middle kingdom to biological millennium" does so by calling forth cultural traditions centuries old in China, not the least of which is writing predicated on elite scholarly practices of marking, seeing, and knowing. Interestingly, something very traditional also proved key to "Transnation: Contemporary Art and China," a symposium held at the University of North Texas on the occasion of the opening of "from middle kingdom to biological millennium."[2] Three art historians in addition to a historian, a curator, and an artist analysed the concept of looking, a theme American art historians of the twentieth century once considered essential to their practice, then too passé in its conventionality, and now

embrace as fundamentally complicating and implicit to art and art history.[3] In addition, and in contrast to catalogues surveying Wenda Gu's art as part of an encyclopedic presentation of the work of contemporary Chinese and specifically Chinese diasporan artists, "Transnation" asked participants to consider from the perspective of their own professions what "China" and "contemporary art" might mean in connection with one another. In this context, the symposium speakers remarked on the ways that Wenda Gu has moved across, beyond, and through cultural references, thus maintaining and even altering the meaning and significance of art that westerners associate with the nation they call China. In reference to this the artist explained,

> The classic definition of cultural migration is the transportation from one to the other. The future cultural migration is more complex. The formula is like this: one exports something to the other and then imports it back in a completely altered state. It never remains the same thing once it has been digested, interpreted, consumed, and used by the receiver. [4]

By emphasizing the notion of visuality and the gaze, symposium participants examined Wenda Gu's art in relation to the ways the artist views the world panoramically and dialogically ("one exports something to the other and then imports it back") and, as a result, discerns multiple horizons across which to travel or migrate.

Professor Rob Erdle was not alone in approaching the art of Wenda Gu as an oeuvre constructed of compelling images. He analyzed Gu's images from his own perspective as a watercolor artist exploring in the work various techniques and the provocative formal tensions between transparency and opacity, and mark and space. In addition, he viewed the installations as macro versions of Gu's respectful mastery of the subtleties of brush and ink painting that at one time he reserved for smaller scale, two dimensional works. He suggested that the art of Wenda Gu corresponds to traditions of calligraphy and watercolor painting which have for centuries shaped how viewers see the world and subsequently move through and conceptually locate themselves in it.

On the other hand, what do we learn about Wenda Gu's art when we scrutinize it idioletically, a term coined by Roland Barthes to refer to a "language of a... community, of a group of persons who all interpret in the same way all [visual] statements"?[5] In precisely this way, Dr. David Cateforis analyzed the artist's project *united nations—babel of the millennium* (1999) as a provocative, intertextual sampling of cultural references belonging to what westerners conceive as a history of art, including examples from ancient China, the Near East, the Northern Renaissance, and a typology of monuments. Furthermore, Cateforis intimated that both canonical and new art histories offer modes of looking that may enrich viewers' awareness of the contributions of Gu's art to a continuum of images and their attendant narratives and corresponding scopic regimes.

Dr. Jennifer Purtle explored the significance of installations and images in connection to a Chinese socioculture hardly shy when it comes to staring, especially during massive state rallies and parades but also in everyday life. She pointed out that in daily life the Chinese are accustomed to "spectacle," in other words, visual representations of political personages and events intended to be seen either in spaces for official

public events or in the mass print media where official statements appear before citizen readers. We might keep in mind that as an ideological practice, "spectacle" evokes concrete images of many kinds of experience useful in establishing and maintaining hegemony, including fear (spectacle of fear) and shame (spectacle of shame). Dr. Purtle wondered how the images Wenda Gu "digests, interprets, consumes, and uses" are reflected in his oeuvre. Are they conceived as a complex of images, relating to other dimensions of national legacies that shape image production and viewership? As with photographic representations of Mao that dominated the media in China at least until his death if not much later, does Wenda Gu's art enforce a dominant way of seeing political and cultural icons, such as Chinese characters? Dr. Purtle explored a recent tendency to dilute, even subvert iconic images of individuals having political significance in China during the twentieth century. Implicitly, she raised the question of whether in some way we can understand the art of Wenda Gu as sympathetic to this practice. For example, does its very lack of figurative imagery constitute a refusal to participate in a politics dependent on representations of the governing body?

Dr. Harold Tanner considered the ways of seeing belonging to a generation in China who experienced the Cultural Revolution, including its mandate to destroy what was traditional to Chinese civilization and bourgeois Western culture. As with literature and scholarly texts that the state treated as highly suspect during the Cultural Revolution but afterwards permitted to expand and encompass a dizzying array of new possibilities, does Wenda Gu's art propose practices of looking that transgress boundaries of presentation or viewership today?

Melissa Chiu reflected on the cultural stereotypes engendered in Wenda Gu's art when audiences in both the West and East view the artist as solely a member of the Chinese diaspora to Europe and North America. She questioned how individuals who do not consider themselves as part of any dispersion from a traditional homeland constitute "a group of persons who all interpret in the same way," that is, in a manner that may not approximate that of the artist.[6] Wenda Gu has articulately considered this subject:

> Post-literacy is the research on an interesting phenomenon of future cultural influence rather than the classical one. For instance, the man who invented the fortune cookie was the American-born son of a Chinese immigrant. Years later, the fortune cookie became a popular icon of "Chineseness" in America. Now China imports the American "Chinese fortune cookie." Similar things have happened in many other cultures as well. What does the legendary "American fortune cookie" mean? Is it a post-literacy symbol like the stone tablets project? What will American culture do to make my stone tablets different from China's ancient stone tablets?[7]

"Post-literacy" is a current cultural phenomena that develops as references to the visual culture and individuals belonging to one culture come into contact and intermingle with those of another. In this case, new positions generate new perspectives on cultural hybridity. What "post literate" habits of looking might individuals living in the East or West bring to Wenda Gu's art, steeped as it is in ancient and present day cultures of China along with those of contemporary America and Western postmodernism?

Finally, the symposium considered the complications inherent in the visual surface reality of Wenda Gu's art. How does the visuality of the work correspond to the gravity of its message or, conversely, allude to

the intensity of situations involving desires to see it or satisfactions inherent in its becoming visible? Dr. Gan Xu discussed the dangers related to acts of looking. He described prohibitions controlling who was permitted to see Russian-made color reproductions of Western modern art when he was a graduate student of art history in China, and the extremes he took to see them nonetheless. He detailed surprise and frustration that his elite status as a graduate student of art history in China failed to grant him visual access to an exhibition of the art of Wenda Gu, which Chinese state officials closed on the occasion of its opening in 1986. As proof that visibility confers authority and prestige, Gan Xu brought the symposium to a close by relating how his American professors of art history perceived Wenda Gu (the artist he insisted on writing about for his master's thesis and doctoral dissertation) as worthy of notice only when his work was reproduced on the cover of *Art in America*.[8]

1 Wenda Gu, email to author, 18 January 2003.

2 "Transnation: Contemporary Art and China" was funded generously by the Charn Uswachoke International Development Fund, Fine Art Series, and School of Visual Arts Visiting Artist and Scholar Committee, all of the University of North Texas.

3 Today art historians might consider the following texts as essentialist approaches to looking: Rudolf Arnheim, *Art and Visual Perception: A Psychology of the Creative Eye* (1956), Ross Parmenter, *The Awakened Eye* (1968), and Fred Dretske, *Seeing and Knowing* (1969). Other texts are viewed as once hegemonic and now interesting for their complex historical merit (George Nelson, *How to See: Visual Adventures in a World God Never Made* (1977)) and provocative in the ways they analyze ideologies in and of seeing: Guy Debord, *The Society of the Spectacle* (1967), John Berger, *Ways of Seeing* (1972), Hal Foster, *Vision and Visuality* (1999), Rosalind Krauss, *The Optical Unconscious* (1993); Maria Stafford, *Good Looking: Essays on the Virtue of Images* (1996), and Marita Sturken and Lisa Cartwright, *Practices of Looking: An Introduction to Visual Culture* (2001).

4 Wenda Gu, email to author, 18 January 2003.

5 Roland Barthes, *Elements of Semiology*, 1964 (reprinted, New York: The Noonday Press, 1992), 21.

6 Ibid.

7 Wenda Gu, email to author, 18 January 2003.

8 Cover, *Art in America* 87, no 3 (March 1999).

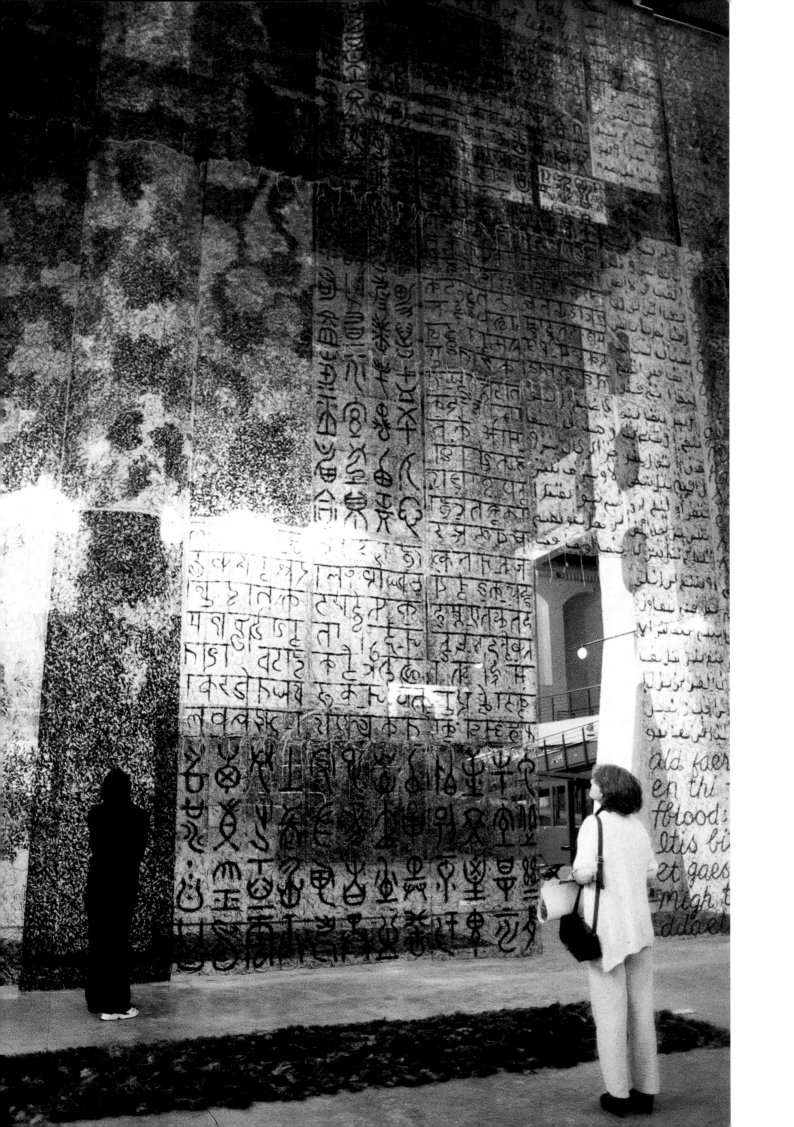

Exhibition History and Bibliography

1955 – Born in Shanghai, China
Lives and works in Brooklyn, New York, U.S.A.

EDUCATION
1976
Shanghai School of Arts and Crafts, Shanghai, China

1981
M.F.A. Zhejiang Academy of Fine Arts
(now China Academy of Arts), Hangzhou, China

1981–1987
Faculty, Zhejiang Academy of Fine Arts
(now China Academy of Arts), Hangzhou, China

1987
Moved to the United States of America
(Legal name change from Gu Wenda to Wenda Gu)

1987–1988
Assistant Professor of Studio Art, University of
Minnesota, Minneapolis, Minnesota, U.S.A.

> *UNITED NATIONS* EXHIBITION HISTORY

2003

united nations – united 7561 kilometers
"Wenda Gu: from middle kingdom to biological millenni-
um," University of North Texas Art Gallery, Denton, Texas;
H&R Block Artspace at Kansas City Art Institute, Kansas
City, Kansas; Institute of Contemporary Art at Maine
College of Art, Portland, Maine, U.S.A.

2001

united nations – australia monument: epnagcliifsihc
Site-specific installation with performance *Tug of War*,
National Gallery of Australia, Canberra, Australia.

2000

united nations – man and space
3rd Kwangju Biennale, "Man and Space," Kwangju,
Republic of Korea; Nigata International Art Festival,

Japan; with performance *Cultural Wedding #2*, (commissioned by Shiseido Company) Utsunomiya Museum of Art, Japan. First Chengdu Biennale, Chengdu Museum of Modern Art, Chengdu, China; National Museum of Contemporary Art, Seoul, Republic of Korea; Asian Civilizations Museum, Singapore.

united nations – great wall of the millennium
"Word and Meaning: Six Contemporary Chinese Artists," University at Buffalo Art Gallery, Buffalo, New York, U.S.A.

united nations – great wall of the millennium
Ewing Gallery of Art and Architecture, University of Tennessee, Knoxville, Tennessee; Kennedy Art Museum, Ohio University, Athens, Ohio, U.S.A.

united nations – temple exoticisms
Site-specific installation, 5th Lyon Biennale of Contemporary Art, "Sharing Exoticism," Lyon, France.

1999

united nations – babel of the millennium
Site specific installation, "Inside Out: New Chinese Art," San Francisco Museum of Modern Art, San Francisco, California, U.S.A.

1998

united nations – china monument: temple of heaven
"Inside Out-New Chinese Art," P.S. 1 Contemporary Art Center and Asia Society Galleries, New York, New York, U.S.A.; Museo de Arte Contemporáneo, Monterrey, Mexico; Tacoma Art Museum and the Henry Art Gallery, Seattle, Washington, U.S.A.; National Gallery of Australia, Canberra, Australia; Hong Kong Museum of Art, Hong Kong, China.

united nations – vancouver monument: the metamorphosis
Site-specific installation with performance, *Confucius Diary*, Morris and Helen Belkin Art Gallery, The University of British Columbia, Vancouver, British Columbia, Canada.

1997

united nations – taiwan monument: the mythos of lost dynasties
Site-specific installation with performance *Blackness*, Hanart Gallery, Taipei, Taiwan.

united nations – hong kong monument: the historical clash
Site-specific installation for "Hong Kong Handover," Hanart TZ Gallery, Hong Kong, China.

united nations – africa monument: the world praying wall
Site-specific installation with collaborative performance with choreographer Nomsa Manaka, Second Johannesburg Biennale, "Trade Routes: History and Geography," Institute of Contemporary Art, Johannesburg, South Africa.

1996

united nations – usa monument #2: dreamerica
Steinbaum Krauss Gallery, New York, New York, U.S.A.; National Museum of Contemporary Art, Seoul; Songe Museum of Contemporary Art, Republic of Korea.

united nations – sweden and russia monument: interpol
Site-specific installation, "Interpol," Färgfabriken Center for Contemporary Art and Architecture, Stockholm, Sweden.

united nations – britain monument: the maze
Angel Row Gallery, Nottingham; Camerawork Gallery, London, England.

1995

united nations – usa monument #1: post-cmoellotniinagl-piostm
Site-specific installation, Space Untitled Gallery, New York, New York, U.S.A.

united nations – israel monument: the holy land
Permanent land art project in Mitzpe Ramon Desert, "5th Construction in Process," Israeli Cultural Ministry and the Artists' Museum, Tel Aviv, Israel.

1994

united nations – italy monument: god and children
Site-specific installation, Enrico Gariboldi Arte Contemporanea, Milan, Italy.

united nations – holland monument: v.o.c. – w.i.c.
Site-specific installation, "Heart of Darkness," The Kröller-Müller Museum, Otterlo, Netherlands.

1993

united nations – poland monument: hospitalized history museum
Site-specific installation, "4th construction in process," History Museum of Lodz and The Artists Museum, Lodz, Poland.

2003

One Person Exhibitions

"Wenda Gu: from middle kingdom to biological millennium"
University of North Texas Art Gallery, Denton, Texas; H&R Block Artspace at Kansas City Art Institute, Kansas City, Missouri; Institute of Contemporary Art at Maine College of Art, Portland, Maine, U.S.A.

2002

Group Exhibitions

First Guangzhou Triennial
"Reinterpretation: A Decade of Experimental Chinese Art (1990–2000)"
Guangdong Museum of Art, Guangzhou, China.

"Babel Tower"
National Gallery of Contemporary Art, Seoul, Republic of Korea.

"Site-Sight"
Singapore Arts Festival, Asian Civilizations Museum, Singapore.

"New Way of Tea"
Asia Society and Museum, New York, New York, U.S.A.

"The Gesture"
Heidi Neuhoff Gallery, New York, New York, U.S.A.

"Translations / Transgressions"
Art Gallery, University of Rhode Island, Kingston, Rhode Island, U.S.A.

"Group Exhibition"
Art Beatus Vancouver, Vancouver, British Columbia, Canada.

"Translated Acts"
Carrillo Gil Museum of Contemporary Art, Mexico City, Mexico.

"Paris – Pekin"
Espace Cardin, Paris, France.

2001

One Person Exhibitions

"Ink Alchemy #3"
Sherman Galleries, Sydney, Australia.

"Translated Acts – Body and Performance Art from East Asia"
Performance *Wenda Gu's Wedding Life – Germany* (renamed *Wenda Gu's Wedding Life #4*), Haus der Kulturen der Welt, Berlin, Germany;
Queens Museum of Art, Queens, New York, U.S.A.

"Ink Alchemy #1"
Enrico Navarra Gallery, Paris, France.

Group Exhibitions

First Chengdu Biennale
Chendu, China.

"Abstract Ink Painting"
Xi'an Convention Center, Xi'an, China.

"20 Years of China Contemporary Ink Painting"
Guangdong Art Museum, Guangzhou, China.

"Word and Meaning"
Ewing Gallery of Art and Architecture, University of Tennessee, Knoxville, Tennessee; Kennedy Art Museum, Ohio University, Athens, Ohio, U.S.A.

"Power of Word"
Emerson Gallery, Hamilton College, Clinton, New York, U.S.A.

"China Without Borders"
Sotheby's, New York, New York, U.S.A.

"Water and Oil – Contemporary Chinese Woodcuts"
Art Beatus Vancouver, Vancouver, British Columbia, Canada.

3rd Mercosul Biennale
Porto Alegre, Brazil.

Second Biennial of Asian Contemporary Art
Museum of Contemporary Art, Geneva, Italy.

"Re: Duchamp"
49th Venice Biennale (Parallel Exhibitions), Venice, Italy;
Istanbul Biennial (Parallel Exhibitions), Istanbul, Turkey.

2000

ONE PERSON EXHIBITIONS

Wenda Gu's Wedding Life#2 – Hong Kong
Performance at Hong Kong Museum of Art, Hong Kong,
China.

GROUP EXHIBITIONS

"Futuro"
Contemporary Art Centre of Macau, Macau, China.

"Contemporary Art Collection of Shanghai Art Museum"
Shanghai Art Museum (grand opening), Shanghai, China.

"Neo-Chinese Painting"
Liu Haisu Art Museum, Shanghai; Jiangsu Art Museum,
Jiangsu, China.

"Power & Tenderness"
Taipei Fine Art Museum, Taipei, Taiwan.

"Wall"
Taiwan Museum of History, Taipei, Taiwan.

"The Big Apple Ink Painting Gallery Show"
Kaikodo Gallery, New York, New York, U.S.A.

"Word and Meaning: Six Contemporary Chinese Artists"
University at Buffalo Art Gallery, Buffalo, New York, U.S.A.

"Conceptual Ink"
Ethan Cohen Fine Arts, New York, New York, U.S.A.

"Michael Sullivan: Chinese Art Collection"
Ashmolean Museum, Oxford, England.

1999

GROUP EXHIBITIONS

"Contemporary Southeast Asia Letter Art"
Seoul Arts Center, Seoul, Republic of Korea; Iton Park,
Taipei, Taiwan.

"Power of the Word"
Taiwan Museum of Art, Taizhong, Taiwan; Victoria and
Albert Museum, London, England; Faulconer Gallery,
Grinnell College, Grinnell, Iowa, U.S.A.

"Global Conceptualism: Points of Origin, 1950s – 1980s"
Queens Museum of Art, Queens, New York; List Center
for Visual Arts, MIT, Cambridge, Massachusetts; Walker
Art Center, Minneapolis, Minnesota; Miami Art Museum,
Miami, Florida, U.S.A.

"Cross Culture"
Gang Gallery, New York, New York, U.S.A.

"Word on Word"
Ethan Cohen Fine Arts, New York, New York, U.S.A.

"Transience – Chinese Experimental Art at the End of the
Twentieth Century"
David and Alfred Smart Museum of Art, University of
Chicago, Chicago, Illinois; University of Oregon Museum
of Art, Eugene, Oregon; Hood Museum of Art,
Dartmouth College, Hanover, New Hampshire, U.S.A.

Fusion-Mythos of Lost Cultural Wedding
(renamed *Wenda Gu's Wedding Life #1*)
Performance at Asian Art Museum, San Francisco,
California, U.S.A.

Biennial of Asian Contemporary Art
Museum of Contemporary Art, Geneva, Italy.

1998

GROUP EXHIBITIONS

Second Shanghai Biennale
Shanghai Art Museum, Shanghai, China.

First Shenzhen Ink Painting Biennale
Guanshanyui Art Museum, Shenzhen, China.

"Inside Out: New Chinese Art"
P.S. 1 Contemporary Art Center and Asia Society and
Museum, New York, New York, U.S.A.; San Francisco
Museum of Modern Art and Asian Art Museum, San
Francisco, California, U.S.A.; Museo de Arte
Contemporáneo, Monterrey, Mexico; Tacoma Art
Museum, Tacoma and the Henry Art Gallery, Seattle,
Washington, U.S.A.; National Gallery of Australia,
Canberra, Australia; Hong Kong Museum of Art, Hong
Kong, China.

"4696/1998: Contemporary Artists from China"
Lehmann Maupin Gallery, New York, New York, U.S.A.

"Asian American Artists: Cross-Cultural Voices"
University Art Gallery, Staller Center for the Arts, State
University of New York, Stony Brook, New York, U.S.A.

"Global Roots: Chinese Artists Working in New York"
Purdue University Galleries, West Lafayette, Indiana, U.S.A.

"Beyond the Form"
Cork Gallery, Avery Fisher Hall, Lincoln Center, New York,
New York, U.S.A.

"Contemporary Art from China"
Art Beatus Gallery, Vancouver, British Columbia, Canada.

1997

GROUP EXHIBITIONS

"Hong Kong Handover"
New Convention Centre, Hong Kong, China.

"In Between Limits: An Aspect of Chinese Contem-
porary Art"
Sonje Museum of Contemporary Art, Seoul, Republic
of Korea.

"Auto-Portrait: The Power of Calligraphy"
Exit Art, New York, New York, U.S.A.

"Diversity"
Artopia Gallery, New York, New York, U.S.A.

"China Turns"
Art Gallery of York University, Toronto, Canada.

Second Johannesburg Biennale
"Trade Routes: History and Geography"
Institute of Contemporary Art, Johannesburg, South Africa.

1996

ONE PERSON EXHIBITIONS

"The Mythos of Lost Dynasties"
Binet Gallery, Tel-Aviv, Israel.

GROUP EXHIBITIONS

First Shanghai Biennale
Shanghai Art Museum, Shanghai, China.

"Scratch"
Thread Waxing Space, New York, New York, U.S.A.

"Interpol"
Färgfabriken Center for Contemporary Art and
Architecture, Stockholm, Sweden.

"Tradition and Innovation: Twentieth Century Chinese
Painting"
Köln Asian Art Museum, Köln, Germany.

1995

ONE PERSON EXHIBITIONS

"Enigma Beyond Joy and Sin"
Alternative Museum, New York, New York, U.S.A.

"The Enigma of Blood"
Khan Gallery, New York, New York, U.S.A.

"Oedipus Refound #2b"
Ise Art Foundation, New York, New York, U.S.A.

Group Exhibitions

"Tradition and Innovation: Twentieth Century Chinese
Painting"
British Museum, London, England; National Art
Museum, Singapore; Hong Kong Museum of Art, Hong
Kong, Great Britain; Steinbaum Krauss Gallery, New York,
New York, U.S.A.

1994

PERSONAL EXHIBITIONS

"Enigma Beyond Joy and Sin"
Art Gallery, The University of Rhode Island, Kingston,
Rhode Island, U.S.A.

"Oedipus Refound #3"
Berlin Shafire Gallery, New York, New York, U.S.A.

GROUP EXHIBITIONS

"Wenda Gu"
Art Omi, New York, U.S.A.

"Heart of Darkness"
The Kröller-Müller Museum, Otterlo, Netherlands.

"Site-Action, The Artists' Project"
Organized by The Artists' Museum, Lodz, Poland and The
Discovery Museum, Sacramento, California, U.S.A.

"Flesh & Ciphers"
Here Foundation, New York, New York, U.S.A.

1993

ONE PERSON EXHIBITIONS

"The Mythos of Lost Dynasties"
Hanart TZ Gallery, Hong Kong, Great Britain.

GROUP EXHIBITIONS

"China's New Art, Post-1989"
Hanart TZ Gallery, Exhibition Hall, Low Block, Hong Kong
City Hall, Pao Galleries, Hong Kong Arts Centre, Hong
Kong, Great Britain; Museum of Contemporary Art,
Sydney, Melbourne International Festival, Melbourne,
Australia; Vancouver Art Gallery, Vancouver, British
Columbia, Canada; University of Oregon Art Museum,
Eugene, Oregon, U.S.A.; Fort Wayne Museum of Art, Fort
Wayne, Indiana, U.S.A.; Salina Arts Center, Salina, Kansas,
U.S.A.; Kemper Museum of Contemporary Art, Kansas
City, Missouri, U.S.A.; Chicago Cultural Center, Chicago,
Illinois, U.S.A.; San Jose Museum of Art, San Jose,
California, U.S.A.

"Mao Goes Pop: China Post-1989"
Museum of Contemporary Art, Sydney, Australia.

"Fragmented Memory: The Chinese Avant-Garde in Exile"
Wexner Center for The Arts, The Ohio State University,
Columbus, Ohio, U.S.A.

"Semblances"
Ise Art Foundation, New York, New York, U.S.A.

Group Exhibition
Steinbaum Krauss Gallery, New York, U.S.A.

Group Exhibition
Art Space, Ontario, Canada.

"New Chinese Art"
Saw Gallery, Ontario, Canada.

"The Silent Energy"
The Museum of Modern Art Oxford, Oxford, England.

1992
ONE PERSON EXHIBITIONS

"Wenda Gu"
The Wallace L. Anderson Gallery, Bridgewater State
College, Bridgewater, Massachusetts, U.S.A.

"Oedipus Refound"
Enrico Gariboldi Arte Contemporanea, Milan, Italy.

GROUP EXHIBITIONS

"Desire for Words"
Hong Kong Art Centre, Hanart TZ Gallery, Hong Kong,
Great Britain.

"Signals"
Gallery Korea, New York, New York, U.S.A.

"Conversations"
The Artists' Museum, Lodz, Poland.

1991

GROUP EXHIBITIONS

"Exceptional Passage: Chinese Avant-Garde Artists
Exhibition"
Museum City Project, Fukuoka, Japan.

"New York Diary—Almost 25 Different Things"
P.S.1 Contemporary Art Center, Queens, New York, U.S.A.

1990

ONE PERSON EXHIBITIONS

"2000 Natural Deaths"
Hatley Martin Gallery, San Francisco, California, U.S.A.

"Wenda Gu: Red Black White Desert"
University Art Museum, California State University (Los
Angeles International Festival), California, U.S.A.

"Wenda Gu: Ink Works"
DP Fong Gallery, San Jose, California, U.S.A.

GROUP EXHIBITIONS

"de-"
Permanent land art project, La Arte Domain,
Aix-en-Provence, France.

1989

GROUP EXHIBITIONS

"China Avant-Garde – No U Turn"
National Gallery, Beijing, China.

"Blackness"
Hanart TZ Gallery, Hong Kong, Great Britain; Hanart Gallery, Taipei, Taiwan.

9th Annual Biennial
Sea Coast Art Association Gallery, Sea Coast Association, Stamford, Connecticut, U.S.A.

"Neo-Tradition"
Neodenfjeldske Kunstindstrimuseum, Norway.

1988

GROUP EXHIBITIONS

"Contemporary Tapestry of China"
Shanghai Exhibition Hall, Shanghai, China.

"China Calligraphy Today"
International Touring Exhibition officially sponsored by governments of China and Japan. Multiple official government venues.

"National Exhibition of Calligraphy"
National Gallery, Beijing, China.

"Last Exhibitionn '86, No. 1"
Hangzhou Cultural Center, Hangzhou, China.

"6th National Exhibition of China"
National Gallery, Beijing, China.

13th International Tapestry Biennale
Musée Cantonal des Beaux-Arts, Lausanne, Switzerland.

1987

ONE PERSON EXHIBITIONS

"Gu Wenda: The Dangerous Chessboard Leaves the Ground"
York University Art Gallery, Toronto, Canada.

1986

ONE PERSON EXHIBITIONS

"Young Art of Progressive China"
Gallery of the Artist's Association, Shangxi, Province, Xi'an, China.

1985

GROUP EXHIBITIONS

"Selected Contemporary Ink Painting From China"
International Touring Exhibition officially sponsored by governments of China and Japan. Multiple official government venues.

"National Art Exhibition of Sports"
National Gallery, Beijing, China.

"Neo-Ink Painting Invitational of China"
Wushang Exhibition Center, Wushang, China.

1979

GROUP EXHIBITIONS

"Shanghai Art Exhibition"
Shanghai Art Museum, Shanghai, China.

> SELECTED BIBLIOGRAPHY

Andrews, Julia F., and Gao Minglu, eds. *Fragmented Memory: The Chinese Avant-Garde in Exile.* Columbus, Ohio: Wexner Center for the Arts, Ohio State University, 1993.

Chang, Danielle. *American Division 'Post-Cmoellotniinaglpiostm': The United Nations Project, 1993–2000, An Ongoing Worldwide Art Project for the Twenty-First Century.* New York: Space Untitled, 1995.

Chang, Tsong-zung. *Power of the Word.* Grinnell, Iowa: Faulconer Gallery, Grinnell College, 2000.

Zhongguo xiandai yishu Zhan/China/Avant-Garde. Beijing: China Art Gallery and Guangxi People's Art Press, 1989.

Art Chinois. Paris: Association Francaise d'Action Artistique, 1990.

Cook Katherine, and Peter Selz. *Gu Wenda, 2000 Natural Deaths.* San Francisco: Hatley Martin Gallery, 1990.

Cufer, Eda, and Viktor Misiano, eds. *Interpol: The Art Exhibition which Divided East and West.* Ljubljana, Slovenia: Irwin; and Moscow, Russia: Moscow Art Magazine, 2000.

Des del País del Centre: Avantguardes artístiques xineses. Barcelona: Centre d'Art Santa Mónica, 1995.

Desire for Words. Hong Kong: Hong Kong Arts Centre, 1992.

Doran, Valerie C., ed. *China's New Art, Post-1989.* Hong Kong: Hanart TZ Gallery, 1993.

Du Pont, Diana C. *Wenda Gu: Red Black White Desert.* Long Beach, CA: University Art Museum, California State University, 1990.

Elliott, David, and Lydie Mepham. *Silent Energy: New Art from China.* Oxford: Museum of Modern Art, 1993.

Emenhiser, Karen, ed. *Word and Meaning: Six Contemporary Chinese Artists.* Buffalo, New York: University at Buffalo Art Gallery, 2000.

The First Academic Exhibition of Chinese Contemporary Art. Hong Kong: Hong Kong Arts Centre, 1996.

Fisher, Jean, ed. *Global Visions: Towards a New Internationalism in the Visual Arts.* London: Kala Press, 1994.

Force, Yvonne, and Carmen Zita. *4696/1998: Contemporary Art from China.* Vancouver, British Columbia: Art Beatus Gallery Ltd., 1999.

Gao Minglu, ed. *Inside Out: New Chinese Art.* Berkeley and Los Angeles: University of California Press, 1998.

_____. *Gebrochene Bilder–Junge Kunst aus China (Broken Pictures–Young Chinese Art).* Unkel/ Rhein: Horlemann, 1991.

Gao Minglu, et al. *Zhongguo dangdai meishu shi, 1985–1986.* Shanghai: Renmin Meishu Chubanshe, 1991.

Heart of Darkness. Otterlo, Netherlands: Kröller-Müller Museum, 1994.

Hoptman, Laura, and Tomas Pospiszyl, eds., and Ilya Kabakov. *Primary Documents: a Sourcebook for Eastern and Central European Art Since the 1950s.* Cambridge: MIT Press, 2002.

In Between Limits. Seoul: Sonje Museum of Contemporary Art, 1997.

Jose, Nicholas, ed. *Mao Goes Pop, China Post-89.* Sydney: Museum of Contemporary Art, 1993.

Kane, Anthony J., ed. *China Briefing, 1989.* Boulder, Colorado: Westview Press, 1989.

Leece, Sharon. *China Style.* Hong Kong: Periplus Editions, 2001.

Lucie-Smith, Edward. *Art Today.* London: Phaidon, 1995.

Lucie-Smith, Edward. *Art Tomorrow.* London: Weatherhill, 2002.

Lucie-Smith, Edward. *Movements in Modern Art Since 1945 (World of Art).* New Edition. London: Thames and Hudson, 2001.

Lucie-Smith, Edward. *Visual Arts in the Twentieth Century.* New York: Harry N. Abrams, 1997.

Mariani, Philomena, ed. *Global Conceptualism: Points of Origin, 1950s–1980s.* New York: Queens Museum of Art, 1999.

Noth, Jochen, Wolfger Pohlmann, and Kai Reschke, eds. *China Avant-garde: Counter Currents in Art and Culture.* Berlin: Haus der Kulturen der Welt; Hong Kong: Oxford University Press, 1994.

Oedipus Refound. Milan: Enrico Gariboldi Arte Contemporanea, 1992.

O'Riley, Michael Kampen. *Art Beyond the West: The Arts of Africa, India and Southeast Asia, China, Japan and Korea, the Pacific, and the Americas.* Englewood Cliffs, New Jersey: Prentice Hall, 2001.

Park, Young M., and Ann Eden Gibson. *Asian American Artists: Cross-Cultural Voices.* Stony Brook, New York: Staller Center for the Arts, 1998.

Parsons, Bruce. *Gu Wenda: The Dangerous Chessboard Leaves the Ground.* Toronto: York University Art Gallery, 1987.

Shanghai Biennale, 1996. Shanghai: Shanghai Art Museum, 1996.

Shanghai Biennale, 1998. Shanghai: Shanghai Art Museum, 1998.

Stokstad, Marilyn, David Cateforis, and Stephen Addiss. *Art History.* Volume 1, Second edition. Englewood Cliffs, New Jersey: Prentice Hall, 2001.

Sullivan, Michael. *Art and Artists of Twentieth Century China.* Berkeley and Los Angeles: University of California Press, 1996.

Tradition and Innovation: Twentieth Century Chinese Painting. Hong Kong: Hong Kong Museum of Art, 1996.

Turner, Caroline, ed. *Tradition and Change: Contemporary Art of Asia and the Pacific.* St. Lucia, Australia: University of Queensland Press, 1993.

Tzou, Shwu-Huoy. *Cultural-specific and International Influences on and Critical Perceptions of Five Asian Installation Artists: Gu Wenda, Yanagi Yukinori, Xu Bing, Miyajima Tatsuo, and Choi Jeong-Hwa.* N.p., 2000.

united nations-italy monument: god and children. Milan: Enrico Gariboldi Arte Contemporanea, 1994.

Wenda Gu: The Mythos of Lost Dynasties, 1984–1997. Hong Kong: Hanart TZ Gallery, 1997.

Wu, Hong. *Transience: Experimental Art at the End of the Twentieth Century.* Chicago: University of Chicago Press, 1999.

Xu, Bing. *Wen zi yu: Xu Bing yu Gu Wenda zhuang zhi yi shu zhan.* Xianggang: Xianggang yi shu zhong xin, 1992.

Xu, Gan. "Shape of Ideas: Minimalization as the Structural Device in Selected Works of Samuel Beckett and Gu Wenda." Ph.D. diss., Ohio University, 1994.

H&R Block Artspace at the Kansas City Art Institute

The H&R Block Artspace at the Kansas City Art Institute is honored to have the opportunity to partner with two dynamic academic institutions, University of North Texas Art Gallery and the Institute of Contemporary Art at Maine College of Art, to realize the ambitious exhibition, *"Wenda Gu: from middle kingdom to biological millennium,"* and this beautiful book.

This project incorporates the combined talent, resources, and support of three institutions to introduce the work of an important, internationally recognized, contemporary artist, thus providing the opportunity to further extend the reach and expertise of educational programs to an even greater community.

Founded in 1999, the H&R Block Artspace at the Kansas City Art Institute supports the creation and presentation of contemporary art through exhibitions, public art projects, and a range of innovative public programs and special initiatives. The Artspace is dedicated to creating unique opportunities for regional, national, and international artists to participate in programs that foster awareness of contemporary art, design, and culture within our community.

Founded in 1885, the Kansas City Art Institute is a private, independent, fully-accredited, four-year college of art and design awarding the Bachelor of Fine Arts degree in art history, ceramics, creative writing, design, fiber, illustration, painting, photography, printmaking, sculpture, and video. The mission of KCAI is to be a leader in visual arts and design education by preparing gifted students for lifelong creativity through interaction with preeminent faculty and facilities and by stimulating active public awareness, support, and participation in the visual arts and design.

The Artspace gratefully acknowledges the inspired leadership and continuing support of many, including KCAI President Kathleen Collins, KCAI's Board of Trustees, the Artspace Advisory Committee, KCAI's contributors, and its students, staff, and faculty. The Artspace is also grateful for the generous support of the H&R Block Foundation and the Missouri Arts

Council, a state agency, in their support of this project and many others.

Finally, the Artspace is extremely grateful to the artist, Wenda Gu; to Dr. David Cateforis, for an initial introduction to the artist and his work and for contributing an insightful dialogue with Wenda Gu for this book; and, finally, to our esteemed collaborators and co-curators, Diana R. Block and Mark H.C. Bessire, for their enthusiasm, their excellent leadership and professionalism, and their very dedicated commitment to "Wenda Gu: from middle kingdom to biological millennium."

University of North Texas Art Gallery

We are grateful to the following entities for project support: to the National Endowment for the Arts and the Andy Warhol Foundation for the Visual Arts for providing significant grant support. At the University of North Texas, we also thank the Texas Commission for the Arts, the Charn Uswachoke International Development Fund Grant at UNT, the UNT Fine Arts Series and the School of Visual Arts Visiting Artist and Scholar Committee for providing additional project funds. We sincerely express thanks to the following individuals for their invaluable services: Sara-Jayne Parsons (assistant to the director), Dornith Doherty (faculty), Jennifer Way (faculty), Brian Wheeler (exhibition design), Danielle Rissler (educational programming), Chen Xinpeng (gallery area assistant), Randall Friedman (head technician), and installations team Jim Burton, Baseera Khan, Kat McKinley, and Peevara Kheereemek. Furthermore we greatly appreciate the work of composer Olivia Block and faculty from the UNT Dance department (Mary Lynn Smith) and College of Music (Terry Sundberg, Tony Baker, James Gillespie and John Scott) for the opening performance in Denton.

Institute of Contemporary Art at Maine College of Art

The Institute of Contemporary Art at Maine College of Art (ICA at MECA) is pleased to collaborate with the University of North Texas Art Gallery in Denton and the H&R Block Artspace at the Kansas City Art Institute in Missouri, to realize this national touring exhibition of the Chinese artist, Wenda Gu. This project demonstrates how three contemporary art spaces at educational institutions can join forces to bring the work of an acclaimed artist to a wider, national audience.

The ICA at MECA features exhibitions and public programs that showcase new perspectives and new trends in contemporary art. Located in MECA's landmark Porteous Building in downtown Portland, Maine, the ICA presents innovative work in a range of media by influential national and international artists as well as emerging artists. A rich array of public programs enhance the ICA's exhibition schedule, including provocative talks by leading artists and critics, timely forums on current issues in art and design, and interactive workshops for young people.

The ICA is an essential part of the Maine College of Art's educational resources for students and faculty, and is free and open to the public. Founded in 1882, MECA is a dynamic college of art and design where nationally recognized faculty, interdisciplinary programs, state-of-the-art facilities and exhibitions give fresh vision to Maine's extraordinary legacy in the visual arts. MECA educates artists at all stages of their creative careers, offering BFA and MFA degrees, professional institutes, and a wide range of Continuing Studies classes for adults and children year round. To learn more about MECA, visit www.meca.edu.

The ICA is deeply grateful to the Maine College of Art Board of Trustees and its ICA Advisory Committee for its strong support of our work.

The generous support of the National Endowment for the Arts and The Andy Warhol Foundation for the Visual Arts have made it possible to realize this national touring exhibition.

One of the great pleasures of editing this book has been my close relationship with Wenda Gu. He responded to every complex and academic question with patience and elegance. It has been a pleasure and an honor to have the opportunity to present his work in this first book dedicated to his art.

Once again Charles Melcher and Margo Halverson of Alice Design Communication have designed a great book that conveys the power of art through type and image.

Without the dedication to education and the arts which Cindy M. Foley brings to the ICA, our projects would not reach the aspirations we set for ourselves.

Editing a book under the tutelage of Roger Conover is to experience the pride that publishing can offer editor, writer, and reader. He is forever on the edge of the art world reaching out to the margins where great art is found, bringing forth the classic relationship between art and book making.

From the moment Aimée Bessire began to read the manuscript, the book acquired a new nature and level of scholarly excellence. Her skill and artistry with words and ideas raised the level of discourse and brought new light to the manuscript. I am forever in debt to her for her talent, support, confidence, and care. She is a great teacher.

MARK H.C. BESSIRE is the director of the Institute of Contemporary Art at Maine College of Art and co-curator of the exhibition "from middle kingdom to biological millennium." He edited *William Pope.L: The Friendliest Black Artist in America* and co-edited *Iké Ude: Beyond Decorum*, both published by MIT Press.

DAVID CATEFORIS is associate professor of art history at the University of Kansas, where he teaches modern, contemporary, and American art. He earned his B.A. in art history from Swarthmore College and his M.A. and Ph.D. from Stanford University. Dr. Cateforis has lectured and published widely, and is the revising author of the chapters on modern and contemporary art in Marilyn Stokstad's bestselling textbook, *Art History*.

GAO MINGLU is assistant professor of art history at the University of Buffalo (SUNY) and earned his Ph.D. in the history of art and architecture from Harvard University. He organized the exhibitions "China/Avant-Garde" and "Inside Out: New Chinese Art," and co-curated "Fragmented Memory: The Chinese Avant-Garde in Exile."

GAN XU received his Ph.D. in comparative arts from Ohio University, M.A. in art history from Vanderbilt University, and was in the M.A. program of art history at Xi'an Academy of Fine Arts from 1984–86. He has been teaching at the Maine College of Art since 1991. Currently he is associate professor of art history and the chair of the department of art history at the Maine College of Art.

DR. JENNIFER WAY is assistant professor of art history at the University of North Texas and was the moderator of "Transnation: Contemporary Art and China," the symposium held at the opening of the exhibition "from middle kingdom to biological millennium."

MARGO HALVERSON and CHARLES B. MELCHER are graphic designers, faculty members at the Maine College of Art and parents of Jack and Cora.

All images in the plate section *from middle kingdom to biological millennium* are by Abraham Bencid and Jonathan Reynolds (University of North Texas, Center for Media Production, 2003).

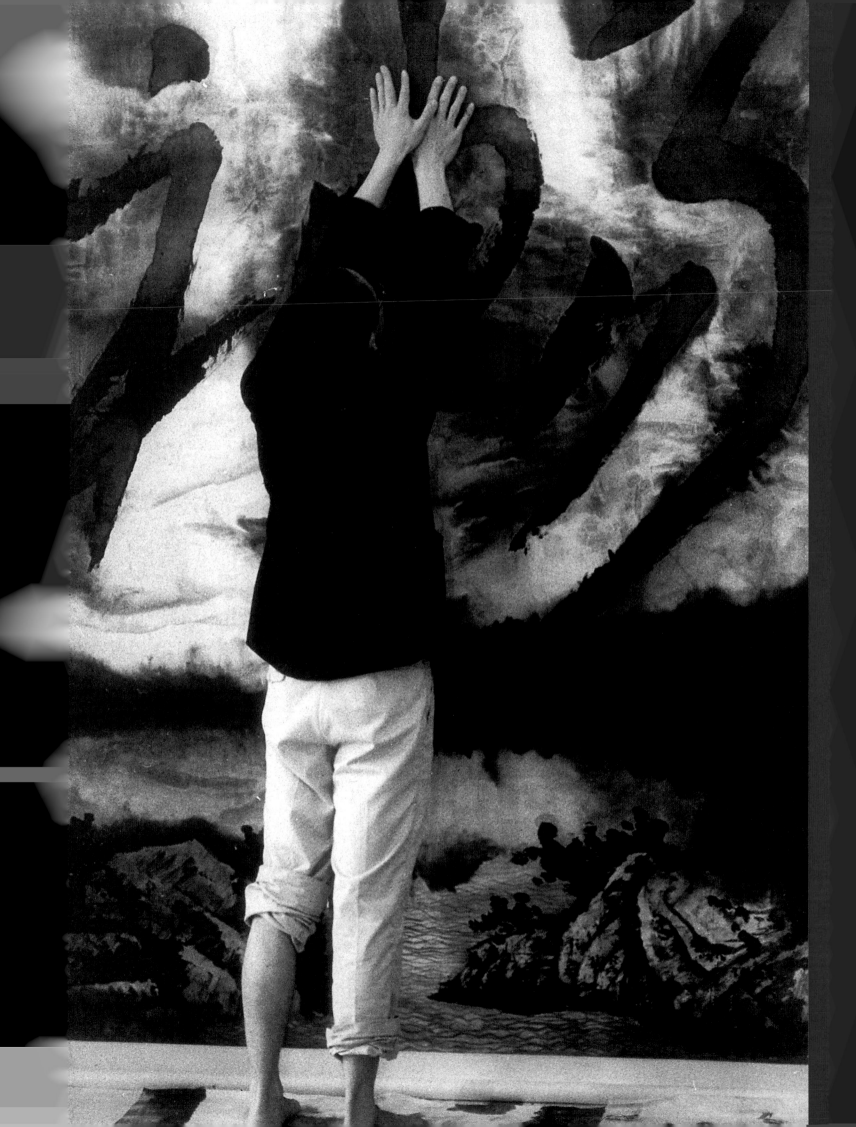